Raphael's Bible

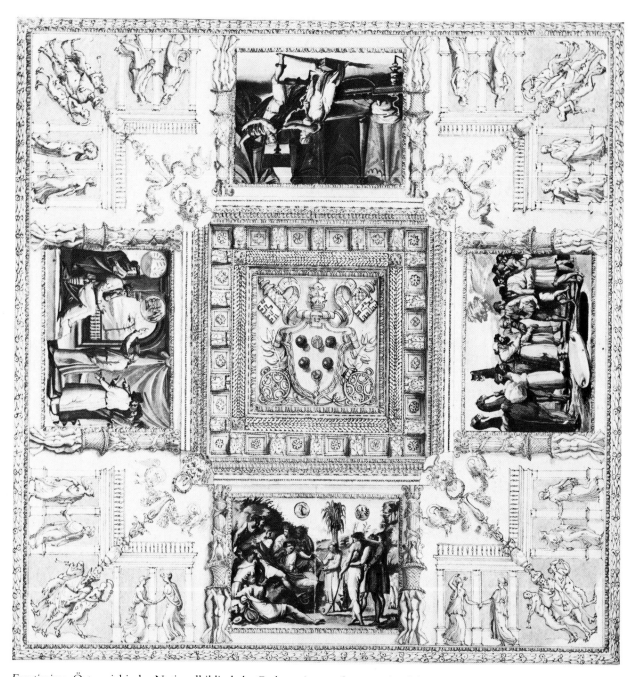

*Frontispiece*. Österreichische Nationalbibliothek, Codex min. 33, f. 56, vault of the central bay of the Logge.

BERNICE F. DAVIDSON

# Raphael's Bible
## A Study of the Vatican Logge

*Published for*

THE COLLEGE ART ASSOCIATION OF AMERICA

*by*

THE PENNSYLVANIA STATE UNIVERSITY PRESS
UNIVERSITY PARK AND LONDON

1985

Monographs on the Fine Arts
*sponsored by*
*THE COLLEGE ART ASSOCIATION OF AMERICA*
*XXXIX*

*Editor, Carol F. Lewine*

Library of Congress Cataloging in Publication Data

Davidson, Bernice F.
Raphael's Bible.

(Monographs on the fine arts ; 39)
Includes bibliography and index.
1. Raphael, 1483–1520.   2. Bible—Illustrations.
3. Mural painting and decoration, Renaissance—Vatican
City.   4. Vatican Palace (Vatican City)   5. Galleries
(Architecture)—Vatican City.   I. Title.   II. Series.
ND623.R2D3   1985          759.5          84-43088
ISBN 0-271-00388-X

# Contents

# List of Illustrations

# Acknowledgments

THIS book is dedicated to the staff of the Pontifical Museums and Galleries. From the director on through the various departments, to each guard whom I have encountered over the years, the Vatican employees, despite the enormous burden of their responsibilities, have unstintingly given their precious time to aid and smooth the way for a visiting colleague. Among the many who have been extraordinarily kind, I should like especially to thank Dr. Deoclecio Redig de Campos, Dr. Carlo Pietrangeli, Dr. Walter Persegati, Monsignor Gianfranco Nolli, Dr. Georg Daltrop, Prof. Gianluigi Colalucci and other members of the conservation department, and the staff of the Archivio Fotografico. Above all, I am beholden to Dr. Fabrizio Mancinelli. Without his ever-generous, sensitive, and intelligent assistance—in matters of scholarship as well as by providing access to areas and resources that might otherwise have been closed to me—this book would never have been written.

   Other friends and colleagues have helped in countless ways. I am most grateful to Iris and Donald Cheney, Nicole Dacos Crifo, Anne and David Ferry, Christoph L. Frommel, Richard Harrier, the late Howard Hibbard, Michael Hirst, Carol Lewine, the late Wolfgang Lotz, and Jennifer Montagu. Kathleen Weil-Garris offered a constructive critique on an early draft of the first chapter and has been supportive in many personal and important ways. John W. O'Malley, S. J., kindly reviewed the manuscript to preserve me from theological error and bibliographical deficiencies. John Shearman, with his usual generosity and learning, contributed valuable suggestions and corrections. Sydney J. Freedberg also made extremely helpful corrections, catching everything from spelling errors to major structural defects, and offering deeply appreciated support.

   Among institutions, I am particularly indebted to the Frick Art Reference Library, the New

York Public Library, Union Theological Seminary Library, the American Academy in Rome, the Archivio di Stato, Rome, and the Bibliotheca Hertziana.

I also wish to acknowledge with gratitude a Grant-in-Aid received from the American Council of Learned Societies in 1979.

# Introduction

WHY, you may well ask, should anyone wish to publish yet another book about the Vatican palace Logge? The literature on the subject already is vast, extending from contemporary comments—recorded as the last brush strokes were being applied—up to our own day, to the superlative book published by Nicole Dacos in 1977.[1] Without Dacos's invaluable monograph, its extraordinary fund of information and ideas, and the lavish illustrations supplied from the photographic campaign she directed, my own study of the Logge would not have been feasible, or not in its present form.

I began my inquiry into alterations made to the Logge by popes Paul III, Julius III, and Pius IV before Dacos's volume appeared.[2] But the material dealing with the original decorations by Raphael and his assistants could not have been written without the foundations established by *Le Logge di Raffaello: Maestro e bottega di fronte all'antico*. Like a great work of art, significant scholarship inspires thought as well as admiration. No ambitious monograph, not even Dacos's monumental achievement, is or should be definitive; one service such a book can provide is to open new avenues for investigation. Nicole Dacos's example has encouraged rather than inhi-

---

1. N. Dacos, *Le Logge di Raffaello: Maestro e bottega di fronte all'antico*, Rome, 1977.

Only abbreviated references to *bibliography* will appear hereafter in my footnotes. For more complete bibliographical information in all following footnotes (even for first references), see the References Cited at the end of the text. Exceptions will sometimes be made for early sources, where the date in particular might be immediately useful.

Throughout the book, Logge, capitalized, will be used to refer to Raphael's Logge on the third level of the Vatican palace. References to other levels or to entire wings of the logge will appear with l printed in lowercase.

2. See References Cited under B. Davidson.

bited my more limited efforts. We are concerned with different matters, as the titles of our books imply.

From the beginning, discussions of the Logge decorations have concentrated almost exclusively on two issues: sources—chiefly the antique sources—for the figures and ornament; and attributions—attempts to assign specific portions of the decoration to the individual artists working in Raphael's studio. Dacos directs much of her text and a catalogue, which includes most of the stucco and painted motifs with their sources, to an examination of these two difficult and controversial areas. A third subject of research that has, at least since the nineteenth century, proved interesting to scholars is the cataloguing of drawings for or after the Logge decorations and prints reproducing them. Both Konrad Oberhuber[3] and Nicole Dacos have made substantial additions to the earlier inventories of graphic works. Except when it seems unavoidable, I shall make no attempt to enter any of these already much-explored fields. My interests lie in more neglected territory.

Most admirers of the Logge reveal a bias toward either the biblical scenes of the vault or, more often, the grotesques that surround them and descend to clothe the lower portions of the Logge walls in a many-hued sheath of stucco and painted ornament. Writers tend to view these two basic components of the decoration separately, at times as though they were in actual conflict with one another, and nearly always as though any logical or systematic relation between the two zones were unimaginable.[4] Even the biblical scenes of the lower zone, the bronze monochrome basamenti, have been described as detached theologically, as well as geographically, from the scriptural narrative—afterthoughts, only loosely associated with the biblical sequence of the vaults. But any slight acquaintance with Renaissance art and literature should make the student wary of assuming lack of coherence among persons, stories, and objects that appear to modern eyes to be disparate and random. Moreover, it is unwise when faced with a great work of art by a great artist from any period in history to suppose that if one cannot understand, there is nothing to be understood. In fact, no one has made a serious attempt to analyze the meaning of Raphael's Bible. Considering the tomes devoted to theories about the Sistine ceiling or even to the Vatican Stanze, this default is astonishing.

The choice of biblical subjects in the Logge is said to be inexplicable. The selections and the omissions have often been called unusual, even unique. In a sense—a literal sense—that is true, simply because no two decorative programs can be identical. But the harder one tries to understand this highly sophisticated work of art, the more one comes to see that its special qualities do not, ultimately, derive from the character of the theological program. The program of the Logge is composed from a deeply orthodox and conventional (for the day) blend of Christian theology, philosophy, literature, and politics. Its basic tenets and the allegorical modes through which those doctrines are presented may be found time and again, over many centuries, in art and in literature.

The extraordinary aspects of the Logge lie not in the ideological concepts conveyed, but in the ways that established tradition is translated, shaped, and expressed to create a fresh and moving masterpiece of art. Before, however, one can fully appreciate the true quality and originality of the Logge decorations, it is of course important to fathom their meaning as

---

3. K. Oberhuber, *Raphaels Zeichnungen*.

4. Perhaps the most notable exception to this history of confusion was J.-D. Passavant, the industrious and perceptive author of what still remains the most useful catalogue of Raphael's work (*Rafael von Urbino . . . ,* 1839), especially the revised French edition of 1860. See also L. Pastor, *Storia dei papi*, IV, 494–96.

deeply as possible. Illustrations to a book lose their clarity of focus if one cannot comprehend the text. Lacking sufficient skills for a proper reading—adequate training in classical languages, theology, literature, and history—I can only point in what seems to me the right direction for a more nearly perfect understanding of Raphael's achievement, hoping that others will proceed farther toward that still distant goal. For me, a somewhat circuitous approach to an interpretation of the Logge program offers the most promising route.

The first chapter, therefore, will sketch in a background that should help to place within their historical framework the patterns of iconography found in the Logge decorations. Leo X's education and tastes and, most distinctively, his portrait by Raphael afford a revealing perspective of this princely priest, the patron who was so exquisitely cultivated and so devout. Additionally, a survey of imagery fashionable in the literature, theater, and festivals of his reign can extend this historical background to include broader vistas of contemporary rhetoric and propaganda about the pope and the Church, which are expressed in more restrained yet more eloquent terms by the figures of the Logge.

Again, and repeatedly, it will be emphasized that the doctrines and politics affirmed so consistently throughout Leo X's reign are in substance traditional and have long histories. The vault of the Sistine Chapel and the decorations of the Casino Pio IV, however much they differ from the Logge in appearance, share a number of basic ideas about Church and pope. Many of the same points and parables are found in art and literature made for Sixtus IV or Gregory XIII, not to mention for other Medici and for yet more distant courts and countries. Indeed, as recent investigations have only begun to demonstrate, many of the figural motifs and compositions of the Logge go back not to pagan classical example but instead reflect early Christian and medieval models and literary sources.[5] Revivals may come and go in waves, but the heritage of pagan and of early Christian Rome survived sturdily, side by side. Antiquity itself was filtered through the purifying justifications of Christian metaphor and allegory, which often trace their roots to apostolic authorities. Attempts to divide and separate the entwined sources of Christian imagery can, if performed too crudely, lead to worse distortions of Renaissance beliefs than an ignorance of their mingled nature.

The second chapter of the book presents the physical *mis en scène*, with a brief introduction to the Vatican palace Logge and the commission for its decoration. Shop practices and the condition of the decorations will also be touched upon. All these topics are discussed more thoroughly elsewhere by other writers, but a review will serve to orient the reader and offer an opportunity for suggesting certain corrections to generally accepted ideas. This chapter also introduces important documentation offered by the Vienna codex, a volume of miniatures after Raphael's Logge executed in watercolors.[6] Dating from the mid-sixteenth century, the codex records the appearance of the Logge only about thirty-five years after their completion. While other sixteenth-century drawings reproducing the Logge decorations have survived, these are scattered, partial sketches—such as Girolamo da Carpi's—that in general were personal notes made as reminders for the artists. The codex was instead a commissioned work of art intended to be complete and as scrupulously accurate as possible. It is also of remarkably high quality for a reproductive effort. As a tool for examining the Logge program, the codex is invaluable. Obviously, any interpretation of Raphael's Bible must be founded exclusively upon the original

5. See, for example, N. Dacos, "La Bible de Raphael," as well as the many derivations cited in her *Le Logge di Raffaello*.

6. See B. Davidson, "The Landscapes of the Vatican Logge from the Reign of Pope Julius III."

material. The codex is of prime assistance in distinguishing the early decorations from misleading accretions, both the inaccurate restorations and the entirely new additions made by later popes.

The third chapter, "Raphael's Bible," comprises the major portion of the book. Armed with the preparatory reasoning and apparatus of the previous chapters, I will attempt to identify the most significant cohesive themes of the Logge decorations. I will try to demonstrate that the ecclesiastical concerns and deep spirituality of Raphael's portrait of Leo X, as well as the propaganda issues of literature and festival, come together in the Logge, where they are stated in much the same figurative vocabulary found elsewhere. The familiar appellation for the Logge, "Raphael's Bible," will be seen as remarkably accurate, not merely the handy, popular nickname for a series of religious paintings. The arguments for my interpretation will be outlined in condensed form, with more omitted than included, and much that is speculative, some being based on lost elements of the decoration. By no means will every scene and ornamental motif be dissected in detail. It seems more useful to select for comment the threads that hold together the program and those portions of the decoration that best exemplify Raphael's genius for transforming the commonplace into the extraordinary.

At least some of the abbreviations are deliberate choices rather than oversights. Since virtually all the underlying ideas embodied in the Logge decorations are familiar ones to theologians and to students of Renaissance literature and philosophy, I shall try not to labor the obvious. But the choices of what to explain and what to assume as facts and ideas too well-known to require justification have been difficult decisions to make. Equally difficult—and part of the same dilemma—is when to provide footnote references and which authorities to cite. In matters of liturgy, for example, or Renaissance philosophy, the bibliography on any single point might easily stretch to a page or more. My selections have been arbitrary, guided by reading that I personally found useful. My inability to read Greek or Hebrew and the elementary level of my Latin have forced me to depend on modern language translations of most texts written in these languages. The reader will not find a single reference to J.-P. Migne, whose multivolume compendium of texts published in their original languages is a basic source for scholars. Nevertheless, I have tried to read widely and to avoid one error that often traps the inexpert student of theology.

It is always tempting to discover a specific literary source for an artist's interpretation of Scripture and to identify that particular text or theological school of thought as the authority for an entire visual program. I think this is a very dangerous game for the amateur. An image used by St. Augustine, for example, can often be traced back through the Greek fathers to a germinal passage in the New Testament and forward again through many diverse branches of exegetical writings to works of the Renaissance theologians and philosophers who advised the artists and their patrons. Without a profound knowledge of the entire range of literature, attributions to a single source of influence are almost inevitably too narrow and lead to misunderstandings. I do not feel that any one mind or school of theology exclusively determined the Logge program, although, as might be expected, traces of philosophical attitudes associated with Florentine humanists seem distinctly identifiable. The scholars of the papal court read widely; neither their cultural interests nor their theological predilections were strictly curbed or censored by their well-educated pontiff. The Logge, in fact, communicate an enthusiasm for diversity.

All bibliographical references in the footnotes are listed at the end of the book. A much longer list composed of all authorities consulted would be more haphazard than helpful. Bibli-

ography on the Logge itself is supplied in abundance by other writers, notably by Nicole Dacos. Because my original manuscript was completed in 1981, I may have missed important later bibliography, especially that from the Raphael anniversary year of 1983–84, which has produced more literature than I can hope to subsume into my text.[7]

7. Another important contribution to the literature that appeared after my text was in production and in many ways complements my own discussion is J. Cox-Rearick, *Dynasty and Destiny in Medici Art,* Princeton, 1984.

# I

# Leo X: Portraits and Pageants

THE patron who commissioned the Vatican Logge decorations was already an ambiguous figure in his own day. Leo X's manifold virtues and weaknesses educed from his contemporaries partisan responses, which often were exaggerated to accord with the religious, moral, or political bias of the writer or to further his personal ambitions.[1] In a period of so much threat and conflict, it would be rare indeed to find an observer capable of regarding with detachment the man who, potentially, wielded the mightiest powers, both in this world and in the next. Unfortunately, Leo X was not energetic and forceful enough to heal the schisms and quell the heresies that were beginning to ravel the authority of Catholicism. Despite his lofty position, his intelligence, talents, and piety, the pope was by temperament too indulgent and mundane to take the stern, difficult measures that might have spared the Church much imminent humiliation.

The Fifth Lateran Council, which met at intervals between 1512 and 1517, proposed many reforms of the Church and clergy, but its recommendations were largely ignored.[2] Abuses—moral, social, fiscal, and doctrinal—continued, provoking Luther to nail his portentous theses to a church door in Germany and reform-minded Italians to express profound discontent. The pestilence, flood, and war that engulfed Rome during the decade after Leo X's death in 1521

---

1. The best general history of Leo X's papacy remains that of L. Pastor, *Storia dei papi*, IV. Also invaluable is W. Roscoe, *The Life and Pontificate of Leo X*, especially in the Italian edition, with its added source material: *Vita e pontificato di Leone X. di Guglielmo Roscoe,* ed. and trans. L. Bossi.

2. A useful summary of the Fifth Lateran Council is provided by O. de La Brosse, *Histoire des conciles oecuméniques,* x. Texts of the Council's decrees may be found in *Conciliorum Oecumenicorum decreta,* 593–655. For texts of sermons and other official statements released by the Council, see *Sa. Lateranen concilium . . . ,* 1520. For further bibliography, see N. H. Minnich, "The Participants at the Fifth Lateran Council," 157 ff.

were considered by many to be just punishment for the sinful ways of its inhabitants and its Church. Those who foresaw the dangers to the Church condemned the pope as lazy, indecisive, ruinously extravagant, and spoiled by his taste for worldly distractions.[3] Later writers, with the advantages of hindsight, tend of course to stress even more strongly than did his contemporaries the pope's inaptitude for the role of shepherd to an increasingly wayward flock. But those who knew Leo X and to sufficient degree shared his tastes, found him delightful company—gentle, kind, sensitive, gifted, and unstintingly generous, deeply religious, and extremely concerned to observe and promote the rites, dignity, and authority of the Church.[4]

Giovanni de' Medici was born in Florence on 11 December 1475, in a highly privileged milieu. In terms of riches, rank, and cultural advantages, his opportunities were extraordinary. The finest minds and talents of the city provided education and companionship, books, music, and works of art for the sons of Lorenzo il Magnifico. The second son, Giovanni, was an excellent student of Latin, competent in Greek, and showed particular fondness for music, a taste no doubt inherited from his father.[5] From infancy, however, he was destined for an ecclesiastical career. He received the rite of tonsure at age seven, and before he reached the age of ten he had acquired, through the influence of his father, literally dozens of benefices. In 1483 he was confirmed, and only six years later, after much pressure from Lorenzo upon the Vatican, the thirteen-year-old was named cardinal. Even for that period, and though on probationary terms, the appointment was considered a bit premature. As Pico della Mirandola wrote so tactfully in a book dedicated to Lorenzo, "Your son Giovanni at an unprecedented age has been destined by the Pontiff Innocent VIII for the highest college of Christian orders, both for his native qualities, which promise all good things, and because your merits and authority ask it rightly and justly for him."[6]

Thus the future pope received the best education available to a wealthy, powerful family, and from youth he learned to take for granted that all benefits at the disposal of the Church were to be bought and sold, through influence or for cash, in the normal course of ecclesiastical business. His later inability to grasp the dangers of trading in offices, benefices, pardons, and indulgences reflected habits learned in childhood. Such a background does not, obviously, imply that Giovanni's religious education was neglected or that he was not a serious scholar and devout Christian. The Florentine humanists of his father's circle leaned toward elaborate forms of syncretism and mysticism, which later were to shape elements of the imagery employed at the pope's own court. These intricate modes of theology would have held great attraction for a mind such as Leo's, which always preferred the complex in literature, music, and art. To balance the curriculum of classical studies, and as a condition for receiving his cardinal's hat, the boy then spent several years of concentrated training in canon law at the university of Pisa. In 1492 Lorenzo's determined efforts finally won for his son the formal investiture as cardinal.

3. An excellent study of Leo X's finances is provided by M. Bullard, who sums up his economic policy with the remark that "Leo spent money as soon as he received it, if not before" (*Filippo Strozzi and the Medici*, 121).

4. As Onofrio Panvinio put it, "fu grand' osservatore delle cose divine e molto amico delle cerimonie sacre" (*La Historia di Battista Platina delle vite de' pontefici . . .*, 1563, 326). See J. Shearman, *Raphael's Cartoons*, 9 ff., on Leo X's respect for the forms of liturgy and the *Maiestas papalis*. Shearman's impressive knowledge of the historical background to the period makes his book and the bibliography he provides essential for any study of the papal court and commissions.

5. For Lorenzo's interest in music, see L. Parigi, *Laurentiana*. On his son's talents, see A. Pirro, "Leo X and Music." Giovanni's youth and education are discussed by G. B. Picotti, *La prima educazione e l'indole del futuro Leone X*.

6. Giovanni Pico della Mirandola, First Proem to *Heptaplus* (1489), 75. L. Landucci (*Diario fiorentino dal 1450 al 1516 . . .*, 56) reported simply that the Florentines welcomed the honor as "una grande grazia."

Shortly after his arrival in Rome, in March of 1492, Cardinal Giovanni received a letter of advice from his father. In it Lorenzo exhorts his son to be devout, chaste, and virtuous as cardinal, for if all cardinals led exemplary lives, he argues with deceptive logic, then all popes would be good. Among many sage admonitions regarding his conduct, Lorenzo reminds Giovanni that although he is now devoted to God and the Church, he should find these obligations no obstacle to favoring his family and his native Florence. Leo X dutifully observed this recommendation all his life.[7]

Lorenzo's premature death a few weeks after writing this letter cut short the cardinal's first residence in Rome. His elder brother, Pietro, who succeeded Lorenzo as head of state, was so detested by the Florentines that in 1494 they revolted, forcing the Medici into exile, among them Giovanni, who escaped in the disguise of a Franciscan monk. These two catastrophic losses—that of his father and of his homeland—were followed by six years of bitter, wandering exile. The cardinal only returned to Rome and to his rightful post and honors in 1500. After the election of Julius II in 1503, his career prospered, although the inevitable involvement in Julius II's wars hardly suited his peaceful and comfort-loving disposition. When Leo X was elected to the papacy, his pacific inclinations were recognized and encouraged as a welcome contrast to his predecessor's bellicose reign. In 1512, at the battle of Ravenna, the cardinal was abruptly relieved of military entanglements by capture and imprisonment. His subsequent fortunate escape was considered by Giovanni and by his contemporaries to be a divinely ordained intervention that spared him for the papacy. Less than a year later, on 11 March 1513, at thirty-seven, a tender age for popes, Cardinal Giovanni became Pope Leo X, the first Florentine pope in history. Explanations for his choice of that name were much discussed even in his own day.[8] One reason for the selection, among many valid motives and others rather more fanciful, derived surely from a pairing of the two traditional guardians of his native city: St. John the Baptist, his name saint, and the lion, the Florentines' treasured *Marzocco*.

## THE PORTRAIT

The new pope was likable, but he was not lovely to look at, as all verbal and pictorial portraits of him confirm.[9] Although tall, Leo X had a remarkably large head and a body that appeared unhealthily bloated—"pectore amplo; ventre magno."[10] His physical condition, as well as his moral and intellectual constitution, posed problems that were difficult to surmount. The Venetian orator reported in 1517 that Leo X "ha qualche egritudine interior di repletion e cataro, et altra cosa non *licet* dir, *videlicet* una fistola." But, he continued, "è homo da ben, è liberal molto, à bona natura, non voria fatica si'l podesse far di manco; ma per questi soi si tuo' fatica. . . . Il Papa non voria nì guera, nì faticha."[11] The pope's dark eyes were severely myopic, yet his hearing was remarkably acute, and his voice and manners were exceptionally

---

7. The text of Lorenzo's letter is published, among other places, in W. Roscoe, *The Life of Lorenzo de' Medici*, 467–70. Leo X was not perhaps as entirely and inevitably biased toward Florence and Florentines as he usually is reputed to have been: see R. D. Jones, *Francesco Vettori*, 85–108 passim.

8. J. Shearman, *Raphael's Cartoons*, 18 ff.

9. For other portraits of Leo X, see L. Pastor, *Storia*

dei papi, IV, 332; V. Cian, "Su l'iconografia di Leone X," 559 ff.; and J. Shearman, *Raphael's Cartoons*, 59 ff.

10. W. Roscoe, *Vita e pontificato di Leone X.*, XII, 155 (from a contemporary biography of Leo X).

11. *I diarii di Marino Sanuto*, XXIV, col. 90. The pope also perspired copiously (G. Pieraccini, *La stirpe de' Medici di Cafaggiolo*, I, 220, with further discussion of his health; see also L. Pastor, *Storia dei papi*, IV, 334).

pleasant. The pride that Leo took in his delicate, snow-white hands, a vanity noted in several contemporary accounts, suggests that he may have been equally, but painfully, conscious of his less attractive features. Despite the public nature of his career, the pope seems to have been a rather private man who preferred the company of the friends and family companions of his youth.

Among all the portraits of Leo X, by far the most beautiful and the most understanding was Raphael's portrait of the pope with two of those family companions (Fig. 1).[12] Raphael shared a great many of his patron's enthusiasms and no doubt was more congenial company than most of the clerical members of his court. Like Leo, he was noted for his generosity and his courteous manners, his cultivated tastes and his broad range of talents. Many contemporary writers offer touching evidence of the pope's deep personal affection for Raphael and his "ismisurato dolore" at the artist's sudden, early death.[13] The variety of responsibilities, both artistic and administrative, that he showered on Raphael testify to the pope's perfect confidence in him; Leo X entrusted Raphael with all the most important commissions of his reign, from the architecture of Christendom's holiest temple to the preservation of antiquities in Rome.

Because the portrait was executed during precisely the same period that Raphael and his assistants were decorating the Vatican Logge, a closer look at this painting offers useful insights to certain ideas of the patron and his artist and to the figurative means employed in communicating them. The portrait and the Logge—superficially such diverse works of art—in fact share important underlying affinities. Both represent fundamentally orthodox, institutionalized, theological traditions, which Raphael's genius expresses and embodies in such grand, opulent, dramatic, yet subtle forms that the basic ecclesiastical content, which must have seemed too obvious to contemporaries to be worthy of comment, has since been forgotten. Richness, skill, and novelties catch the eye, are newsworthy, and monopolize contemporary accounts of the works of art designed for the pope, particularly in references to his portrait and to the Logge. Similarly, in reports on Leo X's way of life, the displays of pomp and entertainment naturally tended to attract attention rather than the pope's daily private devotions and frequent confessions and communion.[14]

In addition to the pope, Raphael's portrait of Leo X depicts two Medici relations, both of whom he had made cardinals. Cardinal Giulio de' Medici, the pope's cousin, had shared the vicissitudes of his earlier life and would become Pope Clement VII. Cardinal Luigi de' Rossi, whose mother was an illegitimate sister of Lorenzo de' Medici, had been educated with Leo. On 1 July 1517, Leo had named Luigi cardinal, but he survived only two years thereafter, dying on 19 August 1519, to Leo's great distress. The date of the portrait, however, can be determined more narrowly even than this two-year period, for it had already been delivered to Florence by early September 1518. At the festivities celebrating the marriage of the pope's nephew Lorenzo de' Medici to Maddalena de la Tour d'Auvergne, a much-desired French

12. Now in the Uffizi, Florence. Oil on panel, 154 x 119 cm. A summary bibliography for the portrait is provided by L. Dussler, *Raphael*, 46. For more complete information, see E. Allegri, in *Raffaello a Firenze*, 189–98. The complex tale of Giulio Romano's possible collaboration in the execution of the painting and of Andrea del Sarto's copy after it may be found in Vasari, v, 41–43. See also S. J. Freedberg, *Andrea del Sarto*, 131 ff.; J. Shearman, *Andrea del Sarto*, ii, 265–67; and N.

Dacos, "Tommaso Vincidor un élève de Raphaël aux pays-bas," 63. See also note 15.

13. V. Golzio, *Raffaello nei documenti*, 114.

14. Such pious participation in the rites of worship, especially the taking of Holy Communion, was not common even among clergy, who often received communion only one to three times a year (P. Tacchi Venturi, *La vita religiosa in Italia . . .*, 253 ff.). See also L. Pastor, *Storia dei papi*, iv, 336–37.

alliance that rewarded Leo X for long and patient negotiations, his image hung in a place of honor over their banquet table.[15] The clothing worn by Leo X in this portrait suggests an even tighter calendar for the sittings. He is dressed rather simply for a pope: no official vestments, no jewelry. Layered over a white rochet, he wears a white damask furlined cassock and an ermine-lined red velvet *mozzetta*. His red velvet *camauro* also reveals a fringe of ermine lining. For a man who perspired heavily, the pope is wrapped so warmly that we may suppose the season to be winter: the winter, therefore, of 1517–18.

In the portrait, Leo X is seen raised on a dais and seated in a thronelike chair before a table covered with a red cloth. Along with the luxurious textures of the silks, furs, and velvets, the objects displayed on the table have also been admired as a virtuoso demonstration of Raphael's skill at rendering reality, with an almost Flemish definition of surfaces and light. Vasari's description of the painting dwells exclusively on this brilliant imitation of the visible world, wherein, he says, "si veggono non finte, ma di rilievo tonde le figure: quivi è il velluto che ha il pelo; il domasco addosso a quel papa, che suona e lustra; le pelli della fodera morbide e vive; e gli ori e le sete contraffatti sì, che non colori, ma oro e seta paiono: vi è un libro di cartapecora miniato, che più vivo si mostra che la vivacità, e un campanello d'argento lavorato, che non si può dire quanto è bello. Ma fra l'altre cose vi è una palla della seggiola, brunita e d'oro, nella quale a guisa di specchio si ribattono (tanta è la sua chiarezza) i lumi delle finestre, le spalle del papa, ed il rigirare delle stanze."[16]

The illuminated manuscript and the finely chased silver bell, so highly praised by Vasari, have been understood to represent Leo X's love of precious trinkets, his collector's appetite for books and *objets d'art*. The handbell, described as an everyday utensil for the short-tempered master,[17] and the book, "to which the Pope sits up—as if to a meal," have held no significance for writers about this portrait beyond, at most, symbols suitable for any man of wealth and leisure; indeed, it has been said that "the pope is painted without any specific suggestions of power, earthly or spiritual."[18] Yet the evidence is there, both specific and allusive, that this is the portrait of a powerful ruler and a devout priest. Although unveiled in Florence for a fete celebrating a Medici political triumph, the portrait asserts to the citizens and princes of the world that these Medici are invested with powers superior to all others. A comparable claim is made contemporaneously in the Logge, where again a theological program and statement are presented in a place and with a view toward occasions that would not be considered strictly religious. Ostensibly, Raphael's portrait displays Leo X for our homage as a cultivated and august prince, but in a deeper reality the pope is presented as an icon that we are urged to regard with reverence for the sake of our own salvation.

Certainly, the portrait is a declaration of family dynastic strengths and loyalties, but just as surely, the powers concentrated in these three members of the Medici family are expressed primarily in terms of spiritual and ecclesiastical authority. However impressive its show of material opulence may be, the portrait of Leo X is not a simple statement of worldly magnificence, for as such it is remarkably restrained. One cannot look seriously at this picture without feeling an uneasy sense of something happening, perhaps something being said or seen, that we

15. The portrait is mentioned in a letter of September 8, 1518 (J. H. Beck, "Raphael and Medici 'State Portraits,'" 132, with a list of earlier publications of this letter). See also R. Sherr, "A New Document Concerning Raphael's Portrait of Leo X," 31–32.

16. Vasari, IV, 352.

17. O. Fischel, *Raphael*, 121. In fact, Leo X was noted

for his patience, as reported, for example, when unlike others of the court, he bore the foolish pretentions of a speaker whom he "patiently tolerated . . . according to his tolerant and amiable disposition" (J. W. O'Malley, *Praise and Blame in Renaissance Rome*, 30–31, quoting Paris de Grassis).

18. M. Levey, *Painting at Court*, 89.

have missed. Cardinal Giulio looks at Leo with a seriousness bordering on sorrow. Leo's attention appears to hover between his cousin and something occurring out of sight, in front of him.[19] Cardinal Luigi, who stares directly at us, seems to expect from us some response to his silent communication. The hieratic solemnity of the red-robed figures—the two cardinals standing like attendant deacons—and the strange spatial, physical, and psychological dislocations among them suggest that this is not the ordinary portraiture of the humanist or collector comfortably settled in his study, surrounded by his books or business accounts or treasures. Nor is it the portrait of a contemplative man, whose averted gaze might imply thoughts that are turned inward. The pope is listening and looking, his interest drawn toward something beyond the confines of the picture space.

Amidst the regal blaze of many-shaded reds, the swelling, bulbous shape of Leo X appears larger than life but is not. Raphael has been sympathetic to the fleshy face, compared with the many other, grosser likenesses of the pope. The monumental body, thickly swathed in the crimson velvet *mozzetta,* seems astonishingly weightless, an effect achieved not only through the rising lines of the composition but also by expunging all ties to the ground. Figures and furniture float in deducible but undescribed relation to the floor and to each other, balanced in dynamic equilibrium upon the fulcrum of the pontiff. The architectural background of the painting does not appear to describe a specific, real location. For such monumentally scaled piers, the cornice is inexplicably low in relation to the figures, thus contributing to their floating, uneasy *bilancia.* The funnellike structure of the painting is in part directed by the chords played upon these austere architectural elements, which propel the movement leftward, pausing to accent each head. The composition thus fans out from the arch behind Cardinal Luigi to space above, below, in front, and to the left of the picture plane: to our space. Yet we can participate in this scene only spiritually. We cannot locate ourselves physically in the bottomless space, nor is our presence or the presence of any spectator visible in the room that is reflected from the chair finial. Only a blur of red from the pope's back may be identified in its glossy surface, and a window that illumines the figure of the pope from behind his left shoulder (Fig. 2).

On the table before the pope lies a book, which he will study with the aid of a magnifying glass (Fig. 3). This book has long been identified as a mid-fourteenth-century Bible, known as the Hamilton Bible, produced in Naples and now in the Kupferstichkabinett, Berlin.[20] The illuminated miniatures copied in Raphael's portrait of the Bible are sufficiently true to life and detailed so that one may recognize the exact page reproduced here. The Bible is open to folio 400 verso, which contains seventeen small scenes: eight from the Passion of Christ up to the Crucifixion, two depicting his descent from the cross and the Pietà, and the remaining six his appearances after death, concluding with the Ascension. The Last Judgment initiates the text; the end is seen at the beginning. Were the lettering rendered accurately to scale in relation to the illustrations, the words would be far too small to read. Legibility, however, was essential, because we must recognize this text in order to enter the spiritual domain of the portrait. Written as clearly as a signpost, then, are the words: *In principio erat verbū & verbū . . . . :* "In the

19. The slight cast to his eyes makes the direction of the pope's glance ambiguous. See J. Shearman, *Raphael's Cartoons,* 61, for evidence regarding Leo's eyesight.

20. I wish to thank Dr. Peter Dreyer, Staatliche Museen Preussischer Kulturbesitz, Kupferstichkabinett, Berlin, for kindly supplying me with photographs of and information concerning the Bible. I am also indebted to Dr. Hanns Swarzenski for his assistance. The most recent catalogue information on the Hamilton Bible is published in *Zimelien,* no. 48.

beginning was the Word, and the Word was with God, and the Word was God." The opening lines from the Gospel of St. John echo those of Genesis, for this Gospel announces the advent of a new Creation: Christ, the incarnate Word of God.[21]

A few lines lower on that same page of the Hamilton Bible lying open before the pope appears a verse that refers to his baptismal name: *Fuit homo missus a Deo, cui nomen erat Ioannes.* "There was a man sent from God, whose name was John." Although omitted because of spatial limitations from Raphael's representation of the Bible, these apposite tidings seem only to gain in significance from their invisible presence.[22] The primary importance of the manuscript, therefore, is not as a collector's item, but as a reminder of this Gospel text, used in the liturgy of the Mass, that any devout Christian would recognize from the opening line and could probably proceed to quote from memory.

Centered directly beneath the words "In principio erat verbum . . ." stands the scarlet-tasseled gold and silver bell with its reliefs of scrolled vines and a half-figure emerging from the foliage. The inclusion of a bell in ecclesiastical portraits became commonplace by the sixteenth century, and the tradition persisted long afterward.[23] I have never come across a bell in any sixteenth-century portrait other than those representing clerical figures.[24] Although churchmen with handbells already appear in the fifteenth century, the immediate source of the bell for Raphael's portrait no doubt was Sebastiano del Piombo's painting of Cardinal Bandinello de' Sauli with his secretaries, dated 1516, now in the National Gallery, Washington, D.C.[25] This work by a competitor must have challenged Raphael and his papal patron to attempt a superior group portrait. Sebastiano's painting also included a handbell on the table before the cardinal. The bell had so many meanings in the context of an ecclesiastical portrait that an entire dissertation might be written on the subject. Fortunately, the salient points may be summarized more briefly.[26]

From Old Testament times, the bell was associated with the priest and later became one of

21. See, for example, E. C. Hoskyns, *The Fourth Gospel,* 137, 140. Bibliography devoted to the Gospel of St. John is of course immense. It was the Gospel especially dear to St. Augustine (*Homilies on the Gospel of St. John,* XXXVI, 8.1), to Neoplatonists throughout the centuries, and to Florentine philosophers in general. See Giovanni Pico della Mirandola, *Heptaplus,* 70 (First Proem); A. Chastel, *Art et humanisme à Florence,* 84–85; G. Saitta, *Marsilio Ficino e la filosofia dell'umanesimo,* 244; and J. W. O'Malley, *Giles of Viterbo,* 51, 71.

22. The pope's baptismal name offered association with St. John the Apostle and Evangelist, as well as with the Baptist. Once an exile himself, the pope would have felt a personal parallel between his life and that of the presumed author of the Gospel.

23. My entirely informal and incomplete survey of clerical portraits with handbells petered out owing to a surfeit of examples. Before weariness overcame the effort, my list included: *St. Jerome,* in a Morgan Library manuscript dated 1488 (Didymus Alexandrinus, *De spiritu sancto,* Florence); Carpaccio, *St. Augustine,* S. Giorgio degli Schiavone, Venice; Joos van Cleve, *Bernardo Clesio,* Galleria Barberini, Rome; Jacopino del Conte, *Cardinal Marcello Cervini,* Galleria Borghese, Rome; Tintoretto, attributed to, *Portrait of a Prelate,* Galleria Doria, Rome; Prospero Fontana, attributed to,

*Julius III,* Spinelli sale, June 11–14, 1928, Lot 29; Pasquale Cati, *Pius IV,* S. Maria in Trastevere, Rome; Carlo Maratti, *Clement IX,* Pinacoteca, Vatican; Francesco Trevisani, *Cardinal Pietro Ottoboni,* Bowes Museum, Barnard Castle; Murillo, *Don Justino de Neve,* National Gallery, London (A. Braham, "Murillo's Portrait of Don Justino de Neve," *Burlington Magazine,* CXXII, 1980, 193; the author mentions the frequency of handbells in Roman ecclesiastical portraits). Dr. Fabrizio Mancinelli kindly called my attention to three later papal portraits with handbells in the Vatican storerooms: one of *Leo XI* and two of *Alexander VIII.*

24. John Shearman has pointed out an apparent exception: a strange, lost portrait by Giovanni Bellini, dated 1507, of Doge Leonardo Loredan with four attendants. Judging from a poor photograph of a painting that was in bad condition, the Doge appears to be blessing a large bell on the table before him.

25. See M. Hirst, *Sebastiano del Piombo,* 99–100. The rivalry between Sebastiano and Raphael became most overt in the paired commissions for *The Raising of Lazarus* and *The Transfiguration,* painted for Cardinal Giulio de' Medici.

26. The two most useful books I have found on the subject are an anonymous author's *Essai sur le symbolisme de la cloche* and N. Bossi, *Le campane.*

the principal instruments of his ministry.[27] Among other functions, bells represented the Old and New Covenants, exorcised the devil, symbolized the eloquence of the preacher, summoned the faithful to worship, and were rung at the Sanctus to announce the advent of Christ in the Eucharist. The bell in Leo X's portrait evokes all of those associations, especially the last. Centered beneath, almost touching the passage in the Gospel that reveals the Word Incarnate, the bell inevitably is linked with the Word, with the High Priest and his ministry, and with the authority of Christ that resides in him as the Vicar of Christ. This chain of closely woven associations, running from the Gospel of St. John to John the Baptist to the pope and to Christ, is reinforced by the liturgy, for the Gospel of St. John was read after Holy Communion. Both the bell and the Bible, then, represent more than costly bibelots, and more even than suitably splendid church furnishings for the service of God.[28] They signal the real presence of Christ, his sacrifice and Resurrection, which promise salvation to the Christian through the ministry of the Church by participation in the New Covenant. The presence of Christ is secreted, then, in the subject and objects of the portrait; through them the Christian is invited to worship. Other items enlarge this invitation.

In his left hand the pope holds, at an angle that reflects more than it reveals, a magnifying glass. Contemporaries described the pope's visual limitations as so severe that objects both near and far were difficult for him to distinguish clearly.[29] The papal accounts record a payment of fifty ducats for "ochiali,"[30] and Paolo Giovio reported that the pope used an instrument, which sounds like some form of telescope, for watching hunts.[31] This physical handicap must have been a torment to one so fond both of reading and of the chase. No doubt the well-known words of St. Paul, throughout all their various interpretations, carried a particular meaning to Leo X: "For now we see through a glass [or mirror: *speculum*], darkly [or dimly, unclearly: *in aenigmate*]; but then face to face: now I know in part; but then I shall know even as also I am known" (1 Cor 13:12). The passage seems touchingly suitable to Raphael's portrait, which makes known to us, in part but in perpetuity, this dim-sighted pope, with his glass in hand, his Bible open to the lines promising a Light that shineth in darkness (Jn 1:5), and his gaze turned to something undefined, beyond our sight.

Behind the pope, Cardinal Luigi holds the back of the chair. His hands isolate the chair upright crowned with its gilded finial, so that it suggests a scepter ceremonially displayed for our attention. Through his solemn comportment, the finial becomes transformed into a Medici *palla*, the word used by Vasari for finial in his description of the portrait and the word for the torteaux in the Medici coat of arms. *Palle*, the Medici rallying cry, alternating with *Leone*, rang through the streets at the pope's *solenne possesso*, when countless forms of *palle* were featured in the decorations. Some of these spheres performed marvelous feats, such as opening to disclose a pious child conversing with an angel or a boy declaiming eulogistic verses to the pope. Another seems miraculously to have grown a covering of eucharistic emblems over a terrestrial globe.[32]

27. A bell is included among the required sacred furnishings for bishops, according to canons established by Pius IX, and a Sanctus bell was one of the prescribed furnishings for the Mass (E. L. Sadlowski, *Sacred Furnishings of Churches*, 56, 115).

28. Concerning Leo X's desire for splendid vestments and church furnishings to adorn and honor sacred places, see J. Shearman, *Raphael's Cartoons*, 9 ff.

29. W. Roscoe, *Vita e pontificato di Leone X.*, XII, 155.

30. A. Mercati, "Le spese private di Leone X . . . ," 104.

31. P. Giovio, *Illustrium virorum vitae*, Florence, 1549, 109. See also L. Gaurico, *Tractatus astrologicus*, Venice, 1552, 19; and G. Boffito, "L'occhiale e il cannocchiale del papa Leone X," 555–61. The pope used "occhiale" as well to look at theater scenery (V. Golzio, *Raffaello nei documenti*, 94).

32. See below, pp. 20–21. Acorns, symbols of the Rovere family, appear as finials on the chair in Raphael's portrait of the Rovere pope, Julius II (L. Partridge and R. Starn, *A Renaissance Likeness . . . Raphael's Julius II*, 50, 56).

The *palla* so pointedly brought to our notice by the cardinal—and by the painterly bravura of the artist—embodies many meanings beyond the heraldic reference. This golden globe has a lengthy history of symbolic and metaphoric allusions. It incorporates simultaneously, quite like the festival *palle,* terrestrial, celestial, and eschatological references to the orb of the cosmos, the sun and light, and even the Heavenly Jerusalem, which "was pure gold, like unto clear glass" (Rv 21:18). It represents kingship both earthly and spiritual, like the pope's. In the dark reflection of this sphere, we see clearly only the light of a window with a crossbar. It is the mystical window, "the glory of the Lord," which we are "beholding as in a glass" (2 Cor 3:18), the light of Christ, with the cross of his sacrifice, the sign of the Eucharist: "Et sic facta est speculum dei in quo refulsit Christus qui est imago dei."[33] The mystical window was a familiar Christian metaphor that became especially popular in Flemish art of the fifteenth century. It is found frequently in images of the *Salvator mundi,* whose golden or crystal globe, instead of being crowned by a cross, often reflects the window with a crossbar. In many examples, such as Roger van der Weyden's Braque triptych or Memling's Antwerp altarpiece, the surreal nature of the reflected window is stressed by a celestial setting or sky-filled land-scape behind the figures—places where no window could exist.[34] Literary sources for the image of the luminous window as a sign of Christ also were multiple, the most authoritative and most often invoked being the Song of Songs (2:9) conflated with the prologue to the Gospel of St. John. On the page lying in front of the pope we are told: "There was a man sent from God, whose name was John. The same came for a witness, to bear witness of the Light, that all men through him might believe" (Jn 1:6–7). Like his name saint, Giovanni de' Medici appears—literally—before Christ, before the golden orb that holds the "light of the world" (Jn 8:12) and the cross of Christ. The Vicar of Christ, this pope named John, through whom all Christians may be led to believe, is illumined not as in the usual portrait, from a light source that shines upon his face, but from the mystical window behind his left shoulder.

The magic of reflections and mirrors has always fascinated, and their metaphors are as dear to classical mythology and philosophy as to scriptural, patristic, or poetic literature. Among the most familiar of mirror images, especially to Neoplatonic Christian writers, is the mirror as image of the soul.[35] Divinity, which can no more be seen directly "face to face" than the eye can look at the sun, may be glimpsed as a reflection in the purified human soul. Cardinal Luigi

33. Jacobus de Varagine, *Mariale,* Sermon VII, lxi. The fundamental article about the globe reflecting the mystical window, including numerous illustrations of the motif, is that of C. Gottlieb, "The Mystical Window in Paintings of the Salvator Mundi," 313 ff. See also Gottlieb's *The Window in Art,* 83 ff., 143 ff. Dr. Gottlieb has written other articles related to this theme, but they are less pertinent to the Raphael portrait.

34. The condition of the Braque triptych renders the reflection of the window on the globe uncertain (Gottlieb, *The Window in Art,* 153). An odd example of a landscape with a crystal globe reflecting a mystical window may be seen in a manuscript *Canzoniere,* attributed to Antonio Grifo, in the Biblioteca Marciana, Venice (It. Z. 64, f. 251). An illuminated page, attributed to Cima da Conegliano, shows a group of pagan gods standing in a landscape (M. Salmi, *Italian Miniatures,* pl. LXIX). At their center, poised on the crystal globe, is a nude Venus, who cradles Amor in

one arm and gestures upward (?) with the other, while Mars appears to point to her pudenda. Both the somewhat peculiar imagery and the love poem beneath it suggest references to chaste love and the celestial Venus. For associations of divine love and divine light—such as may be implied by the crystal ball—with the celestial Venus, see E. Panofsky, *Studies in Iconology,* 142 ff.; and A. B. Ferruolo, "Botticelli's Mythologies . . . ," 17 ff.

35. G. di Napoli, *L' immortalità dell' anima nel rinascimento,* 157. Numerous examples of such metaphors through the centuries might be cited; among them, see J. T. Muckle, "The Doctrine of St. Gregory of Nyssa on Man as the Image of God," 73 ff.; G. T. Peck, *The Fool of God: Jacopone da Todi,* 50–51; and H. D. Austin, "Dante and Mirrors," 16. For light and mirrors, see also A. Chastel, *Art et humanisme à Florence,* 320–21. Many of these images derive from reconciliations of Plato (as in *Phaedo*) with St. Paul.

de' Rossi, who stares out at us so intensely over the shining orb, seems to invite us to look into the mirror of Christ's unblemished life and to remember his sacrifice—into the mirror of salvation, through which we may obtain, if reflected only darkly and in part, some vision of God.

Mirrors and reflections exercised their sorcery not only upon writers and theologians but also on artists, who sought the challenge to their skill and the opportunity to display their talent. Vasari, for example, wryly reported his struggle to capture the reflections in Duke Alessandro de' Medici's armor.[36] He was advised by Pontormo, with either common sense or Platonic philosophy, to stop comparing the image with real armor, which would always make his copy look pale and inadequate. Raphael's marvelous depiction of real objects and surfaces in his portrait of Leo X reminds one of northern painters, whose ability to render mirrors, glittering jewels, and shiny metals, as well as other surfaces less reflective of light, far surpassed that of their Italian contemporaries. In his youth Raphael would have seen the court portraits, representations of famous men, and allegories, which are attributed to Justus of Ghent, at the ducal palace of Urbino.[37] The lustrous surfaces of armor and jewels and the magical quality of the light in these paintings could not have failed to fascinate the young artist.

The Urbino paintings, with their elaborately furnished interiors and luxurious paraphernalia of identity and status, as well as the inclusion in several scenes of more than one figure, may well have lingered in Raphael's mind when he planned the portrait of Leo X. But any number of models must have contributed to Raphael's painting. Among other examples by north European artists that were familiar to him was Jean Fouquet's portrait of Pope Eugenius IV, which hung in the sacristy of S. Maria sopra Minerva. Described by Filarete as having "due altri de' suoi appresso di lui; che veramente parevano vivi proprio,"[38] this lost painting has been suggested as the direct inspiration for Raphael's triple portrait. The notion of some link between the two works is appealing, not only because of the at least generically related composition of the group portrait but also because the rich oil medium of Raphael's portrait and his detailed observation of the material world, which cloaks so complex an iconographic structure so full of veiled symbols, seem northern European in character. The chair finial with its mystical window resembles in its hidden message the reflections on the crystal globes of the throne in Fouquet's *Virgin and Child with Angels,* from the Melun Diptych, Musée Royal des Beaux-Arts, Antwerp.[39] While there could be no direct relation between the two paintings, other works by Fouquet, especially the lost papal portrait, might have offered similar iconographic and compositional models.

Among Raphael's own compatriots, one artist could rival the northerners in his uniquely sensitive ability to paint the effects of light upon various surfaces; Leonardo da Vinci studied, wrote about, and painted reflections with consummate genius. He was resident in Rome,

36. Vasari, VII, 657.

37. The allegories may have been in nearby Gubbio (M. Davies, *London. National Gallery Catalogues: Early Netherlandish School,* 52 ff.).

38. W. von Oettingen, "Antonio Averlino Filarete's Tractat über die Baukunst . . . ," 307. See also O. Pächt, "Jean Fouquet: A Study of His Style," 89; and K. Schwager, "Über Jean Fouquet in Italien und sein verlorenes Porträt Papst Eugens IV.," 212 ff.

39. The mystical windows in the crystals of Fou-

quet's Virgin's throne were noted by J. Białostocki, "The Eye and the Window," 168. Białostocki's disagreements with some of Gottlieb's arguments (see my note 33) do not seem to me to affect the validity of those of her conclusions that relate to Raphael's portrait. Schwager ("Über Jean Fouquet," 217 and note 103) tentatively proposed an iconographic connection between the mystical windows of Fouquet's *Virgin and Child* and the similar reflection in the finial of Leo X's chair.

with interruptions, from 1513 to 1516.[40] Although reclusive and evidently unproductive as a painter during this period, Leonardo must surely have had substantial associations with Raphael, his admirer from Florentine days. Leonardo had been given quarters in the Belvedere and an assistant, both of which were sources of acute aggravation.[41] He suspected this assistant, along with other iniquities, of plagiarizing his experiments with mirrors, for according to Vasari, among Leonardo's odd and distracting preoccupations in Rome were mirrors.[42] One can easily imagine conversations between Leonardo and Raphael on a subject of such obsessive concern.

Leonardo's influence on Raphael's "dark manner" of these years has been thoroughly analyzed.[43] The frescoes of the Stanza d'Eliodoro and the late altarpieces, especially *The Transfiguration,* have been compared in technique to Leonardo's dark style, and study of other works has yielded further compositional and figural derivations from Leonardo's example.[44] The portraits of Castiglione and the "Donna velata," for instance, depend ultimately from the *Mona Lisa,* which Leonardo may have brought with him to Rome.[45] The portrait of Leo X does not immediately bring to mind the *Mona Lisa;* nevertheless, the feathery delicacy with which Raphael models the surfaces, the sensitive bath of light flowing over curves and planes, the exquisitely refined distinctions among the various optical effects of diverse substances and of the same colors on different materials strongly recall Leonardo's interests, his scientific observations, and his paintings. But most akin to Leonardo's spirit is the mysteriously dramatic illumination of the silent figures. They seem drawn from their shadowy backgrounds by the power of this real yet supernal light coming from the window with the crossbar behind the pope. The subject of the portrait becomes in a sense this pervasive light, which, like Christ and like the pope himself, embodies both the terrestrial and the divine.

Raphael's portrait of Leo X is an extraordinary display of the unstated and unseen. As Vasari acutely observed of Raphael's paintings, "in vero ogni cosa nel suo silenzio par che favelli."[46] Around the figure of the pope, we sense earthly and spiritual extensions of the visible scene that are in many respects more important than what is overtly declared. The kinds and levels of interconnection, the echoes and reflections that shuttle among the visible and the invisible, are of a complexity perhaps unparalleled in a portrait of the Italian Renaissance. In the Logge, with their sixty-four biblical scenes and incalculable number of stucco and painted grotesque motifs, a similar pattern of ideas unfolds, but there expanded far beyond the concentrated nucleus of the portrait. In the Logge, Scripture, liturgy, and doctrine again provide a traditional basis for multiple, shifting, merging associations, into which is then woven an abundant imagery of allegory drawn from sources ancient and contemporary, poetic and political.

40. For the dates of Leonardo's trip and an extensive analysis of his influence on Roman artists, see K. Weil Garris Posner, *Leonardo and Central Italian Art: 1515–1550.* Note 1, p. 49, includes a summary of chronology and of other bibliography concerning dates. See also K. Oberhuber, "Raphael and the State Portrait—I," 128–29; D. A. Brown and K. Oberhuber, "*Monna Vanna* and *Fornarina:* Leonardo and Raphael in Rome," 25 ff.; and C. Pedretti, *The Literary Works of Leonardo da Vinci,* II, 303 ff.

41. *The Notebooks of Leonardo da Vinci,* II, 537. K. Clark, *Leonardo da Vinci,* 164–65.

42. Vasari, IV, 47. "Fece infinite di queste pazzie, ed attese alli specchi. . . . " M. Kemp, *Leonardo da Vinci,* 329–31.

43. See K. Weil Garris Posner, *Leonardo and Central Italian Art: 1515–1550;* and G. J. Hoogewerff, "Leonardo e Raffaello," 173 ff.

44. In addition to Weil Garris Posner, many other scholars have of course recognized Raphael's debt to Leonardo. Numerous references are made to Leonardo's influence in, for example, S. J. Freedberg, *Painting of the High Renaissance in Rome and Florence,* see index.

45. Weil Garris Posner, 5 and note 13.

46. Vasari, IV, 361.

# THE PUBLIC IMAGE

The priest's unique, divinely conferred authority and the primacy of pope and Church over terrestrial as well as spiritual spheres are the tenets, usually polemical, that constitute the foundations of much of the art designed for the Renaissance popes and their predecessors. The principles established by the bull of *Unam Sanctam,* which had set forth the claim of papal authority over all rulers and nations and affirmed the precedence of spiritual over secular affairs, were officially endorsed by Leo X at the Lateran Council of 11 December 1516. Not only his portrait, but most of the art sponsored by the pope emphasized these interdependent themes, as did literature, theater, and pageants produced in his honor. Branching out from those basic doctrines was a thicket of ecclesiastic and political issues—some perennial, some more personal and current—which were expressed in many media, but with remarkable consistency of imagery and ideas. The pope, his artist, and his court must have shared in planning many of the artistic undertakings that propagated such doctrines, festival productions as well as palace decorations.

The complicated ideology involved in these projects would certainly have interested many of Leo X's circle. One may imagine that these scholars enjoyed formulating the ideas and suggesting the subjects to illustrate them. But it is unlikely that a program had to be dictated in complete detail for Raphael. His portrait of the pope demonstrates that he too was capable of translating iconological material and the pope's beliefs about himself and his role into terms and forms of art so subtly designed that neither the basic structure nor every individual element that elaborates the meaning of the work of art could have been fully prescribed by others. The affinity between the pope and his artist seems to have stimulated each to an inspired form of collaboration, which would bear its finest fruit in the Logge.

Before surveying the image of the pope that is presented through literary and festival propaganda—and that will be important to the Logge decorations—other commissions to Raphael from Leo X should be recalled, if but in passing, because they date from around the same period as the portrait and the Logge, and the issues they introduce are related to both the form and the content of the Logge decorations. The frescoes of the Vatican Stanze and the tapestries for the Sistine Chapel differ obviously in appearance from the Logge, yet they develop thematically similar points through compositions that quite often resemble those of the Logge. In the Stanza d'Eliodoro, which had been completed under Leo X after the death of Julius II, the four Old Testament scenes of the vault parallel in meaning and composition subjects that will appear a few years later in the Logge. The vault scenes of this Stanza summarize the central arguments of the wall frescoes and elevate their significance from specifically political and Julian propaganda toward the more universal story of God's preservation of the elect for the salvation of humankind,[47] a major concern of the Logge.

Some of these same ideas are expressed in Raphael's cartoons for the tapestries of the Acts of the Apostles, designed for the Sistine Chapel, and in the frescoes of the Stanza dell'Incendio, both launched at approximately the same time, about 1515. The tapestries have been brilliantly analyzed by John Shearman, who has also contributed much toward explaining the meaning of

47. F. Hartt, "Lignum Vitae in Medio Paradisi: The Stanza d'Eliodoro and the Sistine Ceiling," 124. See also

J. Shearman, "Raphael's Unexecuted Projects for the Stanze," 173, with further bibliography.

the Incendio decorations.[48] One can but mention here a few familiar concepts that will be echoed in the Logge, probably begun shortly after the other two projects. One theme, insistently sounded throughout each of these programs—and already proclaimed in the preceding Stanza d'Eliodoro—is that of God's saving intervention on behalf of the elect throughout scriptural history and of his saints in more recent history. In the Stanza dell'Incendio, as on the walls of the Stanza d'Eliodoro, where Julius II prevailed, the popes and the Church again perform great and miraculous deeds through powers lent them by divine intercession. Leo X had already benefited from such assistance in his miraculous escape following his capture at Ravenna; God's special protection of him had been demonstrated. Events from the lives of popes Leo III and Leo IV are used, in addition, to paraphrase statements about Leo X that we find repeatedly in art, literature, and pageant.

Leo X is portrayed as a leader distinguished by personal and public virtues, one who brings peace to Christendom, establishes harmony among its princes, and strives to enlist them in a crusade against the enemies of Christianity. The tapestry designs for the Sistine Chapel, which reiterate these refrains as a secondary counterpoint, emphasize New Testament confirmation for the divine, supreme authority lodged in pope and Church. Both of these projects also incorporate much specifically Leonine iconography, ranging from Medici imprese to an implied identification of the pope with divine and heroic figures by processes sometimes similar to those found in Raphael's portrait of Leo X.

The practice of identifying Leo X with Christ, St. John, St. Peter, David, Solomon, and various other heroes of the Scriptures was extended to include analogies with pagan deities. Such affiliations are made, for example, in the border motifs of the Sistine Chapel tapestries between Leo X and Hercules,[49] and, as we shall see, will be implied throughout the Logge. This form of eulogy, found normally in combination with Christian iconography, was applied frequently in many periods and countries both to secular and to ecclesiastical figures. It was particularly widespread in the imagery of panegyric at the papal court, especially in literature, theatrical performances, and festivals, all of which Leo X much enjoyed. The language of ideology and encomium tended to be more blatant in both the occasional literature and the festivals of the period than in works of art designed for greater permanence or for a more elite audience. Because their messages are made more explicit, it is useful to glance at the evidence provided in these other areas. Much of what may seem obscure in the Logge is ostentatiously proclaimed elsewhere.[50]

Although Leo X was accomplished in Latin and capable in Greek, his taste regarding literature was less finely discriminating than his judgment of art. He could be patiently tolerant of the most pretentious displays of verbiage, although on more than one occasion he found amusement in humiliating poets too pompous even for current fashion. From the beginning of his reign, the

48. J. Shearman, *Raphael's Cartoons,* 19; J. Shearman, "The Vatican Stanze," 22-23. Obviously, the bibliography on the Stanze is endless, but see in addition L. Dussler, *Raphael,* 62 ff.; and I. L. Zupnick, "The Significance of the Stanza dell'Incendio. Leo X and François I," 195 ff. (with references to earlier bibliography). An analysis of the Stanza della Segnatura in terms of interwoven Christian and pagan traditions, again very similar to combinations found slightly later in the Logge, has been proposed by H. Pfeiffer, *Zur Ikonogra-*

*phie von Raffaels Disputa: Egidio da Viterbo und die christlich-platonische Konzeption der Stanza della Segnatura.*

49. J. Shearman, *Raphael's Cartoons,* 89.

50. Sometimes festival propaganda as well, however, became too recondite for even the most learned interpreters. A Venetian reporting on Leo X's *possesso* remarked that an arch constructed on the Via Pontificum bore "due quadri grandi, quali non sono da nullo interpretati" (*I diarii di Marino Sanuto,* XVI, col. 695).

poems, speeches, and homilies extolling Leo X[51] make particular association with Jupiter and Apollo, as in a poem by Jano Vitale, published shortly after Leo's coronation.[52] It opens by announcing that Jupiter has newly descended to earth from Olympus and continues with the assurance that the benevolent light of the Leonine Apollo and a medicine (that is, Medici) sweeter than ambrosia or nectar will restore health to ailing humanity. After Leo's death, another eulogy, by Girolamo Bordoni, manages to incorporate an interminable roster of classical deities and heroes, who, in one way or another, are related to the pope's virtues and accomplishments.[53] Between these introductory and memorial salutes to the pope streamed a honeyed flow of generally undistinguished literature praising Leo in every guise, from Good Shepherd to Thunderer of the Vatican.[54] These authorized and public verbal portraits of Leo X allow us to see how he and his court wished the pope and the papacy to be understood.

The festivals lent many additional touches to the official portrait and must have been, on the whole, more entertaining than the literature. The first of them, held on 11 April 1513, honoring the pope's formal possession of the cathedral of Rome, began a series of celebrations staged during his reign that exploited the same range of homologous relationships. Unfortunately, only scraps of visual evidence survive to evoke the appearance of these ephemerae, but the literary documentation of them is fairly extensive. Each occasion had a somewhat different audience and propaganda aim, hence the emphasis and imagery varies, but with more overlap than deviation. The *solenne possesso,* wherein the bishop of Rome takes possession of his official seat, the Lateran, was perhaps the most spectacular of these pageants.[55] The route from the Vatican to the Lateran, passing many of the most famous monuments of Rome—ancient and modern, civic and ecclesiastic—was festooned with flowers, garlands, tapestries, and sumptuous hangings. The costumes, jewels, and regalia of the cortege were costly, dazzling, and of every color and material. Spanning the streets at intervals along the way were splendid triumphal arches, some "facti de cartoni,"[56] imitating marble, gold, silver, and bronze, but often including genuine ancient sculptures. The arches, obelisks, and other trophies constructed by various individuals and groups were not dictated by a single controlling body, as other festivals would be, but certain themes and images recur repeatedly.

Most numerous, of course, in this as in all other celebrations, were such personal and family emblems as the *palle,* the imprese of the yoke and of the diamond ring and feathers, the family saints and name saints, the Florentine lilies, and the lions—often referred to as *marzocchi,* the Florentine *leone*—which lay, crouched or posed rampant, in every available location. The figural scenes and symbols often bore Latin labels and included scriptural, allegorical, and

51. Leo X proscribed eulogies of himself in sermons, but these of course formed a small portion of the court rhetoric (J. W. O'Malley, *Praise and Blame in Renaissance Rome,* 33). Other examples of panegyric writings on Leo X are cited by J. F. D'Amico, "Papal History and Curial Reform in the Renaissance," 161–62.

52. Ianus Vitalis Castalius, *Leonem X. P. M.,* reprinted in W. Roscoe, *Vita e pontificato di Leone X.,* v, 233–37 (another in a similar vein, IV, 10). I am indebted to Dr. Donald Cheney for translating for me some of the ornate lines of this poem, as well as various other particularly difficult Latin passages. See also J. Shearman, *Raphael's Cartoons,* 1–2, for yet another poetic confection in honor of Leo X's election, this one by Zaccaria Ferreri.

53. G. Bordoni, *Triumpho della morte de Papa Leone X.*

54. H. M. Vaughan, *The Medici Popes,* 169. Since St. John the Apostle also was known as the son of thunder (Mk 3:17), a typical double entendre may have been implied in the epithet, pairing the pope's baptismal name with Jupiter.

55. See F. Cancellieri, *Storia de' solenni possessi de' sommi pontefici,* 67 ff.; *I diarii di Marino Sanuto,* XVI, col. 158 ff.; A. Luzio, "Isabella d'Este ne' primordi del papato di Leone X . . . ," 463 ff.; and F. Novelli, *Compendium vitae Leonis papae. X.* L. Pastor, *Storia dei papi,* IV, 24, offers further source material and bibliography.

56. *I diarii di Marino Sanuto,* XVI, col. 163.

classical subjects. Angels, Christ, Saints Peter and Paul appear frequently, with scenes of Christ giving the keys to St. Peter being an obvious favorite. The baptism of Christ and the Last Supper were represented too. Association was made between the pope and the Old Testament high priest Aaron, and also of course with Moses. The patron saints of physicians—and therefore of the Medici—Cosmas and Damian are honored, as well as the other favorite Medici pair, Saints Lorenzo and Giuliano. The pope's horoscope (a zodiacal band with Leo at its zenith, similar to the one painted above the pope's portrait in the Sala di Costantino) and a strange scene of astrologers allude to his faith in such studies, and in fact Leo X would establish a chair in astrology at the university in Rome.[57] The description of the procession also refers to the pope's superstitions regarding numerology, specifically to the auspicious power of the number eleven in his life.[58]

Hordes of allegorical figures pay tribute to the new pope, among them: Faith, Hope, Charity, Prudence, Justice, Peace—burning arms and in diverse other forms—Virtue overcoming vices, Fortune, the seven Liberal Arts, the practical arts of agriculture, commerce, and many others. More specific hopes for the new reign are evoked by such scenes as one representing the Lateran Council and its anticipated reforms. In an arch especially thickly encrusted with Leo's emblems, the sybils—prophesiers of the Messiah, and, by implied extension, of Leo X as Messiah[59]—stage an appearance. On the same arch the "tre Re," a reference both to the magi and to the three leading contemporary Christian kings, pay homage not to Christ, but to a figure being crowned with a Medici *palla*.

A number of other scenes show the enthroned pope adored by kneeling kings and emperors, some offering gifts. This chorus of obedience to spiritual rule will be repeated emphatically in the Logge. Several arches referred to the pope as peacemaker and reformer of the Church. Many of the Latin captions to these scenes had long familiarity in Golden Age iconography. The *parcere subjectis* and *debellare superbos* tags, attached to scenes of rulers kneeling to the pope, are quotations from the sixth book of the *Aeneid* (lines 851 ff.) in which Anchises predicts to Aeneas the future greatness of Rome: "Remember thou, O Roman, to rule the nations with thy sway—these shall be thine arts—to crown Peace with law, to spare the humbled, and to tame in war the proud." These same two tags would be used more than three decades later for Paul III, there associated, it is interesting to note, with the generous nature of lions, who were traditionally believed to be fierce and proud, gentle and merciful.[60] These and other virtues of lions are proclaimed throughout Leo X's *possesso*. Roman heroes found a place in the crowds of figures on the arches, including Scipio Africanus, Numa Pompilius, Antoninus Pius, Mucius Scaevola, and other luminaries, some probably personifying aspects of good government. But most numerous of all, amidst their following of nymphs and fauns, were the pagan gods, especially Apollo, who in Virgil's fourth Eclogue is proclaimed king of the Golden Age.[61] From evidence of the descriptions, Apollo appears at least a half-dozen times in the *possesso*. His mother and sister also are honored. Ganymede, Venus, Mercury, Bacchus, Hercules, Neptune, Narcissus, Perseus, and others pay homage to Leo X, many of them more than once.

Several of the mottoes transcribed by reporters implied that with the death of Julius II the

57. See F. Bell and C. Bezold, *Sternglaube und Sterndeutung,* 36; L. Pastor, *Storia dei papi,* IV, 458–59, note 1; and J. Seznec, *The Survival of the Pagan Gods,* 57.

58. See also J. Shearman, *Raphael's Cartoons,* 17, 84 ff.

59. For other analogies between Leo X and the Messiah, see ibid., 16–17, 75–76.

60. V. Forcella, *Tornei e giostre . . . sotto Paolo III,* 89–91.

61. Virgil, *Eclogues,* IV, line 10.

god of war had fled, to be supplanted by Pallas (pun intentional), while love (Venus), according to verses on one arch, would reign forever. Appropriately, the 1512 *festa* of Pasquino had been dedicated to Mars, while in the 1513 celebration Pasquino was clothed as Apollo, to whom verses were composed for the occasion, praising the new reign dedicated to peace and the arts.[62] Obviously, Leo X was welcomed with hopeful enthusiasm by the Romans, as a messianic leader,[63] one who was expected to bring peace, prosperity, patronage to the arts and letters, and spiritual and political renewal to the Church and city. With eternal optimism, couched in traditional terms of myth and pageantry, the Romans once again looked forward to a Golden Age, this time inaugurated by the surviving head of the Medici family.[64]

The second of the great festivals of Leo X's reign, which also was recorded in considerable detail, took place in September of the same year, 1513, and in part commemorated the birth of Rome and its anticipated rebirth under the Medici pope.[65] The occasion for the festivities was the conferral of Roman citizenship upon the pope's brother Giuliano and his nephew Lorenzo. This celebration was more focused on dynastic and political issues than was the *possesso,* and the tone was distinctly less religious. Instead of being a parade that moved from St. Peter's basilica across Rome to the Lateran, and which might be viewed by every man in the street, the September spectacle took place on the Capitoline hill, the legendary civic center of Rome, where attendance was limited by spatial restrictions, although the theater, decorated to rival ancient Roman theaters, was viewed by additional thousands of visitors.

Again the festivities blended Christian, pagan, and contemporary political elements. The ceremonies involved a Mass, held on the theater stage, and endless hyperbolic speeches and verses. The banquet, considered to be *all'antica,* for which the gargantuan menu survives, lasted for hours.[66] The redundance of dishes was so excessive that the sated diners ended by flinging the cooked birds and meats at each other. The guests were further entertained by music and buffoons, and by a series of floats bearing allegorical tableaux, followed the next day by more theatrical presentations. The theater, so ingeniously constructed that it seemed "in luogo di legno et pitturati veli haveriano posto pario marmo, alabastro et avorio,"[67] was thoroughly veneered with Leonine motifs, as well as with lavish applications of gold and silver. Our knowledge of this surely influential complex of many arts is based almost entirely on literary sources, a severe handicap that limits attempts to reconstruct any of the Roman festivals of the period. Only a ground plan of the theater exists, and a few sketches of minor details have been tentatively proposed as studies for the decoration.[68] Considering the relatively modest scale of the theater, the noise and heat from the crowds packed into it must have been stunning, and the smells, despite jets of perfumes, overwhelming.

The chief object of the entire magnificent event was to emphasize the ancient origins of the ties grafting the Florentine, or Etruscan, stem of the pope's family to the city of Rome. From the very beginning of his reign, Leo X was claimed to be of the "natione etruscus," a claim that

62. L. Pastor, *Storia dei papi,* IV, 403, 434. D. S. Chambers, *Cardinal Bainbridge in the Court of Rome,* 122–23. J. Shearman, *Raphael's Cartoons,* 15.

63. J. Shearman, *Raphael's Cartoons,* 17, 75.

64. Literature on the Golden Age mythography of the period is extensive and ever growing. See, for example, E. H. Gombrich, *Norm and Form,* 29 ff.; H. Pfeiffer, "Die Predigt des Egidio da Viterbo über das goldene Zeitalter und die Stanza della Segnatura," 237 ff.; F. A. Yates, *Astraea;* B. Davidson, "Pope Paul III's Additions to Raphael's Logge," 403–4; and T. Puttfar-ken, "Golden Age and Justice in Sixteenth-Century Florentine Political Thought and Imagery," 130 ff.

65. Some descriptions of this event were printed at the time and have been published by F. Cruciani, *Il teatro del Campidoglio e le feste romane del 1513,* with an extensive and useful introduction and notes.

66. Ibid., lxviii–ix, 12–14, 37–45.

67. Ibid., 66.

68. Ibid., 141 ff. For Peruzzi sketches associated with the *festa,* see C. L. Frommel, *Baldassare Peruzzi,* 76 ff.

was to become even more insistent with later Medici.[69] This theme of fraternal alliance supplied the subject matter for most of the paintings that adorned the wall surfaces between the pilasters of the theater, inside and out. The ancient accord and the blood ties between Rome and Etruria were illustrated by scenes (several drawn from the *Aeneid*) of Janus and Saturn (those Golden Age god-kings whose encounters recalled the links between Latium and Etruria),[70] of Aeneas, who was hero to both kingdoms, of Romulus and Remus, and of many others whose histories demonstrated that in antiquity the two regions had learned much from each other's customs, literature, government, and, especially, religion.[71] Auguries, sacrifices, priests, and gods were influenced by these beneficial relations. Methods of sacrifice and augury, it was claimed in two paintings, had been taught to the Romans by Tuscan priests and prophets. These huge poster-like paintings bore labels so that the messages, with their modern applications, could be understood by all the attending diplomatic representatives of Italian and foreign states, as well as by the leading citizens of Rome and Florence. The same propaganda was elaborated in the speeches and verses declaimed by priests, poets, actors, and noble Romans, much of which was widely disseminated within the year by published descriptions of the festival.

Other motifs of the Medici papacy that already were current in the literature and had been exploited at the *possesso* reappear on the Campidoglio and would endure throughout Leo X's reign. Elaborations of puns on the Medici as physicians and as medicine that will bring health to Rome abound in the speeches.[72] At one point, Leo and Giuliano's late mother, whose Roman origins are duly emphasized in this festival, appears during the performances deified, and as a goddess she informs the audience that "la santa Hetruria manda gli Dei salutiferi."[73] The pope as peacemaker and as supreme ruler are ideas also weighted by repetition. The Tiber tells the Arno in one scene enacted on a float that the pope "darà a gli Italiani pace eterna,"[74] a no doubt deliberately ambiguous promise. The Tiber proceeds to extend that peace politically and geographically from Rome to the "ultimo Oceano" and to the kings—"gli Re"—of the earth, who will, he predicts, submit to this rule. The pope's reign of peace is compared, inevitably, with the Golden Ages of Saturn and of Augustus. Associations also are made again between Leo and Apollo, as god of healing, of the arts, and of the sun, and, by easy transition, with Apollo and the sun as pagan equivalents of Christ, Christus medicus, and the sun of justice.[75]

69. M. Armellini, *Il diario di Leone X di Paride de Grassi*, 1. The Medici, it was claimed, inherited the "virtù etrusca" combined with the "forza romana" (G. Cipriani, *Il mito etrusco nel rinascimento fiorentino*, 28). See also W. Roscoe, *Vita e pontificato di Leone X.*, XII, 155; A. Chastel, *Art et humanisme à Florence*, 63 ff.; J. W. O'Malley, *Giles of Viterbo*, 30–31, and index; R. Quednau, *Die Sala di Costantino im Vatikanischen Palast*, 500 ff.; and *Palazzo Vecchio: Committenza e collezionismo medicei*, 19 ff.

70. See Virgil, *Aeneid*, bk. VI, lines 791 ff.; Macrobius, *The Saturnalia*, 66 ff., and *passim;* E. Wind, "The Ark of Noah," 416; and J. W. O'Malley, *Giles of Viterbo*, 123, 190.

71. F. Cruciani, *Il teatro del Campidoglio*, 31–33. It was believed that Etruria in the Golden Age of Janus had extended to the Tiber River (including, therefore, the Vatican as well as the Gianicolo), while Saturn's kingdom began on the southern bank, and his altar was

on the Capitoline (Annius of Viterbo, *Le antichita di Beroso Caldeo Sacerdote*, 42, 48), site of the 1513 *festa*. No doubt connections also were made in the theater between Janus with his keys and the pope with the keys of St. Peter.

72. For puns on the name Medici and the tradition of Christus medicus, see also G. K. Brown, *Italy and the Reformation to 1550*, 46; N. H. Minnich, "Concepts of Reform Proposed at the Fifth Lateran Council," 190; and J. Shearman, *Raphael's Cartoons*, 77.

73. F. Cruciani, *Il teatro del Campidoglio*, 58.

74. Ibid., 57.

75. These associations of Leo's are tied into the ancient analogies between Christ and Apollo (see note 72 above) and images of Christ as healer that go back to the earliest days of Christianity. See T. P. O'Malley, *Tertullian and the Bible*, 101 ff.; and R. Arbesmann, "The Concept of 'Christus medicus' in St. Augustine," 1–28.

One of the most complex passages of embroidery, composed of puns, similes, and other modes of stitching together diverse matters, was reported by Aurelio Sereno. He attributes to Fortezza the speech in which she says that the brothers Castor and Pollux (meaning, of course, Giuliano and Leo) now reign. The one brother not only holds the reins of the world but also possesses the power to open and shut the doors of Olympus. A flower, he came in the spring (when Leo was elected) from "florenti e patria redolens flos," a reference both to Florence and to Nazareth.[76] Furthermore, she continues, it was not by chance that the world began in this season or that it was the month of Christ's conception, and, in addition, a time of year when "en orbem in totum venit medicina salubris." Apollo also is woven in among the strands of this typical Leonine tapestry, which fluently reconciles pagan and Christian iconography with specifically Medici imagery in the same fashion that we will encounter throughout the Vatican Logge decorations. Sereno's transcriptions of the Campidoglio rhetoric may not have been strictly accurate, but the iconography and the patterns of association that he employs are characteristic of the papal court.

The next two festive occasions from Leo X's reign that should at least be mentioned here are somewhat less relevant to the Logge program than the *possesso* or the Campidoglio ceremonies. The first, which occurred probably in 1515, celebrated carnival with a procession of floats in the Piazza di Agone, the usual terminus for such events.[77] Unfortunately, the floats are very summarily described, but they evidently represented various virtues and desiderata of an ideal government, such as Speranza, Amicitia (the cart of "amore"), Libertà, Pace, Iustitia, Fortuna, and others of similar significance, which will reappear among the Logge stuccoes. From the terse listing of the participating floats, one may deduce that several at least were explicitly related to the pope's reign by familiar iconography. Mansuetudine, for example, is personified as a gentle and generous lion. Obedentia is portrayed by women carrying a yoke, presumably light and unburdensome as was the yoke of Leo X's impresa, which bore the motto SUAVE. Eternità, the last float, was drawn by two more lions. Had a detailed description of the carnival survived, undoubtedly other ideal qualifications would be associated with the Golden Age of Leo X through symbols and imprese.

The fourth of the festivals that bears some relation to the Logge program took place not in Rome, but in Florence.[78] Leo X's triumphal entry on 30 November 1515, occurred as he was en route to meet Francis I in Bologna, where he would negotiate the abolition of the detested Pragmatic Sanction, with its impairment of papal authority. His native city greeted him as though he were a returning hero of antiquity. "Non si raunò forse mai tanto popolo in Firenze," one diarist exclaimed.[79] The decorations consisted most conspicuously of triumphal

76. F. Cruciani, *Il teatro del Campidoglio*, 103–4. This passage, founded ultimately on the Song of Songs, is drawn from St. Bernard of Clairvaux, who on several occasions remarked that Nazareth signified *flower* and who expounded on the flower symbolism of the Song of Songs and the birth of Christ. See, for example, *St. Bernard's Sermons for the Seasons* (The Annunciation, Third Sermon), III, 168; and Y. Hirn, *The Sacred Shrine*, 202. For political associations of spring with Medici and Florentine renewal in the fifteenth century, see J. Cox-Rearick, "Themes of Time and Rule at Poggio a Caiano," 184 ff.

77. See C. Corvisieri, "Antonazo Aquilio Romano," 158; H. Janitschek, "Notizen-Ueber einige bisher unbe-

kannte Künstler, die unter Leo X. in Rom arbeiteten," 416–17; and J. Shearman, "The Florentine *Entrata* of Leo X, 1515," 142. F. Cruciani (*Il teatro del Campidoglio*, lxxv) gives the date of the *festa* as 1514, but it is usually believed to describe the 1515 carnival. The copy of the festival description found in Vat. lat. 3351, f. 171v, leaves a blank space for the last two digits of the date; evidently the copyist was unable to read the numbers in the original text.

78. J. Shearman, "The Florentine *Entrata* of Leo X, 1515," 136 ff. Raphael probably was in Florence at the time (V. Golzio, *Raffaello nei documenti*, 36, 40).

79. L. Landucci, *Diario fiorentino dal 1450 al 1516 . . .*, 353.

arches, whose construction had taken weeks of work and the services of virtually every artist and artisan in Florence.[80] Churches had been commandeered as studios and were clogged to the portals with the immense supplies of lumber used to create the illusion of marble arches carved with reliefs and enriched with bronze, gold, and silver. Despite these efforts, and partly because it had rained much of the preceding month, not all the decorations were completed on time.[81] In these much more elaborate Florentine decorations, many of the attributes of good government lauded in the Roman carnival celebration are repeated, along with numerous additional tributes.

Various triumphal arches displayed some obviously personal virtues especially credited to Leo X, such as Chastity, a figure on an arch with personifications of other forms of temperance, including Sobriety and Modesty, which were further illustrated by examples from the Old Testament. Among the scriptural scenes on this arch were stories of King David, who, as will be seen in the Logge, was associated with the musical pope; the arch was indeed one of those described as enlivened "cum musica."[82] More old Testament heroes and allegories of religion and the Church decorated an arch at the Badia. Old Testament exemplars of faith and charity were installed on several arches. The Fates, a Neoplatonic and papal preoccupation, also were represented.[83] One structure is tantalizingly described as representing "la felicità humana, et divina," a *paragone* that would be of great interest for the Logge program.[84] These Florentine festival decorations were in one sense a Tuscan ratification of the claims made on the Campidoglio. The triumphal arches, obelisks, and colossi must have been intended to confirm that their own and the pope's classical heritage indeed sprang from the same ancestry.

This language of rhetoric and hyperbole, of allegory and symbols, of the loudly proclaimed and the obliquely implied, was a normal language of communication in the papal court, and elsewhere. Today, any individual—ruler, priest, or commoner—who encouraged his adherents to equate him with Christ, Apollo, John the Baptist, or lions would be considered a prime candidate for protective confinement. It requires substantial adjustment of manners and standards to comprehend that such equations were perfectly acceptable and familiar. In fact, many of these same associations with historical, mythological, and biblical heroes were made in the fifteenth and sixteenth centuries for all sorts of persons, not only rulers and popes. Egidio da Viterbo, for example, was called the lyre of David and the cithara of the Church; he too was compared to Jupiter and Apollo, and his own Etruscan origins were advertised with pride.[85] This vocabulary of praise was common parlance. But choice, emphasis, the context of imagery, and, above all, the forms selected and the quality of expression could bring cliché to life. Raphael employed the standard vocabulary of Scripture, verse, festival, and theater in the Vatican Logge, using for the decorations much the same hackneyed cast of characters (often playing the same scenes) that we encounter in poetry and parades. But in the Logge, as in his portrait of Leo X, the ordinary and the conventional are transformed; they become inspired with fresh beauty and with newly expressive meaning.

Leo X and those contemporaries who remained loyal to the papacy despite the incumbent's human shortcomings, his poor achievement as a reformer, his unfortunate political ties to Florence and to family, and his weak control over financial affairs merely followed traditions rooted in antiquity, when they sanctified and deified the Pontifex Maximus of the Church in

80. Ibid., 358.
81. *Istorie di Giovanni Cambi,* 82.
82. J. Shearman, "The Florentine *Entrata* of Leo X, 1515," 145.

83. J. Shearman, *Raphael's Cartoons,* 17.
84. J. Shearman, "The Florentine *Entrata* of Leo X, 1515," 148.
85. G. Signorelli, *Il card. Egidio da Viterbo,* 109, 114.

art, literature, and festival. On a different level, a similar process of adulation and deification transformed the pope's artist into another Olympian figure. Even before Vasari recorded and perpetuated Raphael's superhuman status as one of the "Dei mortali,"[86] he was described as "quasi caelitus demissum numen,"[87] had acquired the epithet "divino," and had attracted a personal devotion, in addition to professional homage, that remains unique in the jealous world of art.[88] When Raphael died on Good Friday, some even believed that a genuine miracle had occurred, and a parallel was drawn with Christ's death.[89] As a sign of the Heavens' sorrow over the tragic loss, such menacing cracks—like the rent stones of the day of Crucifixion—began to open in the fabric of the Vatican palace that the logge seemed in danger of collapse. Perhaps the real miracle was that they have survived.

86. Vasari, IV, 316.

87. Celio Calcagnini, c. 1519, in V. Golzio, *Raffaello nei documenti*, 282.

88. Much has been written about the "divinity" of Raphael, including the inscription on his tomb (ibid., 119–21). See, for example, U. Middeldorf, *Raphael's Drawings*, 6–7; O. Fischel, *Raphael*, 289–90; and C. da Empoli Ciraolo, "La 'Divinità' di Raffaello," 155 ff. One must of course subtract from the host of Raphael's admirers the often virulently hostile Michelangelo partisans.

89. V. Golzio, *Raffaello nei documenti*, 114–15.

# II

# The Logge

THE Vatican palace has possibly the most complicated and disorderly architectural history of any building in Europe. Now and then, through the many centuries of its growth, a pope would determine to make sense and beauty from its hodgepodge accretions. Such ambitions inevitably were frustrated, victims of the brevity of papal reigns and the insufficiency of funds. Yet the most grandiose vision for renovating the palace and the basilica, that of Julius II, became in fact the one that defines to this day the basic forms and appearance of the Vatican complex. These plans too had only begun to be realized when both the pope and his architect died: Julius II in 1513 and Bramante in 1514. Their successors, Leo X and Raphael, continued to build on the ambitious Julian foundations, but Leo X was particularly handicapped by that endemic papal difficulty: inadequate resources. Despite all the ecclesiastical offices and benefices sold and the sacks of indulgences peddled by the clergy for the construction of St. Peter's, Leo X's extravagance and generosity had reduced his treasury to dangerous levels long before his death, which left vast unpaid debts. In quantitative terms of accomplishment, another sixteenth-century pope, the amazingly busy builder Pius IV (1559–65), should receive credit for carrying to completion the largest portion of the projects commenced by Julius II, including the logge.

The precise chronology of construction and the question of the degree to which Raphael altered Bramante's designs for the Vatican logge remain unclear, although many opinions have been aired.[1] Other problems also have not been resolved, and some of the most important have

1. Bibliography for the following cursory description of the construction and architecture of the Vatican logge may be found in D. Redig de Campos, "Bramante e le Logge di San Damaso," 517 ff.; J. Shearman, "The Vatican Stanze," 7–8, and *passim*; and numerous earlier publications listed in Dacos's bibliography (*Le Logge di Raffaello*, 307 ff.). The chronology of construction has never been clearly established, but C. L. Frommel has

scarcely been recognized. Horizontally as well as vertically, the logge were left unfinished after Bramante's death, and they remained in that state for half a century, again until the reign of Pius IV. This pope began the northeast wing of the logge and probably formulated but did not start work on a project for the south end of the main façade, which would connect the logge with the basilica and the piazza of St. Peter's.[2] We do not know how Bramante intended to terminate the two ends of the logge façade or whether, indeed, he thought of this screen that is applied to the ancient agglomerate of buildings as the palace façade, or simply as one side of a court, or as both. Since persuasive if insufficient evidence can be mustered to support either of the first two possibilities, the last may best fit the case. At the time of Bramante's death, the ground floor of the four-story façade and the next floor, which is the lowermost of what eventually became three superimposed floors of logge, apparently were built. The second, or middle of the three logge, where Raphael's Bible would shortly be installed, may not have been completed at the time. Construction continued under Raphael's direction with the extension of Bramante's *cordonata* to the fourth level, the uppermost logge, which were not entirely finished or decorated until Pius IV began tying up the many loose ends left by his predecessors.

Viewed from the outside, the logge masked all irregularities of the old structures with a unified, modern design based on well-known classical models (Fig. 4).[3] Looking out from the inside, the logge offered a magnificent panorama of Rome and a view down into the so-called *giardino segreto,* which, because of the inevitable ravages from construction of the palace logge, may not have survived except in name as the idyllic garden glimpsed in quattrocento views of the palace. The logge also provided convenient corridors through which one might pass between the main stairway, actually a *cordonata,* or ramp, behind the south end of the façade to the relatively public north end of the palace, while skirting the more private central core of rooms. Internally, the Logge extended approximately 65 meters in length (and about four meters in width) from the south end to the medieval tower at the north end, which must have housed another staircase. Bramante's south *cordonata* was so broad and so gradually inclined that one could ride up it on horseback, but the tower stairs at the opposite end would have been comparatively narrow, with many tight turns and few windows. Pius IV eventually removed these stairs, along with the tower, and substituted, as means of access to the north end of the palace, a remodeled, enlarged version of a second *cordonata.* This one originated in the Belvedere corridor and rose to the north side of the *giardino segreto;* under Pius IV it was extended upward as a stairway, eventually reaching the fourth level of the northeast wing of the logge.

Under Julius II and Leo X the third level of the palace became, in effect, the *piano nobile,* with the suite of state apartments—the Stanze decorated by Raphael—ranged along the north side of the palace, overlooking the Belvedere Court. At right angles to them, along the east side of the palace immediately behind and parallel with the Logge, were two other important rooms, one used for secret consistories, known as the Sala de' Palafrenieri, and the robing room, called the

---

offered many important hypotheses regarding the early stages ("Eine Darstellung der 'Loggien' in Raffaels 'Disputa'?"). For analyses of alterations to the Logge architecture and decoration made by later popes, through Pius IV, see References Cited for my articles, portions of which have been incorporated, with some revisions, in this chapter.

2. In 1564 there were reports that the pope had ordered demolition work to begin in the vicinity of the piazza of St. Peter's to clear space for porticoes to encircle it (L.

Pastor, *Storia dei papi,* VII, 585, 632). In connection with this project, designs probably would have been prepared for finishing the south end of the logge façade, but no traces of such plans have yet been identified. See B. Davidson, "Pius IV and Raphael's Logge."

3. Heemskerck's drawing dates from 1534–35 (see J. Ackerman, *The Cortile del Belvedere,* 201). The best treatment of the classical sources for the logge architecture is the dissertation by J. Daley, "The Vault Decoration of Raphael's Logge."

Camera de' Paramenti. Tucked protectively into the crook of the angle formed by the two suites of rooms were the pope's private chambers. It seems highly probable, then, that the third-level Logge were from the beginning conceived as a corridor leading from the grand *cordonata* at the south end of the palace to the state rooms at the north end (Figs. 5 and 6), a corridor to which access would be tightly controlled and regulated, especially when consistories were in session.[4]

By their very nature and structure, porticoes, arcades, galleries, and logge had always served as covered promenades. Vitruvius uses the term *ambulatio* and says that they were often decorated with paintings and statuary.[5] Bramante, Raphael, and their patrons obviously had in mind the classical models, known best through literary descriptions, which they adapted from their visual interpretation of surviving architectural and decorative schemes, often of different shape and diverse purposes. However, Raphael's decoration for the Vatican Logge differs significantly—and not only thematically—from what is known of ancient portico decorations and from the usual Renaissance examples, including the loggia he decorated for the Chigi. Because of their narrative sequence, the Logge have a highly organized directional movement, from a beginning to an end, despite the accent on a central bay. The classical loggia has in effect been joined in harmonious union with the church nave: a reconciliation once again of pagan and Christian traditions, that synthesis that seemed so reasonable to humanists of the day.

If the third level of the façade—the middle one of the three logge—remained unfinished at Bramante's death on 11 April 1514, then actual physical work on the Logge decoration could not have begun much earlier than the end of that year, although the first plans might have been presented before the architectural framework was completed. Dates proposed for the beginning of work in the Logge range from 1515 to 1518, dates that seem too early and too late.[6] No documentation survives for the chronology of the decoration until the few references to its later stages in the spring of 1518,[7] but such a difficult and innovative project would surely have required at least two, and probably more, years of work, no matter how many artists were employed on the site.

At this particular site, so unprotected from the weather, the schedule must have suffered frequent interruptions, for it would not have been feasible to work continuously during every season throughout the year. On dark days, especially in the afternoon, the vaults fade into dusky shadow, which would have been further deepened by the obscuring scaffolding. And as the present-day restorers of the Vatican can testify, the Logge become intolerably hot under the summer sun, while in winter the cold can be so severe that hands cease to function and supplies and wall surfaces congeal. The glass that now seals the originally open arches of the Logge mitigates the winter winds that sweep across Rome from the east and northeast and intensifies the summer heat. But in summer the Vatican was considered an unhealthy place to stay. Popes,

4. J. Shearman, "The Vatican Stanze," is most useful on the names and functions of rooms. See B. Davidson, "Pope Paul III's Additions to Raphael's Logge," for further discussion of access to the Logge.

5. Vitruvius, VII, v, 2. One occasionally finds the term portico or corridor (by its very name implying movement) designating the Vatican logge in sixteenth-century sources. See, for example, various plans for the conclaves (F. Ehrle, H. Egger, *Die Conclavepläne*).

6. E. Müntz (*Raphael*, 348) believed that Raphael did not direct his attention to the Logge before 1515 or

1516. F. A. Gruyer (*Essai sur les fresques de Raphaël au Vatican: Loges,* 203) also suggested 1515 or 1516 as the starting date. S. J. Freedberg (*Painting in Italy,* 44) proposed 1518. The majority of scholars suggest 1516/17, but 1516 seems to me the most reasonable guess. See N. Dacos, *Le Logge di Raffaello,* 22, for a proposed chronology based on attributions.

7. V. Golzio (*Raffaello nei documenti,* 68, beginning with the entry of March 1518) and N. Dacos (*Le Logge di Raffaello,* 139–41) both publish the relevant documents.

and as many of the household as could, fled to safer regions, farther from the humid, malarial banks of the Tiber.

The earliest-known accounts that refer to decoration of the Logge date from 1518 and record payments for the production of the della Robbia floor tiles, which once spread a colorful filigree of ornament interlaced with Medici imprese along the length of the Logge.[8] By May of the next year, 1519, the Logge evidently were finished. A letter from Marcantonio Michiel to a Venetian friend mentions that Raphael "ha dipinto impalazo 4 camere dil pontefice, et una loggia longissima," almost certainly a reference to the third-level Logge, since the writer goes on to say that "va drieto dipingendo due altre loggie che saranno cose bellissime"[9] (meaning the lower logge, which were shortly thereafter painted by Giovanni da Udine, and the upper logge, which, although begun under Leo X, were in fact to be completed only in Pius IV's reign). Further confirmation of the terminal date is provided by a payment on June 11 to "li garzoni hanno dipinta la logia duc. venticinque."[10] A few days later, on 16 June, Baldassare Castiglione, writing to Isabella d'Este, reports that the pope is more than ever absorbed with his music and also with architecture. Something new is always being added to the palace, he says, "et hor si è fornita una loggia dipinta: e lavorata de stucchi alla anticha: opra di raphaello: bella al possibile: e forsi più che cosa che si vegga hoggi dì de moderni."[11]

During the years that the Logge were being frescoed and stuccoed, Raphael had under his supervision numerous other commissions, both major and minor, including the portrait of Leo X. No one will ever know, or agree, to what extent he was responsible for the design of the Logge decorations and how much independence was allowed the assistants working, according to Vasari, under the guidance of Giulio Romano for the figure paintings and of Giovanni da Udine for grotesques and stucco. It is my sense of the situation that Raphael was responsible initially for the basic planning of the Logge decoration, that he provided drawings for most, and perhaps all, of the biblical scenes and for enough of the wall grotesques and stuccoes to establish the general design and some of the detail. Once the work was underway, I would guess that he kept a close but not constant watch over the enterprise. As the work progressed and assistants gained experience and confidence, he must have left more responsibility to those who proved most capable. Raphael was noted for kindness and generosity to his colleagues, some forty or fifty of whom were said to follow him about.[12] He was always willing to teach (or to learn) and would give away his drawings or leave his own work to help another artist. Under these circumstances it seems unrealistic to attempt a rigid or too detailed assignment of responsibilities on this large and extremely complicated project, where, during the normal round of daily tasks, considerable fluidity of roles must have been accepted and even encouraged.

Among the artists who worked on the Logge decorations, Vasari mentions (in addition to Giulio Romano and Giovanni da Udine) Giovanni Francesco Penni, Tommaso Vincidor da Bologna, Perino del Vaga, who had been trained in Florence, Pellegrino da Modena, Vincenzo Tamagni da S. Gimignano, Polidoro da Caravaggio, and "molti altri pittori," as well as Giovanni Barile, the wood carver from Siena, and the della Robbia of Florence for the manu-

---

8. Although it is not entirely certain that the first small payment applies to the Logge pavement tiles, the succeeding payments do. See V. Golzio, *Raffaello nei documenti*, 68–69; N. Dacos, *Le Logge di Raffaello*, 139. Some idea of the pavement design, if not the color, may be seen in Francisco La Vega's monochrome codex of 1745 (Vat. lat. 13751, f. 58; R. Quednau, "Rezensionen:

Konrad Oberhuber: Raphaels Zeichnungen . . . ," fig. 4). See note 17.
9. V. Golzio, *Raffaello nei documenti*, 98.
10. Ibid., 99.
11. Ibid., 100.
12. Vasari, IV, 384.

facture of the pavement tiles.[13] The crew assembled by Raphael was chosen then from a broad range of geographical and artistic backgrounds, and, as their future careers testify, its members diverged widely in their abilities. Several of this motley équipe were also remembered later in their independent years for being considerably less generous and accommodating to others than Raphael had been to them. Yet Raphael formed of them an effectively concordant team and encouraged each individual to develop the skills required to execute elements of decoration in the various media used in the Logge. Polidoro da Caravaggio, for example, who began by carrying supplies for the workmen, was promoted because of his evident talent to the rank of figure painter.

Vasari explains this "scuola de' giovani di Raffaello"[14] in his life of Perino del Vaga, who at first helped Giovanni da Udine with decorative elements and soon graduated to larger responsibilities as a figure painter. Raphael, Vasari says:

> aveva raccolto una compagnia di persone, valenti ciascuno nel lavorare chi stucchi, chi grottesche, altri fogliami, altri festoni e storie, ed altri altre cose; e così secondo che eglino miglioravano, erano tirati innanzi, e fatto loro maggior salari. Là onde gareggiando in quell'opera, si condussono a perfezione molti giovani, che furon poi tenuti eccellenti nelle opere loro.[15]

To trace the career of any one student from the humble role of porter of supplies, to painter of trellises and arabesques, through his promotion to executant of grotesques in stucco or fresco, and finally perhaps of entire biblical scenes would be impossible. Even at the more accomplished levels of performance, it is not always feasible to attempt to separate, much less to identify, individual artists, for all obviously were striving as hard as they could to please and to emulate the *maestro*. Efforts to attribute portions of the work to one or another artist are of course useful and necessary for those who wish to study the development of a particular artist. But the gamut of individuality revealed in the Logge decorations seems to me essentially too narrow to alter our understanding of them as the creation of Raphael's own imagination; the quality and style of the decorations are more remarkable for consistency than for diversity, as comparison with, for example, the frescoes of the logge on the floor above would demonstrate.

The thirteen vaulted bays of the Logge decorated by this talented team offered education in a variety of media. To several of the youths, the skills learned in Raphael's studio led to highly successful careers, notably those of Giulio Romano and Perino del Vaga, who themselves became court artists, versatile entrepreneurs, and perpetuators of Raphael's shop organization. The Logge that formed their school included within the range of its decoration marble frames and pediments for the doorways, windows, and niches, elaborately carved wooden shutters and doors, glazed painted tiles for the pavement, and a coating of fresco and stucco applied to all remaining surfaces. In its pristine state, every inch of the Logge shimmered with gold and many hues, with lively alternations of materials and contrasts between shadow and light, between hollows and reliefs, "like a living skin upon the body of the architecture, mobile and

13. Vasari, IV, 362–63. See also N. Dacos (*Le Logge di Raffaello,* 85 ff.) for these and other artists proposed as participants in the decoration. For her more recent contribution on Tommaso Vincidor, see "Tommaso Vincidor," 61 ff.

14. Vasari, VI, 550.

15. Vasari, V, 593.

porous, giving respiration to the underlying form."[16] Mingled with the real were the "pretend" elements of the decoration: the imitation bronze reliefs in fresco beneath each niche and window, the veined, colored marbles painted in the dado, and the illusionistic skies, canopies, and visionary architecture painted or modeled in stucco in the vaults surrounding the biblical scenes. While the imitations of costly materials were of course economically expedient, such deceptions, like the imaginative extensions of the real into the fantastic, were relished for themselves, for the skill of their deceits. They reflect the same tastes, the same love of make-believe and *trompe l'oeil* that were displayed in the festival decorations of Leo X and in the theater of the Campidoglio.

Today, however, the Logge are like a theater set seen palely through a scrim. The extent to which their colors have faded and their forms have blurred can best be documented by the set of watercolor copies made from the decorations around 1555, which are now in the Österreichische Nationalbibliothek, Vienna.[17] These drawings are brilliantly fresh. Their sparkling colors and gleaming whites skillfully reproduce fresco, gilt, and stucco, offering invaluable evidence for the original appearance of the decorations, as well as grim contrast to the present bruised and faded condition of the Logge. One must rely frequently on the Vienna codex for guidance in discussions concerning details of the decoration. These copies help to locate changes and restorations and permit us to reconstruct certain lost or damaged portions of the frescoes and stuccoes. Before attempting to relate any element of the decoration to the thematic or formal structure of the Logge, it obviously would be prudent to identify and to discriminate among the original elements, the inaccurate restorations of those original portions, and the later additions that do not relate to Leo X's program, including the alterations to the interior architecture. The Vienna codex offers solid evidence for making these distinctions.

Not only have the fresco and stucco decorations suffered with the passage of time, but the underlying architecture of the Logge also no longer represents the full strength and discipline of Raphael's design, as the Vienna codex enables us to recognize. His carefully planned sequence

16. S. J. Freedberg, *Painting in Italy,* 45. Many scholars have remarked on Raphael's love of rich and mingled materials and surfaces, of this close interplay among sculpture, painting, and architecture. See, for example, regarding similar tendencies displayed in the Chigi Chapel, J. Shearman, "The Chigi Chapel in S. Maria del Popolo," 154 ("this greater surface richness is one of the major innovations in his architecture"). Kathleen Weil Garris made particularly illuminating remarks on the role of sculpture in these ensembles in a paper delivered at a College Art Association meeting, "Raphael and the *Paragone,* or What Didn't Happen in Cinquecento Sculpture and Why It Mattered," Washington, D.C., 1975. For the letter attributed to Raphael, which criticizes contemporary architecture as deficient in ornament compared to the antique, see V. Golzio, *Raffaello nei documenti,* 85.

17. Codex min. 33. See *Abendländische Buchmalerei, Österreichische Nationalbibliothek,* 60, no. 156. I am grateful to Professor Otto Mazal, director of the Handschriften und Inkunabelsammlung, and to his staff for its assistance in studying the codex. I am also much indebted to Christine and Janos Baltay for their help and for the excellent color slides they made for me. For

dating and background of the commission for the codex, see B. Davidson, "The Landscapes of the Vatican Logge from the Reign of Pope Julius III." A second set of these watercolor copies after the Logge decorations, which according to Armenini (*De' veri precetti della pittura,* Libro III, 180) was sent to Spain, has not been traced. Possibly it was known to and inspired a Spanish artist from Bilbao, Francisco La Vega, who, almost two centuries later, made what appears to be the next attempt at a complete copy of the Logge decorations (Vat. lat. 13751; see note 8 above). This work, dated 1745 on the title page, was commissioned by Cardinal Valenti Gonzaga (A. Taja, *Descrizione del Palazzo Apostolico Vaticano,* 126) and may have been intended as a model for an engraver; it is executed in monochrome washes. The La Vega copies offer a useful supplement to the Vienna codex and a record, not always reliable, of conditions in the Logge by the first half of the eighteenth century. See N. Dacos, *Le Logge di Raffaello,* 5 ff., for a survey of prints, drawings, and paintings copied through the centuries from the Logge decorations; the earliest copies are cited in her individual catalogue entries.

of doors, windows, and niches along the west wall of the Logge and his projects (never entirely realized) for the end walls were altered bit by bit over the years, with consequent diminution of architectonic clarity and order.[18] The first reference to the niches of the Logge appears very early, in 1519, in a comment by Marcantonio Michiel, who wrote of the Logge: "il Papa vi pose molte statue, chel teniva secrete nella salva roba sua parte et parte già avanti comprate per papa iulio, forsi a questo effetto, et erano poste in nicchii incavati tra le finestre alternamente del parete opposto alle colonne over pilastri, et contiguo alle camere, et conclavii consistoriali del Papa."[19] If this unusually detailed account may be interpreted literally, windows and niches alternated regularly down the entire length of the Logge, and in that case the original design of the inner wall was much revised not long after its completion. The existing niches, their recesses all frescoed at later dates, are located in bays 2, 5, 12, and 13; two other window niches, once filled and frescoed in only the lower third of each window, leaving the upper part open, were in bays 3 and 4.[20] Obviously, the spacing of these niches does not match Michiel's description. We may conclude that the design of the west wall of the Logge has been substantially altered and no longer accurately reflects Raphael's intentions.

It seems reasonable to assume, both for esthetic reasons and from the location of the existing niches, that the niches originally occupied the even-numbered bays, starting with the second bay. A closed-surface treatment of the bay wall would then have followed after the door in the first bay, and niches would have flanked the door formerly in the fifth bay. Such an orderly, rhythmical progression of alternating bays, with the lively contrasts between framed spaces of windows and doors and framed concavities filled with projecting statuary, would have resembled the even more complex articulation of the façade of the Palazzo Branconio dall' Aquila. The first designs for the Logge must have also placed a window in the thirteenth bay, but before the work was completed, plans for decorating the last of the Stanze, the Sala di Costantino, were under consideration.[21] A niche was at that point substituted for a window; otherwise an opening in the thirteenth bay would have broken through the middle of the wall surface that was soon to be entirely covered by the large fresco of the Vision of Constantine. One may then infer that of the original niches, presumably seven in number, only those in bays 2, 12, and 13 remain.

Not only was the west wall of the Logge altered after Raphael's death; both the south and north ends were heavily revised. During Raphael's lifetime these end walls had probably remained unfinished or were covered with provisional decoration. It is uncertain what sort of door, if any, led from the Logge into the north tower and what decorations, if any, had been executed at the north end of the Logge before Paul III determined to improve this approach to

18. John Shearman has argued—most convincingly, it seems to me—that the marble window and door frames of the Logge were designed by Raphael and fitted by him within Bramante's much less sculptural architectural order ("Raphael as Architect," 403). For changes made to the two end walls of the Logge and for the decoration of the niche in bay 5, see B. Davidson, "Pope Paul III's Additions to Raphael's Logge." For dating and attribution of the bird and landscape frescoes in the niches of bays 2, 3, 4, 12, and 13, and a more detailed discussion of alterations to the west wall, see B. Davidson, "The Landscapes of the Vatican Logge from the Reign of Pope Julius III." The richly carved window

shutters bearing the Medici arms are illustrated by La Vega, ff. 25, 33, and 45 (bays 6, 8, and 11).

19. V. Golzio, *Raffaello nei documenti*, 104. Only two of the niche statues have been named: a Mercury mentioned by Paolo Giovio (ibid., 194) and "un idea della Natura," mentioned by Marcantonio Michiel (J. Fletcher, "Marcantonio Michiel: His Friends and Collection," 456).

20. Vienna codex, ff. 10, 18, 26, 34, 90, 98.

21. Possibly a door once existed here, as seems indicated in the plan Uffizi 287A. See C. L. Frommel, "Eine Darstellung der 'Loggien' in Raffaels 'Disputa'?" 112, note 25, fig. 6.

the Stanze and the Belvedere corridor. Vasari's anecdote about the triumph of art over nature, recounted in his life of Giovanni da Udine, offers a seemingly contradictory compound based on classical prototype and hearsay evidence. After describing Giovanni's share in the work of Raphael's Logge, he continues:

> E chi non sa, come cosa notissima, che avendo Giovanni in testa di questa loggia, dove anco non era risoluto il papa che fare vi si dovesse di muraglia, dipinto, per accompagnare i veri della loggia, alcuni balaustri, e sopra quelli un tappeto; chi non sa, dico, bisognandone un giorno uno in fretta per il papa che andava in Belvedere, che un palafreniero, il quale non sapeva il fatto, corse da lontano per levare uno di detti tappeti dipinti.[22]

From Vasari's description it would appear that the *trompe l'oeil* hanging with the balustrade below it was painted on the "muraglia" of the tower at the north end of the Logge, where it might be seen from a distance by anyone walking in the direction of the Belvedere. The wooden doors now at this end of the Logge, which display the arms of Leo X, allow little space at the sides for a painted balustrade with fictive hangings. Conceivably, this door was moved here as part of Paul III's alterations, but on the other hand, it may also be that Vasari was confused, that in fact the balustrade and *portiere* were instead painted at the end of the lower logge, also decorated by Giovanni da Udine. Quite possibly, the *trompe l'oeil* draperies that one sees today, painted to either side of the door at the south end of the first logge, are a simplified version of the "tappeti" employed as *portiere* in Giovanni's day and reflect his lost painting.[23]

Whatever frescoes may once have been painted in Leo X's time at the north end of the Logge, they were replaced by Paul III with others featuring his own imprese. At the south end of the Logge (Fig. 7), Paul III provided a design to match that of the north end, and here he did mask preexisting decorations; at the least, pilasters to both sides and possibly the basamento monochrome of God establishing the Sabbath were covered by these new additions. The wall that Paul III erected at this end was indeed a mask or screen set in front of any surviving Leonine decorations and apparently so constructed that it preserved these decorations behind it. Some of the earlier frescoes were discovered during repairs made to the end wall, work that was undertaken in 1951–53.[24] When the panels of fresco decorations with Pauline imprese flanking the door were carefully removed (they are now in storage but still appear *in situ* in old photographs), strips of the original Leo X grotesque decorations were found on the side walls of the space behind this Pauline screen. Any frescoes on the end wall itself must have been destroyed when a passage (now sealed shut by a blank wall filling the space contained within the door frame) was opened through to a small wing that had earlier been built out from the south end of the Logge by Paul V (1605–21). Although the papal archives may hold the answer, it is still a mystery exactly when the present door frame was installed. Composed of

22. Vasari, VI, 554.

23. A number of such *trompe l'oeil* hangings are painted in various levels and wings of the logge, all based upon actual hangings of a sort still in use in the logge, at least until recently (see a photograph in the Vatican photographic archive, XXXI-72-36). La Vega (ff. 62, 73) copied similar curtains flanking doors in the first

logge that also evidently were painted rather than real. For a more detailed discussion of the north and south ends of the Logge and the architectural changes affecting their decoration, see B. Davidson, "Pope Paul III's Additions to Raphael's Logge."

24. D. Redig de Campos, "Dipinti Raffaelleschi tornati in luce nelle logge vaticane," 3.

travertine rather than marble, this portal differs from all the earlier frames of the Logge, including that of the north end.[25]

Despite these various violations done to Raphael's architectural composition, and although the lavish profusion of colors, materials, and images cloaks the entire surface of the Logge, a sense of underlying order still prevails. Today, because so much of the frescoed epidermis has been scraped and worn away, the bones of the structure are more exposed and obvious than they once were. This highly disciplined order is established in the Logge not only through the obvious recurrence of basic architectural forms from bay to bay, but by an equally firm system of pattern and repetition controlling every aspect of design, including color. The colors spangling the interior from vault to pavement are composed within the white and gold framework of the stucco and against pervasive backgrounds of azurite blue; the range and distribution of hues and values, which reflect classical tastes and models, are as carefully planned as the other components of the decoration.

Repetition and symmetry also impose their unobtrusive discipline upon the fertile abundance of fresco and stucco motifs. The figures, beasts, birds, garlands, fruits, landscapes, and endless caprices that charm and entertain the observer with their seemingly careless, boundless variety dance to orchestrated rhythms. It is the variety that amazes and occupies the eye; the mind only gradually, at first unconsciously, begins to sense the coordinating intelligence. One is, for example, dazzled by the galaxy of images represented in the stucco cameos studding every pier and pilaster the length of the Logge. It may be a long time before one realizes that on each pilaster surface there are four such reliefs, and that although each of these four is composed of a different shape—cartouche, roundel, rectangle, mandorla—the same four shapes are repeated in the same sequence and position throughout the Logge. The interwoven counterpoint of this elaborate composition resembles the complex forms characteristic of music and poetry at the papal court.

The design of the thirteen vaults is equally firmly but discreetly controlled, the diversity of stucco reliefs, painted architectural settings, and biblical scenes being again carefully organized by the repetition of elements. In each bay four biblical scenes are placed within illusionistic frames that rest at bottom on the cornice and are attached at top to the central coffer, where a stucco angel supports the Medici ring with three feathers or, alternatively, the yoke impresa of Leo X. The coffer of the central bay carries the papal arms, and the corners of this bay are composed of stucco reliefs. In all of the other bays the four corners between the biblical pictures recede illusionistically behind the frames in flaring, fluted canopies or into views of azurite sky behind lattices, beyond open colonnades or through openings pierced in grotesque capriccios. The formal design of these vaults is repeated pair by pair; that is, the last bay echoes the first bay, the penultimate reflects the composition of the second vault, until the pattern converges at the unique central vault.

This clear, firm architectonic organization of the vaults is further strengthened by many

25. In my article ("Pope Paul III's Additions to Raphael's Logge," 392), I incorrectly stated that the door frame was marble and implied that this frame, with the reinforced thickening of the end wall, were changes made by Paul III, a hypothesis that is by no means certain. Unfortunately, the first page of the Vienna codex, which might have depicted the south end wall, is missing. The width of the space bracketed by the travertine door frame is only about three inches less than the width of the monochrome basamento scene of the second bay; hence the first basamento scene—God establishing the Sabbath—might have survived in place, slightly behind the door frame, until the eighteenth century. A door appears off center in a set of plans dating from the 1720s (British Library 75.k.2, no. 103), and a door frame appears in section in La Vega's codex of 1745 (f. 4). Today, behind this south wall, which had such a rich and complicated history, lies a bathroom.

details, which are equally deliberately planned. The figures in the biblical pictures are consistently of the same scale, while the decorative figures in the corners of the bays are all smaller, except for the stucco dancers of the central bay, which, being white and in relief, do not compete with or become confused with the history scenes. Within each scene the figures are generally set slightly back from the picture plane and are modeled to a similar, moderate degree of roundness. The ground usually—but not with rigid consistency—tilts gently toward the horizon, which often is placed about two-thirds up the height of the picture plane. The color, too, differentiates the sacred histories from the decorative areas surrounding them. The brilliant, flat azurite blue, used, for example, in the skies seen beyond the stucco angels of the central coffers, behind the garlands of the west wall, and in the vault corners, distinguishes the skies in these areas from the softer, paler heavens of the biblical scenes.

The one exception may be seen in the tenth bay, where the colors are not kept separated, where azurite tints the frames and skies of the Joshua stories a deep shade that is repeated in the grotesques of the vault corners. In this bay, unlike all the others, the clearly defined separation of the biblical scenes from the architectural structure and from the grotesque fantasies has been blurred. A different esthetic sensibility is at work, one that prefers a homogenous decorative surface in which even the biblical figures (at least in the second two scenes) are perceived as rhythmical accents, their forms and their independence of action subordinated to the surface pattern. Vasari attributed this vault (as well as the thirteenth) to Perino del Vaga.[26] Although Perino may not have executed all four histories, one can easily believe, to judge from his later development, that he was indeed responsible for this subtle diminution of architectural strength and individual dramatic character in favor of a decorative unity that places higher value on grace and ornament.[27]

Among the many impressive components of the Logge decorations, the newly revived art of stucco captured the most interest and admiration. Sculptures made of stucco, especially decorative reliefs, had enjoyed a long and fairly continuous popularity, but Giovanni da Udine brought greater refinement to both the material and the technique. Through experiment, he succeeded in imitating the marble whiteness and sheen of the ancient stuccoes then being—literally—unearthed. This attractive medium held many advantages: in bridging the ancient and the modern worlds, the real and the "pretend" materials, and the arts of painting and sculpture. Stucco was a malleable substance that dried almost as hard as marble but, like clay or plaster, could be patted, pinched, and modeled into shape instead of being carved and chiseled from a block of stone. Stucco could also be colored and therefore was easily worked into unified design with the frescoed grotesques that employed similar colors, scale, and motifs.

This brilliant revival of an ancient technique, together with the knowledgeable exploitation of so many classical forms, figures, and ornaments, tended to monopolize the attention of contemporary commentators, whose bias has ever since distorted assessments of the Logge decorations. The biblical scenes of the vaults evidently were regarded as essentially so traditional that they inspired far less notice at the time than the new antiquities: the stuccoes and grotesques of the walls. When, for example, Cardinal Giulio de' Medici was planning the painted and stucco decorations of the Villa Madama in 1520, a year after the Logge were finished, he specified that stories from Ovid would be satisfactory, so long as they were not too

---

26. Vasari, v, 594.

27. I tend, but not dogmatically, to believe that Polidoro executed the first two scenes of this bay and Perino the second pair. See N. Dacos, *Le Logge di*

*Raffaello,* especially 23 ff., 138, 144, for further analysis of the elements of the decoration and how they are arranged.

obscure and were varied and choice, but that "le cose del testamento vecchio bastino alla loggia di N. Sre."[28] The cardinal implies by this rejection that such familiar, conservative biblical subjects might be suitable for his cousin's palace, but they were not acceptable for a fashionable modern villa.

In addition to the novelty that won them instant fame, the stuccoes of the Logge decoration may have claimed a disproportionate share of attention through the centuries simply because, on the whole, they are more visible. Not only are the vault frescoes higher and harder to see, but the frescoes of the Logge in general have suffered far greater damage than the more durable stuccoes. Considering the exposed situation of the Logge, the ferocity of Roman storms, and the extremes of temperature to which this long and open corridor was subjected, it is a tribute to the quality of workmanship in Raphael's shop that any of the decoration did survive. Only in 1813 was glass installed to seal the open arches of the Logge,[29] but, as so often happens, this obvious measure dealt with only one part of the problem, while other, equally devastating conditions were neglected; rainwater, for example, continued to pour through to the vaults from the open logge of the floor above. Not until 1838 were the uppermost logge glazed.[30] Even today, humidity still causes damage, chiefly perhaps from the dampness retained in the thick exterior walls. But nature cannot be blamed entirely for the losses incurred by the Logge decorations. The frescoes located at human level have suffered from the normal bumps and bruises of any human habitation, especially a space used as a corridor. In addition, centuries of *maleducati* have inscribed their barbarous names and other destructive graffiti upon every surface within reach. The punishment inflicted by the combined forces of weather and people has most affected the outer, east side of the Logge, where much of the grotesque fresco decoration has disappeared. On the inner west wall the *finto* bronze reliefs of the dado have almost entirely vanished, perhaps as the consequence of an even more vulnerable technique used for these monochromes, as well as the result of human destructiveness. By the beginning of the eighteenth century the bronze monochromes were already barely legible.[31]

Although Gruyer claimed in 1859 that the Logge decorations had never been restored or retouched, common sense and visual and documentary evidence contradict this strange statement.[32] Quite apart from unavoidable but limited repairs surrounding the alterations made to the architecture of the Logge, it seems reasonable to suppose that from time to time remedial treatment for injuries became necessary. Certainly, during the course of the last century, the vault frescoes were restored more than once, as comparisons among old photographs demonstrate.[33] The restorations recently completed in the vault of the second bay indicated that several layers of later paint can be identified in some areas.

The sorry state of the Logge decorations has no doubt been responsible in part for discourag-

28. A. Venturi, "Pitture nella Villa Madama," 158.

29. N. Dacos, *Le Logge di Raffaello*, 143 (with bibliographical reference).

30. F. Agricola, *Relazione dei restauri eseguiti nelle terze logge*, 4.

31. A. Taja, *Descrizione del Palazzo Apostolico Vaticano*, 171. Regarding the basamenti, he wrote (c. 1712), "ma di presente non ve n' ha che la pura macchia, ed alcuni smarriti profili, e contorni." The precise materials and techniques used anywhere in the Logge frescoes have not yet been determined. Dr. Fabrizio Mancinelli kindly informed me (1981) that the restorers claim that the fresco pigments are not the normal type for the

period. They do not include wax, and hence the substance is not encaustic, but further tests would have to be made to analyze the methods and materials employed.

32. F. A. Gruyer, *Essai sur les fresques de Raphaël au Vatican: Loges*, 280.

33. The earliest set of photographs in the Gabinetto Fotografico Nazionale, Rome, comes from the Fondo Cugnoni and was made around 1870. The Anderson and Alinari photographs reveal sometimes startling differences from these early documents and from the condition of the vault scenes today.

ing study of them. The physical difficulty simply of seeing the myriad details spanning floor to vault are daunting enough, but the condition of the decorations obviously aggravates the problem. Without the photographs taken under Nicole Dacos's direction, brought together with the evidence afforded by the Vienna codex copies, it has been virtually impossible until recently to read these densely disposed stories and images. It is time now to make that attempt.

# III

# Raphael's Bible

The Vatican Logge have long been known as Raphael's Bible; in essence, the title is precisely accurate. His was the guiding mind presiding over this creation. Like the heavenly Craftsman of Plato and patristic literature, Raphael's genius shaped the product even when he was not physically present. Raphael was the author of the Logge, and the product he designed could indeed be termed a Bible. The Logge Bible was an immense illuminated manuscript, conceived to suit an enlightened patron, an ardent reader, a collector of books and manuscripts.[1] Like an illuminated Bible, the Logge offer dramatic scenes of scriptural narrative and grotesque decorations that both frame the biblical scenes painted in the vaults and rise from floor to ceiling to cover the walls. The profusion of stucco and fresco ornament deliberately recalls not only the grotesques of antiquity but also the fantastical growths that creep and sprout around the margins of manuscript pages. Such marginal grotesqueries often include, as in the Logge, architectural elements, portraits, simulated cameo reliefs, animals and fabulous monsters, exuberant and bizarre vegetation, scenes of battle or amusement, and references disguised or explicit to the patron who commissioned the work. The brilliance and preciousness of colors and materials and the diminutive scale of the figures in the Logge also consciously evoke the pleasures of illuminated manuscripts.[2]

1. The relationship between book illustration and monumental decorations of course had a long history. See, for example, K. Weitzmann, "The Study of Byzantine Book Illumination, Past, Present, and Future," 22 ff. See also N. Dacos (*La découverte de la Domus Aurea*, 133) on the relation of grotesques to medieval "drôleries."

2. Each vault scene measures about 1.40 × 2 meters, and the figures are about 70 to 80 cm. high, according to F. A. Gruyer, *Essai sur les fresques de Raphaël au Vatican: Loges,* 20. N. Dacos (*Le Logge di Raffaello,* 145) gives different median-line measurements based on dimensions of the scenes in the first bay. But these and the scenes of the last bay are hexagonal, unlike the other biblical histories; hence their measurements would not be typical.

The literary sources for this pictorial Bible are not confined to Scripture, but range (like the visual models for its imagery) from classical, through early Christian and medieval, to contemporary writings. As in Raphael's portrait of Leo X, the ideas drawn from verbal traditions seem so naturally and perfectly communicated through the visual vocabulary that the opportunities for metaphor, for enrichment of one medium of expression through the language of the other, become multiplied infinitely. It is impossible to exhaust or to plumb fully the richness and subtlety of this illuminated Scripture or to notice sufficiently the abundance of its allusions. In Raphael's Bible, the word becomes incarnate.

The panegyric literature produced for Leo X employs, as we have seen, the same iconography that was embodied in the festival decorations of his reign. Mottoes blazoned on the triumphal arches and labels identifying theater·murals, lines spoken by personifications of gods or virtues, proclamations of a Medici Golden Age pictured in paint and plaster, in poetry and drama, describe, either with words or through visual forms or a combination of both, encomia of the pope and propaganda for the Church. In his portrait of Leo X, Raphael expressed, but more integrally and eloquently, beliefs and attitudes similar to those that less gifted contemporaries were advertising through the media of festival and literature. In the Logge once again, the familiar chords are sounded, but here the scope of the decorations provided Raphael with a scale of operations comparable to that of festivals. In the Logge he could translate, with the same magical powers of transmutation that turned a chair finial into a world of meanings, the common coin of the day into gold.

With the Bible as his subject, Raphael had the world's greatest literature for inspiration, but it was also the most familiar and repeated source of imagery; like contemporary propaganda, it was hard to see freshly. Grafted to the scriptural roots were various other species of philosophical and theological tradition almost as well known to the papal court as the Bible. This court, composed chiefly of clerics, humanists, and businessmen, had been nurtured on classical, biblical, and patristic literature; it was knowledgeable about its heritage of medieval and Renaissance poetry, theater, moralizing allegory, and history, of a limited sort. The decorations of the Logge depend not only from the Bible and contemporary political ideology but also from the entire range of this literary background. The cast of characters drawn from these sources is headed by Old Testament figures from Adam through Rehoboam, who are chiefly confined to the vault frescoes and the basamento monochromes; the rare exceptions that do stray from the boundaries of the biblical scenes are obviously meaningful in their singularity. Only the last bay of the Logge is devoted to the New Testament.

Beyond the borders of the biblical narrative, the Logge, like the contemporary festival decorations and theatrical presentations, are inhabited by an ecumenical host of personages: ancient gods, oriental magi, sibyls, prophets, historical leaders, allegorical personifications, and contemporary portraits, as well as a protean gathering of flora and fauna, both real and fantastic, of landscape vignettes and architectural capriccios, of elegant man-made objects, most notably musical instruments, and a fluent repertoire of ornamental motifs.

The encyclopedic nature of this heterogeneous assemblage has long been recognized as another chapter of a continuing medieval tradition.[3] This tradition was composed not only of the encyclopedias themselves[4] but also included concordances of the Old and New Testaments and those that harmonized biblical chronology with events of classical myth and history.

3. J.-D. Passavant, *Raphaël d'Urbin,* I, 221. K. Künstle, *Ikonographie der christlichen Kunst,* I, 97.

4. See R. Collison, *Encyclopaedias: Their History*

*Throughout the Ages,* for a survey of medieval and Renaissance encyclopedias.

Embraced within this jumble of syncretic efforts were the apologetics of the church fathers, the moralized versions of Ovid and other authors, the bestiaries, the *Biblia pauperum* and *Speculum humanae salvationis,* and the mystery plays.[5] More recent authors—Dante, Boccaccio, Ficino, Castiglione, and many others—also contributed to the mainstream of current imagery and ideas that is reflected in the Logge. These literary sources varied among themselves in subject matter and on points of interpretation, but the underlying assumptions seem to the modern mind strikingly consistent and confident: the universe and its contents were created by God; everything has a place and a significance in God's design; the mystery of the Incarnation, promised but "kept secret since the world began" (Rom 16:25), was understood, if only imperfectly, by chosen persons from the beginning. If one could trace the heritage of revelation from sage and sacred persons, gentile or Hebrew, and penetrate the hidden messages veiled within the Old Testament (2 Cor 3:14), the lessons of history might become legible and the path to salvation might be clearly mapped.

For the Logge, Raphael was commissioned to illustrate nothing less than such a didactic history, one that would comprise all of creation and time. This history, to be sure, was molded by a most particular viewpoint, being a history designed for a pope. The program was fundamentally conservative and adhered firmly to texts and doctrines inherited from the earliest years of Christianity, repeated and elaborated throughout the intervening centuries. Nevertheless, despite the restrictive framework, the permissible range of iconographic embroidery was virtually endless, too great for any one mind to encompass. Like Raphael, who had many assistants to execute and to spin out variations based upon his designs, the unknown person chiefly responsible for establishing the Logge iconography must also have been aided by contributions from many Vatican associates, including the pope and his artist.

To prepare for this prodigious undertaking, Raphael evidently studied, along with the literature selected and perhaps provided and translated by his friends and advisers, as many illustrations from potentially assimilable prototypes as he could find. Not only book and manuscript illustrations, but mosaics, sculpture, and frescoes, offered examples of the encyclopedic approach to history and religion, along with orthodox patterns for typology and ideas for individual compositions. The great mosaic cycles of the Roman basilicas—St. Peter's, S. Paolo fuori le mura, S. Maria Maggiore—supplied particularly fertile harvests, but certainly Raphael and his circle knew many other examples in Florence, Venice, and elsewhere. Further precedent was offered by church porches, often thickly populated with a similarly encyclopedic array of sculptures, or by church pavements, where one might step smoothly from Theseus to King David.[6]

Most important of all as a source and most inescapably comparable were the frescoes of the Sistine Chapel. To the patron and his artist, the Sistina presented a confrontation from rivals, dead or alive, that was impossible to avoid and seems to have been sought. Leo X differed in character from Julius II in much the same way that Raphael differed in temperament and talent

---

5. For the assimilation of these diverse sources within the imagery and theology of the Renaissance, see J. Seznec, *The Survival of the Pagan Gods;* D. P. Walker, *The Ancient Theology;* and works by many other writers, who will be cited in subsequent notes, especially the publications of A. Chastel, P. O. Kristeller, E. Panofsky, C. Trinkaus, and E. Wind. The roles of numerous figures and subjects prominent in the Logge and in Renaissance literature (such as Amor, Apollo, and Orpheus, or love, prophecy, and music) are analyzed not only of course in the writings of these authors but also by countless others whom I shall cite only if individual comments or the general approach seem especially relevant to the Logge.

6. A. N. Didron, *Christian Iconography,* II, 245 ff. A few examples of sculptural "encyclopedias" are cited by J. Seznec, *The Survival of the Pagan Gods,* 70, 126 ff.

from Michelangelo. The choice of a program for the Logge that to some extent duplicates ideas, subjects, and even figural motifs from the walls as well as the vault of the Sistina, implies a deliberate *paragone*. To the pope and certain members of his court, the frescoes of the chapel, executed in two separate periods and styles, might have seemed clumsily ill-coordinated. By commissioning the tapestries of the Acts of the Apostles from Raphael, Leo X may have hoped to unify the chapel decoration, both its program and its appearance. But the Logge, with its intricately designed, impeccably finished decorations, its erudite classical references, and its calmer, less emotionally demanding presence, may well have suited the refined humanist tastes of the Medici court better than the frescoes of the Sistina.

While the decorations of the Logge have much in common ideologically with those of the Sistine Chapel and with earlier fresco, sculptural, and mosaic complexes, many scholars have remarked that the Logge cycle differs from all others. Although true, the observation is meaningless, for no two programs ever could be identical; each must be tailored to suit a period, place, and patron. It has also been described as unusual that all the biblical stories selected for the Logge are serious, important subjects. The same might be said, however, for virtually any similar biblical history, provided one understands the designers' intentions. It has been said further that, with two bays devoted to him, a special emphasis is placed upon Moses, but again, this ingredient is not unique to the Logge program, as a glance at the Sistina and other earlier cycles quickly demonstrates.[7] In fact, for the most part, the choices of the Logge Old Testament scenes follow historically well-established visual and literary patterns. Only if one isolates the salient, truly unique characteristics of the Logge can one hope to fathom the purposes underlying the particular choices that were made.

Like other illustrated Bibles, the Logge vault narrates the history of the Chosen People, moving from Creation to Adam and Eve, Cain and Abel, Noah, and the patriarchs Abraham, Isaac, and Jacob. The stories of Joseph and Moses tell the saga of bondage and exile, followed by Joshua and the return of the Chosen People to the Promised Land. David and Solomon represent the royal messianic family, which culminates with Christ in the last bay of the vault. As it unfolds in the Logge, this universal history seems to be very close and real. Paradise flourished only the day before yesterday; yesterday, Moses led his people from Egypt. The immediacy of the scenes is due in part to Raphael's genius, which breathes life into these dramas, making them timeless and meaningful. As Vasari said of this exceptional gift, Raphael could "di continuo figurare le storie come esse sono scritte, e farvi dentro cose garbate ed eccellente."[8] But also perhaps tradition surviving from ancient times is again essentially responsible, for to the designers of the Logge, this sacred history was recent and could in fact be estimated in terms of a few thousand years. Renaissance theologians still argued heatedly about how many days God had spent in creating the universe and about the exact date of the Deluge.[9] Time and the universe were measurable and encompassable and could be expressed in familiar, concrete terms and images. It is incorrect—and diminishing—to the Logge decorations to view them as representing primarily a world of fable and dreams. Certainly, poetry, drama, and allegory, inspired by ancient models, played a strong esthetic role in the artists' interpretation of their material, but their material was, to them, true history and fact. Adam was real, and so were unicorns. Hermes Trismegistus was a contemporary of Moses, and Moses wrote the Pentateuch with the direct assistance of God.

---

7. For the Sistina Mosaic cycle, see L. D. Ettlinger, *The Sistine Chapel Before Michelangelo,* and J. Shearman, *Raphael's Cartoons.*

8. Vasari, IV, 344.

9. See, for example, Giovanni Pico della Mirandola, *Heptaplus,* especially the Seventh Exposition, 159 ff.

The choice of Old Testament figures represented in the Logge is neither unusual nor arbitrary. There is, however, a most exceptional, a genuinely unique, feature of the Logge Bible; although twelve bays are devoted to the Old Testament, only one—the thirteenth, and last, bay—is assigned to the New Testament. Such an unbalanced distribution is not, to my knowledge, found elsewhere. A second striking oddity of this program is the choice of New Testament subjects for the last bay. A cycle that begins in the first vault with Creation and ends this universal history at the Lord's Supper (with the Resurrection of Christ as the final basamento) is distinctly peculiar. Yet only a handful of writers has mentioned either of these unusual characteristics and, among them, perhaps three or four at best have ventured an explanation. Both Passavant and Pastor, for example, claimed that the Logge decorations were unfinished.[10] They believed that work on the Logge was interrupted by the death of Leo X and that he had intended to add a wing at right angles to the Logge, wherein the New Testament illustrations begun in the thirteenth bay would be continued around the corner to a more conventional length. While it is indeed possible that Leo X hoped to carry out a building plan of Julius II for a wing extending from the north end of the logge, all internal and external evidence demonstrates that the last chapter of Raphael's Bible concluded precisely where it was intended to close. Only Förster, in 1868, cast a ray of light through the fog when he observed that the New Covenant supplanted the Old at the Last Supper, a destiny toward which the entire Old Testament had led.[11]

As in a detective novel, any deviation from the norm offers promising clues, and clearly the New Testament bay (Figs. 109–14), allotted only five out of a total of sixty-four biblical scenes, is special and extraordinary. To approach an understanding of the program for the Logge, it is best then to begin at the end, for like the greatly magnified text of the Gospel of St. John in Leo X's portrait by Raphael, the frescoes of the last vault provide a signpost to direct our reading of this enlarged illuminated manuscript, the Logge Bible. The brevity of that final, most important chapter within the long sequence of the Logge biblical history implies greater rather than less emphasis and suggests that it may in some sense be a summation and climax of the preceding chapters. It would follow, then, that this summary, consisting of five New Testament subjects, must fill a symbolic rather than a narrative function in the program. The Logge New Testament does not, in other words, attempt to recount the life of Christ, his ministry, his miracles, or his Passion. Missing are several scenes of the highest importance to the Gospels, most notably the Crucifixion. It must be the meaning of the five scenes in terms of Christian mystery, not their dramatic value as historical happenings, that determined their selection and their placement within the thirteenth bay. This priority of spiritual over temporal or historical significance guides the choice and arrangement of other chapters in the Logge Bible.

Any trained theologian and many an amateur will grasp the prevailing arguments of the Logge merely by a naming of the subjects in the last bay: the Adoration of the Shepherds, the Adoration of the Kings, the Baptism of Christ, the Lord's Supper, the Resurrection. These five subjects alone suffice to summarize the primary concern of Christianity: the promised Redemption of humankind by God's grace through Christ and the Church. Finely woven into this fundamental program of the Logge are a number of supporting themes whose complex history and interrelations are revealed, along with the ultimate promise, throughout the decorations of the Logge. Stated in broadest terms, the Logge scenes narrate "the record of God's self-disclo-

10. J.-D. Passavant, *Raphaël d'Urbin*, I, 222. L. Pastor, *Storia dei papi*, IV, 492.

11. E. Förster, *Raphael*, II, 123.

sure," the history of salvation.[12] From the rich sources of the Scriptures, with their thousands of persons, stories, and lessons, those few were chosen that best served to illustrate the pilgrimage of salvation, with its hidden promises of the Messiah: "All things must be fulfilled, which were written in the law of Moses, and in the prophets, and in the psalms, concerning me" (Lk 24:44). The heroes and events of Old Testament Scripture represented in the Logge embody this figure of the future and are the examples selected for that same purpose in theological writings from the New Testament to present-day exegesis.[13]

According to this view of universal history, the pilgrimage toward the promised fulfillment of salvation was hedged by strict precepts, and the clues that might guide the traveler were worded in cryptic forms, but God's frequent and merciful intervention saved the chosen race from extinction. The first requirement for salvation was the obviously basic one of procreation and preservation of the messianic line leading from Adam to Christ. Strong emphasis is placed in the Logge, as in the New Testament, upon this direct, uninterrupted lineage (Lk 3:23–38), which is perpetuated in or through the leadership of each Old Testament hero represented. Among the imperatives for salvation stressed in the Logge are, as Förster partially understood, the covenants of faith, law, and spirit, those formulations of God's love that are reaffirmed at intervals throughout scriptural history. Examples of faith, of obedience and disobedience to God's covenants and commands, and the rewards or punishments for such actions provide yet another refrain in this ageless epic.

The promised Savior is prefigured from the beginning of the history of salvation. His antetypes can be identified in all of the Old Testament heroes of the Logge scenes, which also yield manifold types for his Church and its two chief sacraments, baptism and the Eucharist. Locked into the traditional history of salvation is, in fact, the history of the Church. One of the most pronounced themes of these Logge designed for a pope is an account of the creation and evolution of the Church: historically, legally, physically, and spiritually. In addition, Leo X's image of his role as head of the Church and his concern for the fate of Christianity affected certain aspects of the Logge design.

Looking again at the last bay, we can identify the climactic triumphs of this ecclesiastical history. Paired in the vault are the first two occasions wherein the Word Incarnate was made manifest: the Nativity, when Christ appeared to the Jews, children of the Covenant, who are represented by the shepherds, and his appearance to the magi, the gentile kings of earthly nations who acknowledged the superior rule of Christ ("Then hath God also to the Gentiles granted repentance unto life," Acts 11:18). Together, the two scenes proclaim the spiritual triumph of Christ and his Church over the peoples and princes of the world. The second pair of scenes, baptism and the institution of the Eucharist, commemorate the two mysteries that became the two principal Dominical sacraments of Christ's Church. Through baptism and by participation in the sacrificial memorial of the Eucharist, the Christian might hope to free himself from Adam's sin and the mortal world and to unite with Christ in his Resurrection.

The geographical placement of the five New Testament scenes follows a pattern established, as we shall see further on, in earlier bays of the Logge (see page 68). The first scene in chronological order—*The Adoration of the Shepherds* (Fig. 110)—appears in the west segment of the vault, above the inner wall at left as one walks the length of the Logge. *The Adoration of the Kings* is over the north-end wall, above the door. *The Baptism of Christ* fills the eastern compartment at the right, and *The Lord's Supper* is painted in the south compartment, which one

12. *The Study of Liturgy* (J. D. Crichton, "A Theology of Worship"), 8.     13. O. Cullmann, *Salvation in History*, 127 ff.

sees only by turning around to face back toward the first bay. With *The Resurrection* basamento (Fig. 114), the chronological sequence returns to the west wall, thus completing a circle. One may justifiably theorize that this pattern evolved primarily in order to place two scenes of the last bay in positions of political and liturgical significance.

As in the pope's *solenne possesso* of 1513, special prominence is given to *The Adoration of the Kings,* which in the Logge may be seen from four or five bays' distance (depending on one's height) as one walks toward the north end. The obedience offered Christ by the kings had always held political significance for the popes in their never-ending struggle to assert the supremacy of spiritual over temporal rule. This struggle was a fiercely urgent issue for Leo X, involving wars with Italian rulers, such as the Duke of Urbino, and attempts to assert the primacy of the popes over other bishops. The Concordat of 1516 with France resolved some of the more immediate problems with the bishops. The resulting bull of *Pastor Aeternus,* which abolished the Pragmatic Sanction (an agreement that had seriously reduced papal authority in France), laid heavy stress on obedience due the pope.[14]

Obedience owed by temporal rulers was particularly important for Leo X's attempts to launch a crusade. Throughout his reign, Leo sought by countless routes, from diplomatic maneuvers to barefoot processions, to stir support for a holy war against the Turks.[15] In order that this enterprise might succeed, it was essential to enlist under his pastoral leadership the Christian rulers and their subjects. The Turkish victories resulted, it was claimed, from the sin of war among Christian princes.[16] Not surprisingly, Leo X and his ministers automatically tended to contrast the three magi with the three less ideally reverent contemporary kings—Francis I of France, Charles of Spain, and Henry VIII of England—whom the pope in conversation would refer to as the "tre Re."[17] The Turks offered a genuine threat, not merely an excuse for power contests among European rulers. Their ships menaced Italy's coast and on one alarming occasion nearly carried off the pope.

The crusade against the Turks and the obedience owed by Christian princes were the subject of papal bulls and provided material for many a sermon.[18] In January 1517, for example, the Venetian orator reported that Egidio da Viterbo (vicar general of the Augustinian order and shortly to be named papal legate to Spain for the purpose of promoting the crusade) had delivered a four-hour sermon on the Epiphany.[19] During the course of this oration, Egidio referred to Leo X, who was not present, as the lion of the tribe of Judah, who (like David felling the giant Goliath) would conquer the Turks if today all Christians would unite and kneel in adoration of Christ, as had the three kings. The several scenes of the pope adored by kneeling rulers that had been included in Leo X's *solenne possesso* of 1513 drew the same association between the pope and the King of Kings.

The recovery of Jerusalem from the Turks was a teleological as well as a political and proselytical imperative. For Egidio, this victory would fulfill the history and prophecies of the Old Testament.[20] For the archbishop of Patras, who, at the tenth session of the Lateran Council

---

14. J. Thomas, *Le Concordat de 1516,* II, 32 ff.

15. K. M. Setton, "Pope Leo X and the Turkish Peril," 367 ff. G. L. Moncallero, "La politica di Leone X e di Francesco I nella progettata crociata contro i turchi e nella lotta per la successione imperiale," 61 ff.

16. J. W. O'Malley, *Praise and Blame in Renaissance Rome,* 190.

17. *I diarii di Marino Sanuto* reports the use of the phrase, for example: XXIII, col. 592; XXIV, col. 33. The

youth and inexperience of the three kings was a further source of concern in Rome (L. Pastor, *Storia dei papi,* IV, 140).

18. Some of these bulls are published in *Laertii Cherubini . . . Bullarium sive nova collectio . . . ,* I, 494 ff.

19. *I diarii di Marino Sanuto,* XXIII, cols. 486–88.

20. J. W. O'Malley, *Giles of Viterbo on Church and Reform,* 102.

in 1515, outlined the history of salvation, there were two Sabbaths: the first linked Creation and Redemption with Christ's founding of the Church; the second would be brought by Christ only after the Turks were converted.[21] The role of Leo X as a Christ-like peacemaker, so hopefully reiterated in pageants and poetry, is played with variations both through the legend of the adoring kings and in the image of the soldier who will win a peace that promises an eternal Sabbath.

Thus positioned on the north end wall, *The Adoration of the Kings* is visible to anyone walking toward the Stanze. If, as seems probable, the Logge were designed to constitute the ceremonial entrance approach to these state apartments, any visiting prince or dignitary arriving for an audience with the pope could grasp the message before he reached the presence. In the thirteenth bay, Christ, the thirteenth apostle, and the pope, also known to contemporaries as the thirteenth apostle,[22] exact submission from all who enter. As trumpeted in the bull of *Unam Sanctam,* reaffirmed by Leo X: "We declare, state, define and pronounce that it is altogether necessary to salvation for every human creature to be subject to the Roman Pontiff."[23] Repetitions of this claim upon obedience, couched in similar terms, would be awaiting the visitor once he entered the Stanze;[24] a comparable claim is asserted, as we have seen, in Raphael's portrait of Leo X, which was displayed prominently at his nephew Lorenzo's wedding banquet in 1518 to guests who included many secular rulers and their representatives.

Turning from *The Adoration of the Kings* to *The Lord's Supper* on the opposite quadrant of the vault (Fig. 113), one faces back toward the beginning and can look from the institution of the New Covenant overhead to the ninth-bay scene of Moses presenting the tablets of the Old Law (Fig. 79) and from there to the first bay of the Logge (Figs. 8 and 9), where the basamento at the south end would have been the only scene visible. Although hardly legible at that distance, it would be remembered when one looked from the institution of the New Covenant to that of the Old Covenant and yet further back into history as a representation of the first covenant between God and his people: the institution of the first Sabbath. As always in the Logge, the end and the beginning are to be understood only through their correlation.

The long-lost basamento of the first bay of the Logge poses awkward problems. One can only hypothesize its existence on the basis of a print and a drawing of the composition and fix its location by the process of elimination. Its subject is open to question and the date of its disappearance is a mystery.[25] Illustrated in the series of prints copied in the seventeenth century by Pietro Santo Bartoli after the Logge basamento compositions is this first basamento (Fig. 8), numbered *I* and identified as the sanctification of the seventh day ("Benedixit diei septimo, et sanctificavit illum"). The same composition, with slight variations, is known also through a drawing in Haarlem (Fig. 9), evidently copied after a lost study for the fresco by Giovanni Francesco Penni.[26] The Haarlem drawing is in the same format, style, and technique as a number of other studies for and copies after the basamento scenes. Unfortunately, the Vienna codex lacks the page—probably the first—that should have illustrated the south end wall.[27] One may assume, however, that the basamento of the first bay was painted at the south end because

21. N. H. Minnich, "Concepts of Reform Proposed at the Fifth Lateran Council," 198 ff.

22. W. Roscoe, *Vita e pontificato di Leone X.,* IV, 162 ff. (Arsenius, Archbishop of Monembasia).

23. B. Tierney, *The Crisis of Church and State,* 188–89.

24. S. J. Freedberg, *Painting of the High Renaissance in Rome and Florence,* I, 296.

25. Possibly the basamento survived until the late seventeenth or early eighteenth century. See chap. 2, note 25.

26. Haarlem, Teylers Stichting, A73. K. Oberhuber, *Raphaels Zeichnungen,* IX, 175 (other copies listed). N. Dacos, *Le Logge di Raffaello,* 294, pl. CXXXVI a, b.

27. See chap. 2, p. 34, for the south wall.

the entrance door to the Logge occupied the west wall of this bay (Fig. 12), the wall upon which all other surviving basamenti in the other bays are situated. *God Establishing the Sabbath* (Gn 2:2) would then follow, in correct sequence, the fourth vault scene of the first bay, *God Creating the Animals* (Gn 1:24; Fig. 11), located directly above it in the south compartment of the vault, and it would precede the first scene of the second bay (Gn 2:22), *The Meeting of Adam and Eve* (Fig. 22), which follows in proper sequence of biblical verses, if not in strictly chronological order.

Both print and drawing of this basamento composition in the first bay reveal God enthroned in clouds above a vaguely mountainous terrain, his hand raised in calm, magisterial blessing. Worshiping angels fly toward him from both sides. Not only the placement but also the appearance of the composition fits Bartoli's identification of the subject. Nevertheless, two other possible subjects should at least be mentioned before being dismissed. One alternative is that the scene actually might be considered the first of the cycle and that it illustrates the opening verses of Genesis, with the spirit of God moving upon the face of the waters. Although the basamento of God adored by angels recalls—surely intentionally—the introductory illustration of a great many Genesis cycles, the horizon line of the basamento scene, however sketchy, clearly represents mountains, not waves: solid land, not an abyss. A second, less credible alternative is that the monochrome depicts the creation of angels, a topic so controversial that it would probably have been considered unsuitable for this setting.

Through the ages one finds little agreement and much furious argument among writers concerning the time schedule of Creation, especially the question of when angels appeared on the scene: first, last, or at one of several stages along the way.[28] Their creation is not specifically mentioned in Genesis and is unlikely to have been included in a pictorial sequence so restricted by spatial limitations that other, more orthodox, Creation scenes were omitted. Bartoli's identification of the scene as the institution of the Sabbath must be correct. It is on that assumption that we will make the leap through space and time, from the christological scenes of the last bay back to the Creation scenes of the first bay. But it will be kept in mind that any thesis involving the basamento of *God Establishing the Sabbath* is based upon plausible surmise, not on conclusive evidence, although the former presence of this subject in the first bay has never been doubted.

The establishment, observance, and meaning of the Sabbath day of rest were crucially important both to Jews and to Christians.[29] The seminal Genesis verses (Gn 2:1–3) read: "Thus the heavens and the earth were finished, and all the host of them. And on the seventh day God ended his work which he had made; and he rested on the seventh day from all his work which he had made. And God blessed the seventh day, and sanctified it: because that in it he had rested from all his work which God created and made." To Jews the Sabbath was the first and most conspicuous sign of God's special covenant with Israel, as many Old Testament texts affirm,[30] for example, Ezekiel (20:12): "I gave them my sabbaths, to be a sign between me and them, that they might know that I am the Lord that sanctify them." For Jews the seventh day fell upon Saturday, the following day being the first day of the work week.

---

28. The question of the creation of angels bothered many church fathers and other writers. See discussions of the arguments in F. E. Robbins, *The Hexaemeral Literature,* index; W. G. Heidt, *Angelology of the Old Testament,* 19 ff.; M.-T. d'Alverny, "Les anges et les jours," 271 ff. (with extensive bibliography on the subject); A. Rosenberg, *Engel und Dämonen,* 49 ff. See also note 40 below.

29. The issues and discussants are surveyed by J. Daniélou, *The Bible and the Liturgy,* 242 ff.

30. A. G. Hebert, *The Throne of David,* 144 ff.

In apostolic times, however, the Lord's day of rest and worship became fixed upon the pagan planetary day of the sun. Countless texts elaborate the significance of this choice for Christians; two of the earliest and most beautiful are particularly appropriate here. For St. Jerome, "The day of the Lord, the day of the Resurrection, the day of the Christians is our day. And if it is called the day of the Sun by the pagans, we willingly accept this name. For on this day arose the light, on this day shone forth the sun of justice."[31] And Justin explained: "We assemble on the day of the sun because it is the first day, that on which God transformed the darkness and matter to create the world, and also because Jesus Christ our Saviour rose from the dead on the same day."[32]

Much of Church liturgy may be traced to such early associations—originating in Scripture— among the first day of Creation, the day of rest, the day the eucharistic sacrifice was celebrated, and the Resurrection. From early times, moreover, the day of rest acquired eschatological implications as the Sabbath rest came to prefigure eternal rest. "But the seventh day is without evening and the sun shall not set upon it, for you have sanctified it and willed that it shall last forever. . . . When our work in this life is done, we too shall rest in you in the sabbath of eternal life."[33] Such orthodox exegetical equations, which, among so many, shape Church liturgy, also enter the structure and imagery of Raphael's Bible.

From our post in the last bay of the Logge, looking back toward the first, we begin to perceive some of the unifying strands that weave so consistent a pattern through the decorations. The first and the last basamenti bracket the biblical narrative and are tightly related. The promise of the Sabbath inaugurated on the seventh day of Creation will, through the eucharistic sacrifice commemorated on the Lord's day, be ratified on the day of Resurrection, and all history lying between the beginning that reveals the end and the end that is the beginning is dedicated to attaining this destiny. The supporting themes of the history of salvation thread the interval of time and distance, making all history—Hebrew, pagan, and Christian—but one effort to recover in Christ the eternal Sabbath lost through Adam's fall.

## Bay 1: Creation

The first bay of the Logge (Figs. 10–20) stages the prologue to the drama of sin and salvation, with veiled auguries of both encased within its presentation. God, creator of all that is and will happen, whose manifestations of love will lead humankind out of sin, is the central performer of this opening act. Although the artistic execution of the four Creation scenes is uneven, the conception is magnificent. Time and action seem resolved in one coeternal vision of a force whose "swiftness of moving is called flying, and his watchful care is called his face."[34] In his whirling course through the heavens, God creates and divides the light from the dark, and the land from the waters, and places the sun and the moon in the firmament. Completing this celestial orbit, he alights on land and summons animals from the earth (Fig. 11): first, creatures of the sea and sky, then other beasts, some seen still struggling from the ground.[35] Included are

31. J. Daniélou, *The Bible and the Liturgy*, 255.

32. *The Study of Liturgy* (P. G. Cobb, "The History of the Christian Year"), 404.

33. St. Augustine, *Confessions*, 346.

34. St. Gregory of Nazianzus, "The Fifth Theological Oration—On the Spirit," 207.

35. The Nuremberg Chronicle, wherein God creates

Adam by extracting him from a "lump of earth," offers an even more literal-minded transcription than the Logge Creation of Animals of "let the earth bring forth" or "let the earth produce" (see illustration in S. K. Heninger, Jr., *The Cosmological Glass: Renaissance Diagrams of the Universe*, 19, fig. 10f).

The artist of the Vienna codex who copied the vault

various mythical creatures that were believed to be real, existing in far distant lands[36] as perfectly plausible neighbors to such equally exotic specimens as elephants and giraffes. The wriggly basilisk and prancing unicorn take their place along with more domestic barnyard types, but all have a significance, even the humblest, in moralizing literature, as do the two trees.[37] At a later stage of history, the animals of the Logge Creation scene will come to represent, in traditional exegesis, base and sinful components of man's nature and personifications of the passions. Other references to future events may be read in the cryptic but traditional imagery of these Creation scenes. In each fresco, silhouetted against the blue firmament, the wine red of God's robes evokes not only the vestments of royalty and of priesthood, but "the blood of grapes" (Gn 49:11), while his outstretched arms prefigure the Crucifixion, as do the sun and the moon.[38] The blazing sun at its creation is a sign that "In the beginning was the Word," the sun of justice, Light of the New Testament, whom God faces, looking in the direction of the thirteenth bay. With his right hand he creates the moon, the Old Testament, whose truths cannot be understood without that illumination reflected from the light of the Gospels.[39]

In the heavens, beyond a lattice of coffer frames spanning the vaults of the first and last bays, fly hosts of angels (see Figs. 10 and 115), the bringers of tidings. They appear to comment on the scenes of the vault with gestures of oratory or attitudes of worship. Angels on the lowest ring carry banners with the sign of the cross. The placement of and differentiation among these angels involved decisions by the theologians made with such diplomacy that any potentially

of the first bay (f. 8) became confused; he transposed the scenes of God separating Earth from Water and the Creation of the Animals. The first should be at the north and the latter at the south, instead of vice versa. Such reversals are difficult to avoid when copying an overhead design onto a page held below eye level—the process is a little like trying to thread a needle in a mirror—and they recur occasionally elsewhere in the codex, in copies after the stucco reliefs.

36. J. B. Lloyd, *African Animals in Renaissance Literature and Art,* 78. The author describes Leo X's famous zoo, with its exotic birds, lions, and other rare specimens (p. 47).

37. The dry tree at left, for example, which bears some live shoots and a peacock, well-known symbol of Resurrection, probably alluded to the prophetic verses of Ezekiel, wherein the Lord "made the dry tree to flourish" (17:24). For the basilisk and unicorn, among other curiosities believed to be real in the Renaissance, see D. Franchini and others, *La scienza a corte: Collezionismo eclettico, natura e immagine a Mantova fra rinascimento e manierismo,* 105, 116. Literature on animal and plant symbolism is vast. A useful compendium of meanings for animals is published by L. Réau, *Iconographie de l'art chrétien,* 1. For trees and plants, see M. Levi D'Ancona, *The Garden of the Renaissance.*

38. St. Justin, The Martyr, "The First Apology," 281. St. Gregory of Nyssa, *La vie de Moïse,* 76. See also F. Hartt, "Lignum Vitae in Medio Paradisi: The Stanza d'Eliodoro and the Sistine Ceiling," 193.

39. G. Schiller, *Iconography of Christian Art,* II, 109. Given the ecclesiological emphasis of the Logge decorations, it is probable that the sun and the moon also represent Christ and the Church, as they often do in art and literature. See also E. G. Dotson, "An Augustinian Interpretation of Michelangelo's Sistine Ceiling—I," 244–45. If, as Dotson argues regarding the Sistine ceiling Creation of the Sun and the Moon, a rear view of God represents Christ, the God of the Logge scene, who is turned toward the east, his back to us, may signify both the priest facing the altar and the crucified Christ, as in the cross on or over altars. In this reading, God's left hand would then simultaneously be Christ's right hand, and the sun and moon would be in their more orthodox, but not rigidly prescribed, locations for Crucifixion scenes. It is probable that Raphael here—as in the first fresco of the next bay—was attempting to improve on Michelangelo's precedent. Raphael also was familiar with an earlier, far less sophisticated pictorial tradition for representing Christ's union with God in the acts of Genesis, as illustrated in the Creation scenes of the Hamilton Bible, the illustrated manuscript that he painted in his portrait of Leo X. There, in each scene up through the Expulsion, a Trinitarian God is depicted, with Christ's face joined Janus-like to the back of his own bearded head, and with wings on his shoulders signifying the Holy Ghost. The first words of the Gospel of St. John, shown in Raphael's portrait of the pope, were from early Christian times offered by exegetes as evidence of Christ's unity with God at Creation, thereby linking Creation to the history of salvation (A. Heimann, "Trinitas Creator Mundi," 42 ff.; pl. 6a illustrates the Hamilton Bible Creation scenes).

controversial issues were evaded.[40] By placing the angels not only around all four Creation scenes but also around the christological scenes in the last bay, it was possible to avoid the tricky subject of when exactly they were created. The definition of angelic hierarchies seems to have been approached with similar tact. Although a hierarchy is implied, the designers avoid precision in describing the categories of the angelic choirs, their attributes of rank, or the colors assigned to each order. But since the uppermost two rows are tinted with red and blue, and thus presumably represent cherubim and seraphim, it is reasonable to assume that the descending rows, distinguished by their behavior and the hues of their garments, are meant to suggest the lower ranks, with the standard-bearers at the bottom as archangels. Possibly, reference to the nine angelic orders also was intended, and again equivocally, in the first basamento (Fig. 8), where God is adored by what appear to be nine angels and an obfuscating flock of cherubs.

## *Bay 2:* Creation and the Fall of Man

The frescoes of the first bay set the stage for the history of man's creation and fall and hint at the promise of Redemption, a promise renewed in the second bay of the Logge (Fig. 21), whose frescoes narrate the fall from grace. The tale commences in the south vault compartment with a scene that writers usually describe as the Creation of Eve (Fig. 22). With rare exceptions, they marvel that the Creation of Eve should be included while the Creation of Adam is left out of the Logge. All three observations are inaccurate. The scene depicts, not the Creation of Eve, a subject generally illustrated, as on the Sistine ceiling, by Eve emerging from the sleeping Adam's side, but God presenting Eve to Adam. "And the rib, which the Lord God had taken from man, made he a woman, and brought her unto the man. And Adam said, this is now bone of my bones, and flesh of my flesh: she shall be called Woman, because she was taken out of Man" (Gn 2:22-23). In the fresco Eve stands at the center, her eyes downcast, her hands covering her breasts with instinctive modesty. God presents her to Adam, who has just been awakened from a deep sleep and who, pointing to his ribs, affirms that his bride is indeed the issue of his bone and flesh.

This nuptial scene foreshadows, more aptly and certainly more gracefully than the Creation of Eve, the foundation of the Church. In the Old Testament the nuptial metaphor is often applied to God's covenant with his people, wherein Israel is God's betrothed, an image—illustrated several times in the Logge vault—that was adapted by Christian writers, following a typology found in the New Testament; the bride Eve becomes the Church, fashioned from the body of Adam, who prefigures Christ.[41] The sleep of Adam is compared to the death of Christ

---

40. See note 28 above. Because it was often argued, on the basis of the Book of Job (38:4–7), that choirs of angels joyfully greeted Creation, and angels were believed as well to be present during the sacraments (J. Daniélou, *The Angels and Their Mission, According to the Fathers of the Church,* 21–22), sufficiently orthodox grounds could be established for the presence of attending angels in the first and last bays of the Logge. O. Fischel, "Le gerarchie degli angeli di Raffaello nelle Logge del Vaticano," 161–64. As much has been written on angelic hierarchies as on their creation. See summaries in A. N. Didron, *Christian Iconography,* II, 98 ff.; and K. Künstle, *Ikonographie der christlichen Kunst,* I. 241 ff.

41. T. J. Motherway, "The Creation of Eve in Catholic Tradition," 97–116. R. P. C. Hanson, *Allegory and Event,* 122. These nuptial metaphors were much employed in Leo X's day. They were elaborated by the Bishop of Modrus at the first reconvention under Leo X of the Lateran Council, 27 April 1513 (N. H. Minnich, "Concepts of Reform Proposed at the Fifth Lateran Council," 185 ff.). The bishop referred to two traditional images for the Church—city and woman—and expounded on both in terms of the contemporary situation. Similar images were used by speakers at later sessions of the Council.

on the cross, while the rib taken from him prophesies the water and blood that will issue from the crucified Christ's side to signify the sacraments, baptism and the Eucharist, upon which the Church is founded. Adam's gesture in the fresco emphasizes this point. Because of their ecclesiastical importance, the Creation of Eve and, less frequently, the meeting of Adam and Eve, often replace the Creation of Adam in hexaemeral cycles, especially those of illustrated Bibles where typology is stressed.[42]

The Creation of Adam is not, however, excluded from the Logge. That scene (Fig. 118) appears at top center of the stucco lunette in the thirteenth and last bay, directly beneath the Nativity fresco. Adam "is the figure of him that was to come" (Rom 5:14); Christ is the new Adam, who will enable us to cleanse ourselves of the sins inherited from the old Adam: "For since by man came death, by man came also the resurrection of the dead. For as in Adam all die, even so in Christ shall all be made alive" (1 Cor 15:21–22). The last man becomes the first born, and Christ's kingdom is the new Creation, the new beginning, as the Gospel of St. John lying open before Leo X in Raphael's portrait particularly stresses. Once again in the Logge, as in Scripture and liturgy, beginnings and ends change place, merge, issue, and fall back into place, forming ever more intricate designs.

The history of humanity begins in the second bay of the Logge with scenes of great tenderness and tragedy, and with Eve as the ambiguous central character of this drama. Eve of the nuptial meeting is thrice transformed in succeeding acts of the Fall. From a demure, passive creature wrapped in on herself, she bursts forth in the scene of temptation as a strong, proud woman whose action will alter the course of history (Fig. 23). Depicted is that moment of tremendous import and suspense, when Eve drops the black fruit of the fig tree, the tree of knowledge, into the outstretched hand of Adam. In another instant, the fatal act will be completed and Paradise lost, until it is regained by the new Adam. The sense of impending tragedy reminds one, as in an inverted paraphrase, of paintings where one sees St. John proffering the Christ child a toy wooden cross, or the Virgin offering grapes or grain. Proud Eve separated at arm's length from Adam's tense crouch by the sinister, silvery coils of the serpent contrasts poignantly with the gentle, innocent closeness of the pair in the earlier scene. Their tensions denote sexual awareness, the worst of temptations, as the fig tree symbolizes lust and its leaves the coverings of shame.[43]

The innate modesty of the newborn Eve changes in the third scene, *The Expulsion from Paradise* (Fig. 24), to shame by a shift in the position of one hand, as the couple stumbles from the entrance to Paradise, propelled by an angel and a blaze of golden light. In the fourth, much damaged fresco, *Adam and Eve at Work* (Fig. 25), Eve is again transformed, assuming at the end the role of mortal, humble woman, seated and clothed now, with her work in hand, her children at her knee, her husband laboring beyond her in the neatly cultivated fields. Another visual reminder of Mary, the new Eve, this time with Christ and the infant St. John, may be intended, again with all the bitter inversions as well as the distant promise of such a simile.

Those children who vie for their mother Eve's attention become fatal rivals in the monochrome scene of the basamento in the west wall, *The Sacrifice of Cain and Abel* (Fig. 26). At left, Cain and Abel offer sacrifice to God. Abel's lamb is accepted, but Cain's sacrifice is not respected, to his clearly depicted dismay, and in jealous fury he murders his brother. Adam's son Abel was the second prototype of Christ. Like Christ, he was both priest and sacrificial

42. L. Réau, *Iconographie de l'art chrétien*, II, 73–74. E. Guldan, *Eva und Maria*, 33–35, and index.

43. O. Goetz, *Der Feigenbaum in der religiösen Kunst des Abendlandes*, 18 ff.

victim; his lamb prefigured the Lamb of God. Some dated the foundation of the Church from his sacrifice, which they called a sacrament, and some called him St. Abel.[44] With Abraham and Melchisedec, he is named in the liturgical consecration of the eucharistic wine and associated with that sacrament. In the Logge, Abel is one of many such references to Christ and to the sacraments that are to be established in the last bay.

## The Logge Grotesques

It is the second bay of the Logge that supplies the most explicit clue to the program of decorations beneath the vault scenes, a clue that sends us at this point on a long detour to examine the role of the Logge grotesques before we return once again to the vault scenes of the Old Testament.

Below and on a pilaster to the right of the Expulsion fresco, which is in the north segment of the vault, is a stucco roundel of Adam and Eve fleeing in shame (Fig. 27). Because the two figures so closely echo those of the vault scene, the disgraced couple seem in that instant to have stepped down from the gate of Paradise, having left above them the stern angel: "What was made in the image of heaven has been reduced to earth . . . he who lived in the delights of Paradise has migrated to this place of toil and sickness."[45] The stucco Adam and Eve, pale, diminished shadows of the vault figures, have now entered the lower world, the *sensibilis mundus,* of time and mortality: our world. The same fate, with the same significance, is accorded Lot's disobedient wife, whose salt-sculpt form is lifted from the fourth-bay fresco of Lot and his family fleeing Sodom, to be repeated in stucco below. She too is exiled to our world, her face forever turned back over her shoulder toward the life of sin she could not relinquish. Apart from the Creation of Adam in the last bay, these two stucco vignettes of the fallen are the only Old Testament subjects identified among the countless figures of the wall decorations.[46]

The Hebrew heroes are placed through their faith, in the Logge vault as in traditional Church hierarchy, above other mortals born before Christ (all graded "a little lower than the angels," Ps 8:5). But the populace of walls and vault—pagan and Jewish and including even the figures of animals—belong to the same sublunary tabernacle, which afforded the Christian fragmentary revelations of the future, eternal tabernacle.[47] Visually as well as theologically, the upper realm of the biblical histories and the lower wall decorations are united through numberless ties, not

---

44. See, for example, Rev. W. E. Maguire, *John of Torquemada,* 52 ff.; and J. Daniélou, *Holy Pagans of the Old Testament,* 29 ff.

45. St. Gregory of Nyssa, "On the Beatitudes," Sermon 3, in *From Glory to Glory,* 89. A more explicit illustration of the same fundamental doctrine was designed a few years later by Holbein (for one of his so-called *Totentanz* woodcuts, published only in 1538), who depicted a skeleton prancing down the path ahead of the disgraced Adam and Eve. Other examples in manuscripts and printed books—some dating from the fifteenth century—of the fallen pair received by Death or by the figure of Time are published by S. C. Chew, *The Pilgrimage of Life,* 1 ff.

46. Two other possible Old Testament subjects are the stucco roundel with Adam in the third bay, which

probably is an incorrectly restored figure (it differs from the copies in the Vienna codex, f. 22, and La Vega's codex, f. 16) and the stucco youth riding a sea monster, on a pilaster between bays 4 and 5 (Fig. 44). Because of its resemblance to the statue of Jonah in the Chigi Chapel, S. Maria del Popolo, the relief is sometimes identified as Jonah too. But both of these figures derive from the antique statue of a satyr on a dolphin in the Villa Borghese. There seems to be no reason to interpret the Logge relief as representing Jonah, a symbol of Resurrection, at that particular location in the decorations.

47. Versions of this traditional cosmology are described and illustrated by S. K. Heninger, Jr., *The Cosmological Glass: Renaissance Diagrams of the Universe,* and see 91–92.

the least of which is a common dependence on the same classical models for many figures of both zones.[48] No moral impediment inhibited the assimilation of classical figure types within Christian narrative scenes; such distinctions were as alien to the papal court in the visual arts as in literature.[49]

Our lively world below is chiefly populated by pagan Gentiles, "strangers from the covenants of promise" (Eph 2:12), and with scenes or single figures representing the transient pleasures and pastimes, the sins and passions of this world. But the lower world created in the Logge is not by any means hopelessly condemned; it includes images of the pope, and many of its inhabitants and activities are treated with enthusiastic admiration. To the Church, it was— and is—possible even for those who lived before Christ to have had redeeming prevision of and faith in the Messiah. Furthermore, the earth offers an encyclopedia of God's works, through which one may understand Christianity. With Pico della Mirandola, the Logge authors might be saying, "Nothing moves one to religion and to the worship of God more than the diligent contemplation of the wonders of God."[50]

Indeed, it would seem that the Florentine humanist education the pope absorbed from his father's circle of learned friends colors the imagery and philosophy of the Logge wall decorations. The sources remain elusive and difficult to isolate, but the flavor of Florentine philosophy is hauntingly present, with tantalizing nuggets of solid evidence scattered among the ingredients of this pottage. The sublunar world of the pagan past is invoked to elaborate lessons from the history of salvation of the vault. In the minds of the program authors, no strict antithesis separated the Old Testament subjects of the vault from the pagan figures and histories of the walls; both traditions, although in varying degree, made contributions to Christianity. The arguments employed may be traced in part back to the apologetics of the earliest Greek fathers. This long evolution of Renaissance philosophy from early Christian and medieval theology has been demonstrated repeatedly, and repeatedly it has been ignored. As Trinkaus once tartly remarked, "Medieval Catholic thought had long made peace with Greek logic and psychology, and the view that there was any hostility between medieval thinkers and the pagan classics (Christianly interpreted, of course) is a figment of some modern imaginations."[51] It is a "figment" that continues to distort critical opinion of the Logge decorations.

The populace of the Logge vault and walls derives, as I have suggested, from traditional medieval literary and visual concordances of biblical and pagan sources. Florentine contributions to this variegated history had been stellar. Dante's encounters with pagan and Christian

---

48. N. Dacos, *Le Logge di Raffaello,* traces many such examples. See also her "Les Loges de Raphaël: Répertoire à l'antique, Bible et mythologie," 327 ff. and pl. 3, which illustrates the metamorphosis of a Hellenistic Dionysus into two biblical figures of the Logge: God of the meeting of Adam and Eve and Noah of the ark-building fresco. The same figure appears in his original role, Dionysus, among the stuccoes. It should be noted too that Michelangelo's God in the Sistine *Creation of Eve* is equally important as model for this figure type and forms part of the same flexible language employed by Raphael.

49. The recorded occasions when writers, orators, artists, or collectors were criticized in Vatican circles for unsuitable mingling of pagan and Christian subjects are rare—so unusual that the same examples are repeated over and over in histories of the period. The unfortunate student from Narni, for instance, is often cited. He provoked the wrath of Paris de Grassis with a sermon more pagan than Christian (J. W. O'Malley, *Praise and Blame in Renaissance Rome,* 30–31). Also frequently mentioned is Gianfrancesco Pico della Mirandola's uneasiness over the presence of Venus and Cupid in the Belvedere Court and the placement there of so many gods on pedestals, like idols upon altars (E. Gombrich, "Hypnerotomachiana," 122–25). But see also J. F. D'Amico, *Renaissance Humanism in Papal Rome,* 201, for other, less well-known examples in literary criticism and oratory.

50. Giovanni Pico della Mirandola, "Oration on the Dignity of Man," 249 (see the Wisdom of Solomon, XIII, and Rom 1:20).

51. C. Trinkaus, in *The Renaissance Philosophy of Man,* 148.

personages, neighbors in his dreams, or Boccaccio's visions of gods, philosophers, and prophets, mingled side by side in his verses, provided indigenous authority for such interpretations of the past. Early Renaissance artists enthusiastically disseminated these historical potpourris. The illustrated Triumphs, with their motley celebrants drawn from Petrarch's verses, achieved extraordinary popularity and were reproduced in diverse media throughout several centuries.[52] Even broader in its cast of characters was the mid-fifteenth-century Florentine *Picture-Chronicle,* which may once have begun with Creation and which proceeds through a series of Hebrew, gentile, legendary, and historical figures, including a great many that appear in the Logge.[53] While these diverse religions and philosophies, myths and histories, both exotic and domestic, contributed to the world of the Logge decorations and offered welcome excuse for flights of fantasy, the underlying sermon was Christian; the goal of history was Christianity, and all preceding cults and beliefs signified only in their contributions to Christian truth.

If we return for the moment to the first two bays of the Logge, we will find a sampling of motifs among the stuccoes here that depend from such hybrid traditions and typify the variety of complex thought patterns that relate the figures throughout the lower zone to the vault scenes. Many of the motifs cannot yet and may never be identified. One must advance cautiously, remembering Panofsky's admonition that Renaissance interpretation of such familiar ancient figures as, for example, Mithras, who appears at the center of the arch in the second bay (Fig. 10), may differ substantially from that of today's scholars.[54] I will not attempt to do more than suggest the gamut of roles these stucco and fresco figures or objects play in the Logge *concordia.* Only a few, such as the stucco group of the Three Graces, have been discussed elsewhere in terms of their allegorical significance to Renaissance thinkers,[55] but there has been no systematic attempt to relate these motifs of the wall decoration to a theological program for the Logge.

It seems logical to start with the pendentive stuccoes, which are closest physically and hence, we may assume, symbolically to the vault scenes. Not all of the Logge pendentives include human figures; some bays have birds, beasts, or vegetal motifs. The only reasonably certain identity among the pendentive figures of the first two bays is that of Jupiter, with scepter and eagle, enthroned beneath the fresco of God placing the sun and moon in the heavens (Figs. 14 and 15). As pagan parallel of Jehovah, his presence in the Creation bay is not a surprise. To a Neoplatonist such as Ficino, Jupiter's teachings, recorded by Pythagorus and Plato, among other respected pagan prophets, offered revelations as authentic as God's communications to the Hebrew leaders.[56] Like the Christian God of the Logge, Jupiter, in Orphic theology, was the beginning and the end of Creation.[57] His likeness is found elsewhere in the Logge. Other gods as well—for example, Dionysus, Diana, Venus, Hercules, and, of course, Apollo—make several appearances, perhaps in different roles or perhaps in imitation of a favorite cudgel

52. D. C. Shorr, "Some Notes on the Iconography of Petrarch's Triumph of Fame," 100 ff. Prince d'Essling, E. Müntz, *Pétrarch: Ses études d'art, son influence sur les artistes . . . , passim.*

53. S. Colvin, *A Florentine Picture-Chronicle.* A similar concordance of famous men—historical, mythical, biblical, and pagan—was painted in the fifteenth century for the palace of Cardinal Orsini in Rome (W. A. Simpson, "Cardinal Giordano Orsini . . . Two Descriptions of the Lost Frescoes in Monte Giordano," 135 ff.).

54. E. Panofsky, *Tomb Sculpture,* 74, and his *Renaissance and Renascences in Western Art,* 97. On Mithras, see also F. Cumont, "La fin du monde selon les mages occidentaux," 32.

55. E. Wind, *Pagan Mysteries in the Renaissance,* 51. M. Van Lohuizen-Mulder, *Raphael's Images of Justice, Humanity, Friendship,* 24.

56. E. Panofsky, *Renaissance and Renascences in Western Art,* 156.

57. *Marsilio Ficino's Commentary on Plato's Symposium,* 133.

employed by the apologists, who liked to mock the duplication of names and fragmentation of tasks among the pagan gods. Saturn, however, is significantly absent from the fallen world described in the lower zone of the Logge; his was the Golden Age, which came to an end with the reign of Jupiter, when humankind, as in the biblical narrative, lost paradise, innocence, and virtue.

If we seek other gods among the pendentive figures of the first bay, we encounter a discouraging dearth of specific attributes. Only one, a youth who holds a lyre in so contorted a posture that he seems possessed by his music, may be identified (Figs. 16 and 17).[58] He could be Apollo, and therefore a pagan type for Christ, but he does not comport himself with characteristic Apollonian (or Christ-like) calm. He might be Dionysus, but he displays none of that god's more tangibly vinous attributes, nor was the lyre his instrument of choice. A third possible identity for the enraptured musician is Orpheus, the legendary hero and prophet who at times merges with Apollo, Dionysus, and Christ.[59] Although not a god, he would be an especially appropriate choice for the Creation bay. Of all the mythic heroes of antiquity, Orpheus perhaps was most readily converted to Christian purposes. His adaptable history allowed him to be compared with both Adam and Christ and to be associated with David and the Good Shepherd. He was believed to be the author of theogonies and prophecies that foretold the Incarnation and implied monotheism. To the Florentine philosophers, the so-called Orphic hymns held mystic clues to ancient revelation, which Orpheus was believed to have learned in part from Moses and the prophets.

Orpheus, Plato, Homer, as well as such magi as Zoroaster and Hermes Trismegistus, who appear among the Logge stuccoes, were claimed to have inherited much of their cryptically expressed thought from Hebrew sources transmitted through Moses in Egypt. Informed study of works attributed to them, it was said, would yield hidden truths of great import to Christianity. To Ficino, whose cithara bore a medallion portraying Orpheus and who, with others of the Medici entourage, celebrated Orphic rites, this greatest of musicians and poets was inspired by a divine and prophetic furor, which could raise the soul to God through the power of love.[60] Orpheus was believed to be both the seer of Christian truths and an aspect of one god, one Jupiter. The Orpheus of the pope's Logge is placed at the south end directly beneath *The Creation of the Animals,* whose passions, which exegetes equated with sins, he tamed with his magical melodies. The theurgic efficacy of the Orphic hymns, which was endorsed by Ficino and Giovanni Pico della Mirandola, demonstrated that music could lead to or heighten religious

58. The lyre, like many of the painted elements in the Logge pendentives, has worn to a shadow and is hard to distinguish today without the guidance of the Vienna codex copy (Fig. 17; f. 4).

59. For an analysis of the immense importance of Orpheus in the Renaissance, see D. P. Walker, "Orpheus the Theologian and Renaissance Platonists," 100 ff. Walker includes references to much of the endless bibliography on the subject, both source material and the discussions by writers of our own time. The authors named in note 5 above stress the significance of Orpheus in Renaissance thought, and most of them comment upon the role of other *prisci theologi,* such as Hermes and Zoroaster, all thought to be real, historical figures. The useful notion that the pagans based their theology on Old Testament sources goes back to the early apologetics. See, for example, St. Justin, The Martyr (*The First*

*Apology,* 92), who claimed that demons had identified Dionysus as son of Jupiter and had said he discovered the vine, thereby placing wine among the god's mysteries, which was nothing but a plagiarism from Moses and his messianic prophecy (Gn 49:10 ff.). Origen also argued that Moses and most of the prophets were more ancient than the Greeks, including Homer, who learned from them (*Contra Celsum,* IV, 21; VII, 30). For Orpheus and the Medici see K. Langedijk, "Baccio Bandinelli's Orpheus: A Political Message," 31–52.

60. On Ficino and the Florentine cult of Orpheus, see particularly A. Chastel, *Marsile Ficin e l'art;* P. O. Kristeller, *Renaissance Thought and the Arts;* G. Saitta, *Marsilio Ficino e la filosofia dell'umanesimo;* and A. Sheppard, "The Influence of Hermias on Marsilio Ficino's Doctrine of Inspiration," 103.

contemplation, a belief certainly shared by Leo X, who was a fervent sponsor of church music and could be moved to tears by it.[61]

The other pendentive stuccoes of the first bay represent seated women, some with trumpets, perhaps calling the faithful pagan to worship, and a baffling figure of a Herculean man pulling on a pair of hose to cover his nakedness (Fig. 18). The Vienna codex copy of the pendentive (f. 3) shows some sort of altar or monument and a tree before him, which have vanished. A reference to Michelangelo's bather dressing, in his *Battle of Cascina,* may be intended, but that figure in turn reminds one of the first catechumens sometimes seen disrobing in the background of paintings depicting the baptism of Christ.[62] In traditional exegesis, the putting off of old clothes before baptism is a sign of stripping oneself of former sins. Putting on clothes—from fig leaves to breeches—ordinarily is a sign of shame, and the garment is one of sin, corruption, and mortality, although the donning of linen breeches may mean quite the opposite.[63] To Neoplatonists, putting on or taking off a garment denoted the soul's descent to or ascent from matter, an imagery closely related to traditional baptismal mystagogy.[64] If ideas of this nature are implied by the stucco figure, he, like the fallen Adam and Eve, could signify that the world below the vault is the world of shame and sin, which awaits Redemption through the sacraments of the last bay. But until more legible connections among the pendentive figures of the first bay are established, this interpretation remains highly speculative.

The stucco figures of the second bay pendentives (Fig. 28) are more consistent in type and at the same time even less identifiable as individuals. All recline on antique couches or benches, most have tripods, altars, or vases of elegant shapes, and some gesture with wands, pluck leaves from trees, or consult weighty books. Surely these figures, placed just beneath the scenes of man's fall from grace, represent the ancient oracles and sibyls who prophesied to the Gentiles that a Messiah would redeem the world from sin. The fire, leaves, bowls, and books are all familiar equipment for divination.[65] Along with the Orphica and the Hermetica, other texts, known as the Chaldean Oracles, believed to have been written by Zoroaster, and fragmentary predictions purportedly from the sibyls (which to modern ears sound rather like mystic fortune cookies), all bolstered the Renaissance scholars' attempts to bind Moses and Genesis, Plato and *Timaeus,* with more esoteric Egyptian and near Eastern philosophies into a cohesive system.[66] The sibyls and other ancient oracles provided an immensely popular chorus to accompany such composite biblical and ancient histories. These holy fortune-tellers speak their enigmatic lines in mystery plays, from church portals, playing cards, and any number of painted biblical cycles, including of course the Sistina's.[67] They also featured prominently in festival decorations, such as were seen on the arch erected for Leo X's *solenne possesso,* wherein the pope was indirectly

61. A. Pirro, "Leo X and Music," 7. The theme of the *festa* of Pasquino in 1515 was Orpheus (D. S. Chambers, *Cardinal Bainbridge in the Court of Rome, 1509–1514,* 124).

62. For illustrations of baptisms including such figures, see E. Pogány-Balás, *The Influence of Rome's Antique Monumental Sculptures on the Great Masters of the Renaissance,* 33 ff., figs. 232–41.

63. The moral significance of clothing is mentioned often in Scripture and by church fathers. Useful summaries of the sources and arguments are found in J. Quasten, "A Pythagorean Idea in Jerome," 207–15; W. J. Burghardt, "Cyril of Alexandria on 'Wool and Linen,' " 484–86; E. Peterson, *Pour une théologie du vêtement;* and H. M. Riley, *Christian Initiation,* 161 ff.

64. E. Wind, "Michelangelo's Prophets and Sibyls," 70.

65. For the paraphernalia of divination, see R. Flacelière, *Greek Oracles.*

66. In addition to the authors cited in note 5, and indeed most writers on Renaissance theology and philosophy, see especially K. H. Dannenfeldt, "The Pseudo-Zoroastrian Oracles in the Renaissance," 7–30; and F. A. Yates, *Giordano Bruno and the Hermetic Tradition.*

67. C. de Tolnay, *Michelangelo—II: The Sistine Ceiling,* 46 ff. E. G. Dotson, "An Augustinian Interpretation of Michelangelo's Sistine Ceiling—II," 405 ff. Raphael had himself painted the sibyls only a few years earlier in S. Maria della Pace.

identified with the Messiah.[68] These ancient forms of prophecy had been claimed as a specialty of the pope's native Tuscany in paintings decorating the 1513 theater of the Campidoglio.[69]

Among the otherwise intensely occupied diviners of the second bay pendentives is one who lies fast asleep (Fig. 29). He is placed beneath the fresco in which Adam wakes from his deep sleep, when Eve was created from him in order that the "whole human race should spread out from the one original man (Fig. 22)."[70] Nestled by Adam's foot, as he acknowledges the wife who is to help him beget this race, is a pure white rabbit. Among the convoluted thought patterns characteristic of the Logge, some of the fanciest and most captivating intellectual gymnastics are embodied in this small rabbit. Implied is the same kind of thinking that we find in the contemporary festivals and literature—for example, in Fortezza's speech at the Campidoglio celebration—but transformed from academic rhetoric into high art.[71] On the obvious level, the rabbit symbolizes fecundity (not, in this still sinless context, lust, as is sometimes said), and its position beside Adam rather than Eve indicates that he is the androgynous father and mother of us all. The concept of original man as both male and female goes back to ancient cosmogonies and was echoed by Christian writers from Origen to the Orphic devotees of Florence.[72]

Certain well-known ancient and Renaissance naturalists made similar observations about the reproductive feats of rabbits, or hares, which were believed by some to be androgynous, while others argued that the male gave birth, and without loss of chastity.[73] Yet other talents of the rabbit made it a highly sympathetic companion to Adam. Aelian believed that the rabbit slept with its eyes open: "Its eyelids are never overcome by slumber. They say that it sleeps with its body alone while it continues to see with its eyes."[74] Pliny had earlier noted the same peculiarity, adding, "and so do many human beings while in the condition which the Greeks term 'corybantic.'"[75] Such states of inspired ecstasy, or "sober intoxication," when the soul watches while the body sleeps, were a common and cherished paradox, especially to Neoplatonic writers.[76] Adam, Orpheus, Jacob, and the oracles, among others, were all believed to have achieved this visionary state of inward sight, the *vacatio mentis* of Ficino, when the deepest mysteries were revealed.[77] Adam, the rabbit, and the slumbering stucco oracle in the pendentive beneath them had much in common then, but Adam's little animal offers a further message, the most important one. From ancient times the rabbit was a symbol of spring, of

68. See chap. 1, p.21.

69. See chap. 1, p. 23.

70. St. Augustine, *Concerning the City of God Against the Pagans*, XII, 22.

71. See chap. 1, p. 24.

72. See, for example, *Marsilio Ficino's Commentary on Plato's Symposium*, 154 ff.; Leone Ebreo, *The Philosophy of Love*, 349 ff.; and E. Wind, *Pagan Mysteries in the Renaissance*, 164, 173. It is probable that a link between Adam and the rabbit in scenes illustrating the Creation of Eve also was based on traditional models. A similar purposive linkage may be found, for example, in a Bible of 1471, made for a Florentine family. See L. Armstrong, *Renaissance Miniature Painters*, pl. 18.

73. Philostratus, *Imagines*, I, 6, p. 27. E. Topsell, *The History of Four-Footed Beasts and Serpents and Insects*, 207 ff. H. W. Janson, *Apes and Ape Lore in the Middle Ages and the Renaissance*, 123.

74. Aelian, *On the Characteristics of Animals*, II, 12; XIII, 12–13. The same gift was attributed to lions as a

sign of vigilance, and it may have contributed to the horde of leonine virtues prized by the pope in selecting his name (J. Shearman, *Raphael's Cartoons*, 20).

75. Pliny, *Natural History*, bk. XI, liv.

76. In addition to classical writers' descriptions of these possessed visionary states, the Song of Songs formed the basis for much speculation on the subject: "I sleep but my heart waketh: it is the voice of my beloved that knocketh" (5:2). St. Gregory of Nyssa was one early Neoplatonist particularly enthralled by the concept. See "Commentary on the Canticle of Canticles," in *From Glory to Glory*; J. Daniélou, *Platonisme et théology mystique: Essai sur la doctrine spirituelle de Saint Grégoire de Nysse*, 230 ff.

77. Ficino's thoughts on the subject have been analyzed by many scholars. See particularly A. Chastel, *Marsile Ficin et l' art*, 44, 129 ff.; and C. Trinkaus, *In Our Image and Likeness: Humanity and Divinity in Italian Humanist Thought*, II, 479 ff. See Plotinus, "On Beauty," *Ennead*, I, 6., section 8 (259).

renewed life, and, in the Christian era, of voluntary sacrifice and of Resurrection.[78] Adam's pet is in fact the Easter rabbit, a coded promise of the new Adam.[79]

The Logge, like Raphael's portrait of Leo X, abounds in such oblique references, which must have afforded the pope and his friends much entertainment, all of course as suitably edifying as the moralized versions of ancient mythologies. A simpler sort of elevated amusement was provided by the classical quotations, visual and literary, which then, as now, challenged the viewer to identify the source of an image. Perhaps one received points in this game for recognizing a motif from Cardinal Grimani's Hadrianic coin or the illustration of a passage from one of the pope's Greek manuscripts. In addition to these intellectual diversions, lessons of Christian morality are delivered by the gentile figures of antiquity and the contemporary mortals who inhabit the world below that of the biblical heroes. Such edifying entertainments are again similar to those of the popular moralized fables, which conclude each myth or legend with a Christian interpretation of its characters and events, often bizarrely farfetched. The first two bays of the Logge again offer a sampling of the homilies that are expressed in camouflaged form throughout the decorations and that may be sorted into rough, often overlapping categories.

The largest group of these examples that contrast the *sensibilis mundus* below with the vault heroes of the convenant comprises the sins, follies, and carnal appetites of those who live without faith, and hence without hope of future Redemption. These are often represented in the Logge, as in moralizing literature, by animals, combats, wicked characters from antiquity, or through examples of the hedonist pleasures of life, poetically cloaked in classical guise. It is surely no accident that so many of the figures and groups in the lower zone are derived from sarcophagi and hence evoke funereal themes and monuments to the death that will end their brief carnival.[80] Comparison with the lighter, more carefree fresco decorations of the Vatican Loggetta, which are so witty, frivolous, and irreverent, or with Cardinal Bibbiena's *stufetta*, makes manifest the different temper, often of urgency and passion, that drives the restless creatures of the Logge walls. The few inert figures scattered among their more vigorous neighbors seem by contrast leaden and earthbound. Their bowed heads and sagging drapery echo the posture of lamenting figures from ancient funerary reliefs and suggest prescient mourners among the heedless multitudes.

If the vault scenes of the Logge, with their many nuptial allusions, might be considered a mystical epithalamium, the tenor of the lower zone is distinctly elegiac. A somewhat comparable use of grotesques to represent inhabitants of a kind of limbo—a tempestuous state of being, perilous to the soul's future—would have been familiar to Raphael and the Vatican court; they might have looked to Signorelli's S. Brizio chapel at Orvieto. In this chapel the basamento scenes, drawn from Dante's Purgatory, are surrounded by a framework of grotesques that in their savage spirit seem more medieval than classical. There, and on the entrance arches to the chapel, the grotesques are inspired with a demonic energy, while the little human figures

78. G. Gugitz, *Das Jahr und seine Feste*, I, 187 ff. B. Rowland, *Animals with Human Faces: A Guide to Animal Symbolism*, 89 ff.

79. I am particularly indebted to Elizabeth E. Ferry for first suggesting to me the association with the Easter rabbit.

80. Many of the subjects that appear in the Logge grotesques, and especially in the stucco reliefs, illustrate themes found repeatedly on sarcophagi. See discussions in F. Piper, *Mythologie und Symbolik der christlichen*

*Kunst*, I, 199 ff.; F. Cumont, *Recherches sur le symbolisme funéraire des romains, passim*; E. Wind, *Pagan Mysteries in the Renaissance*, 133 ff.; and E. Panofsky, *Tomb Sculpture, passim*. One is reminded as well of many Vanitas subjects—especially popular in north European art—wherein the hidden figure of Death watches unwary pleasure seekers, or of the Triumph of Death, when Death may be seen riding toward a cheerful company of lovers, musicians, and banqueters, who will shortly perish under his horse's hoofs.

tangled in their midst struggle with fiends or, as do so many in the Logge, slump in attitudes of apathy or despair.

Passavant may have been the first, and certainly is one of the few, to point out that even the smallest elements of decoration often serve to comment on the major themes of the Logge. He cited as an example the grotesque motifs in which Amors, signifying divine love, battle wild beasts such as lions and tigers, representing fierce passions.[81] The many scenes of hunts or of hostility between animals or warriors probably exemplify these baser, bestial aspects of mankind, or struggles between good and evil forces. The sensual or wild side of human nature also lurks in the Logge within such familiar denizens of moralizing literature as satyrs, centaurs, and the various followers of Dionysus, whose pipes were said to rouse uncontrollable urges. Many individual figures or groups are impossible to identify, like so many prints of the period whose subjects remain mysterious, but a number of those that are recognizable recur, somewhat monotonously, in syncretic histories as types of iniquitous pagans. Medea, a dead child slung over her shoulder and another at her feet (the uppermost stucco panel placed beneath the creation of the sun, for Medea was a daughter of the sun), was such an example (Fig. 14). The gory incident of Hannibal presented with the head of his brother Hasdrubal (on a pilaster between the tenth and eleventh bays) was another favorite, a subject not otherwise notably significant in ancient history.[82] Doubtless, other popular villains of moralizing histories, such as Semiramis, may dwell unnoticed here among more conspicuous scoundrels.

Scenes of pleasure, especially of drinking, dancing, and love making, appear almost as often in the Logge as scenes of violence and combat, but Catholic dispensation enables the artists to treat earthly joys with an enthusiasm akin to that displayed toward the beauty of nature. To the Italian Renaissance Christian, the pleasures of this world were imperfect and impermanent, but they were far from being intrinsically evil.[83] Procreation was, obviously, a teleological necessity, and children were a blessing to the race. Mortal love could be considered a primitive stage on the ladder toward a perfect, eternal love, that ecstatic union with God. When savored with moderation, both wine and mortal love offered a faint, shadowy taste of the spiritual love and communion to be found through Christ and his sacrifice. No doubt, a similar *paragone* between terrestrial pleasure and celestial love—quite likely using many of the same motifs—appeared on the arch for Leo X's Florentine entry, described as representing "la felicità humana, et divina."[84] Throughout the Logge the imagery of love murmurs a theme song that will reach a crescendo in the last bay.

Even the vegetation of the Logge grotesques—the fruits, flowers, vines, and vegetables— seem possessed with the energy and excitement of this carnal and transient world (see Figs. 44 and 74). Birds of every variety fly and perch among the leaves, and the stems are alive with small animals: squirrels, lizards, snakes, and snails. Much of the originally illusionistic effect of these creatures has been lost with the surface erosion, as may be seen by comparison with the Vienna codex. For example, the marine bull in bay 4 (Fig. 43; f. 30) is now a blotched shadow of its former virile self, and several birds that skim across the vaulted sky of the next bay (Fig.

81. J.-D. Passavant, *Raphaël d'Urbin*, I, 221.

82. Illustrated in N. Dacos, *Le Logge di Raffaello*, pls. cxviib and cxxxii. The incident is recounted, for example, by Paulus Orosius, *Seven Books of History Against the Pagans*, 191; Otto, Bishop of Freising, *The Two Cities: A Chronicle of Universal History to the Year 1146 A.D.*, 198; and even by Boccaccio, *Amorosa visione*, 55. The subject seems to be illustrated twice among the stucco reliefs of this bay, but possibly at least one of the scenes might represent a similar attractive tale: Romulus giving the severed head of Amulius to King Numitor at Alba Longa.

83. These attitudes do not vary in principle from those of the present-day pope, John Paul II. See his *Love and Responsibility*.

84. See chap. 1, p. 25.

45; f. 41) have nearly vanished. The botanical displays, especially where they can best be seen because best preserved—in the garlands of the west wall, suspended against an azure-blue sky—are ripe to the peak of perfection, that fragile moment of full bloom preceding decay (see Figs. 20 and 44).[85] The appetizing fruits and vegetables are plump and rounded, bursting with juice and seed: "morbida e pastosa," as Vasari described the produce of Giovanni da Udine's painted gardens.[86] Some, like those of the Farnesina, as also noted by Vasari, grow in anatomically suggestive clusters of gourds, pomegranates, and cabbages.[87] The slightest tendrils of a vine are possessed with a springy energy and vitality. Love, even the reproductive fertility of the lowest order of nature, infuses all creation with life, including the grotesques, which are as alive and plausible as the normal creations of this earth.[88]

For the invention of grotesques, according to Lomazzo, the artist could claim poetic license. One needed "un certo furore, e una natural bizarria" or, put otherwise, a "giuntamente furia naturale e arte."[89] But, he goes on to say (and other cinquecento theoreticians made similar points), order and an internal system of credible relations among elements were essential in designing such decorations if one wished to create beauty and meaning rather than deformity and chaos. To illustrate what he would consider violations of this natural order, Lomazzo gives as examples children depicted larger than the adults in the same scene, animals shown flying without wings to support them, and other similar errors. The poetic imagination that created the Logge grotesques did not commit such anarchic errors. Even writers who deplored the use of grotesques—on grounds moral, esthetic, or historical—omitted Raphael's Logge from their criticism of the genre, at least until later centuries. Like the mythical basilisk of the Creation scene, the grotesque seems to grow as naturally in the fertile realm of the Logge as the tamer, more familiar figures, plants, and animals. It appears graceful, even reasonable, when an altar rises magically from a vine and a vine from a faun's grinning head. Foliage turns into snapping dragons, and grimacing masks sprout horns and wings. But unlike the mad world of a Bosch or that of so many medieval artists, these fabulous chimeras do not disturb with ugliness or menace with freakish cruelties. Love rather than terror ultimately triumphs in the Logge.

Although the biblical scenes, with their clear, strong narratives and purposeful progression from a beginning to an end, are distinctly framed and set apart from the tumultuous, aimless

---

85. N. Dacos, " 'Il trastullo di Raffaello,' " 8. Not all the west-wall garlands have been preserved. The Vienna codex (f. 9) includes garlands that have vanished from the first bay. At left, filling the wall space between the marble frame (incorrectly rendered here by the copyist as a window or niche frame instead of a door) and the first pilaster strip, are suspended clusters of vegetables, fruits, and foliage, similar to those at the right. Frescoed vegetation must then once have framed the door in the first bay and is now lost beneath the present plain blue surface. Another detail of folio 9 might be noted here: The horse portrayed on the central pilaster is predominantly brown and hence is not, as sometimes stated, the white horse that Leo X rode at Ravenna and again at his *possesso*. Little more than the white legs of this animal have survived.

86. Vasari, VI, 551. See also A. Chastel, "Les jardins et les fleurs," 48 ff., for hypotheses about Giovanni da Udine's training in botanical representations.

87. Vasari, VI, 558. It is probable that many of the birds, flowers, and vegetables also individually con-

veyed symbolic significance. See, for example, an analysis of such motifs on Ghiberti's bronze doors: M. Ciatti, "La Porta del Paradiso," in *Lorenzo Ghiberti, materia e ragionamenti*, 371 ff.

88. The mystical union of love and nature, with its magical corollaries, is discussed by F. A. Yates, *Giordano Bruno and the Hermetic Tradition*; see, for example, 126.

89. G. P. Lomazzo, *Trattato dell'arte della pittura, scoltura et architettura*, VI, xlviii, 424. For other theoretical writings on grotesques, see N. Dacos, *La découverte de la Domus Aurea*, 121 ff.; and *Scritti d'arte del cinquecento*, 2619 ff. See also the chapter "The Edge of Chaos," in E. Gombrich, *The Sense of Order*. Unfortunately, all the discussions about the role and meaning of grotesques date from later in the century and cannot provide firm evidence of what Leo X and his entourage thought about the subject. But the ideas aired in these texts surely must have derived from debates already familiar by the late quattrocento.

life of the lower orders, both zones are guided by the same design, theologically as well as artistically. Like the veiled allegories of the Old Testament, the Logge grotesques disguised—as some believed their ancient prototypes did—divine truths encoded in their symbolic and hiero-glyphic vocabulary. This unity of program, based on the example of classical art and literature, was understood and explained later in the century by Pirro Ligorio, who, as court artist to Pius IV, was profoundly well acquainted with the Logge and with the Vatican interpretation of its meaning, some forty years after the death of Raphael. In his long discourse on grotesques, Ligorio wrote:

> Per tale cagione simile grottesche erano venute ad una somma eccellenza, e da esse l'eccellente Rafaele d'Urbino et Ioan da Udina, pittori degni d'immortale nome, imitando l'antichità con molta arte ornarono la loggia del sacro Palazzo Apostolico e con tal sorte di pittura molto vagamente e con stucchi legarono le istorie del Vecchio e Nuovo Testamento; i quali ornamenti recano molta vaghezza, dove i pesci, l'augelli, le verdure e le figurette pareno cose vive con vitale spirito. Laonde gli antichi, per simili modi che ha fatto Rafaele a loro imitazione, così aveano ligati di figure grottesche le cose delli eroi e delle Muse, di colori vaghi, di belli ornamenti. Per ciò dunque, se alcuni pareno cose false e vane, dalli dotti furono sempre stimate come figure di cose morali e di cose imitate dalla natura.[90]

A few passages further on he reinforced this defense of grotesques with the comment that "nelle grottesche non è da dubbitare che non vi siano dipinti i fragibili e deboli nostri funda-menti nelle nostre azzioni."

The emblematic and moralizing possibilities of grotesques, with the opportunity they offered (as in the illuminated borders of manuscripts) for commentary on the major themes of a program, were discussed not only by Lomazzo and Ligorio, but by many others later in the century. Of equal interest to these savants were the origins and etymology of the style, which was often said to have been born in subterranean places of worship and of sacrifice to gods of the underworld. The association of grotesques with fear of the unknown, with mystery, enchantments, and death is not surprising. The forms themselves defy the safe familiarity of natural laws, and the places in which the ancient grotesques were found prompted strange speculations about them. Even today, a tour of the Domus Aurea can be somewhat unnerv-ing; in Raphael's time, a visit to the excavations entailed sinister thrills from encounters with nocturnal creatures and from the darkness and sepulchral cold that filled the disorienting tangle of cramped tunnels. Although examples of such decoration were indeed found in burial chambers, rational argument demonstrated that accident and shifts in ground level had pro-duced most of the grottoes in which were discovered so many of the decorations dubbed "grotesques."

Nevertheless, the morbid sensations stimulated by these dark, dank caves tended to cling uneasily to the style of painted ornament found in them, as is suggested by the pseudoscientific attempts to attribute its origins to temple decorations for infernal deities. Revivals and survivals often merge in hybrid forms. Surely some heritage as well from medieval fantastic art, with its monsters and frequent savagery, its tendency to slip from dream to nightmare, further rein-forced the occasional ominous undercurrents and moral lessons found in Renaissance grotesque

---

90. *Scritti d'arte del cinquecento*, III, 2670 (see 2675 for passage cited below).

art. The playful capriccios of Raphael's grotesque vocabulary should not, therefore, be regarded simply as ornament, especially not the stucco reliefs. A prevailing pensiveness lies beneath much of the superficial gaiety and hints here and there at the fate that may befall many of these frail creatures, so absorbed in their frivolous antics and earthly appetites.

The high quality of the stuccoes matches that of the painted grotesques, and they too seem to pulse with life, with a sense of becoming rather than of stasis. These reliefs, with few exceptions, evoke the transitory essence of a sketch or *bozzetto,* which only a moment earlier the artist's hands and tools swiftly drew and modeled in the moist, not yet hardened stucco. At times the figures appear to be still in the process of emerging from the background, their forms only partly discernible in what seems to be an atmospheric haze that blurs their shadowed profiles and their fluttering draperies blown by a feverish, inconstant wind. Comparison of these reliefs, still so close to the classical models, with those made by Giovanni da Udine for the loggia of the Villa Madama only a few years later (the stuccoes of the arch leading from the entrance hall retain the sketchy, low-relief style of ancient stuccoes) illuminates their character. The compact, sculptural forms and clean contours of the later stuccoes distinctly differ in sensibility from the immediacy of vision and execution conveyed by the more impressionistic Logge reliefs.

Consciousness of, and even pride in, the artist's acts of creation is detailed in a series of stucco reliefs in the first bay (Fig. 19). As we have seen in other examples, links between the biblical scenes of the vault and the stucco and fresco decorations below can be relatively direct: for instance, Medea placed beneath the creation of the sun or Orpheus placed beneath the animal passions he tamed. Other associations imply more complex ideas: the creation of Adam beneath the nativity of Christ, Adam and Eve descending from Paradise to the realm of mortality, Adam, the rabbit, and the sleeping oracle. A sequence of stuccoes in the first bay strikes a distinctly Neoplatonic chord and again illustrates the premise that the zone of decorative elements represents our mortal world, the world of shadows that dimly reflects God's archetypal idea. A series of reliefs runs down the north pilaster framing the east arch of the first bay, below the fresco of God placing the sun and moon in the firmament. In the uppermost cartouche sits a man apparently drawing or writing on a tablet held in his lap. The roundel beneath this relief shows an artisan working at a table, perhaps modeling a lump of stucco or grinding materials for stucco or paint. In the next, rectangular, scene, five artists are at work decorating the pilasters of a structure meant no doubt to represent the Logge. (In the first and second bays are other stucco reliefs of an artist at work in the Logge.) The fourth relief concludes the series with Fame poised upon a globe, holding her two trumpets. The narrative moves logically from the artist noting his first ideas, to the physical preparation of materials for the task ahead, to the production of a work of art, and finally to the fame that rewards this creation. The metaphor of God as the Artist, the Maker, the Craftsman passed from Plato through many church fathers to the Renaissance Neoplatonists, when the image sometimes emerged inverted.[91] To Ficino, for example, the artist was "deus in terris," a twist to the old formula that would be promoted heavily later in the sixteenth century.[92] Both views of art, however, could lead to the same conclusion; the human artist, his ideas, his materials, his creation, and the worldly fame that he earns are but pale reflections—images of images—which offer the human mind hints of God's creative powers. The splendid universe created by artists

---

91. For a history of the subject, see E. Kris and O. Kurz, *Legend, Myth, and Magic in the Image of the Artist.*

Plato's *Timaeus* inspired much of the vocabulary for deriving the mortal artist from the Maker-Deity.
92. A. Chastel, *Marsile Ficin et l'art,* 61.

in the Logge is to be understood as a mere mortal imitation of the wonders created by God, as recorded in the vault above.

Interwoven among the deftly delivered theological and moral lessons of the Logge decorations are countless allusions to the pope, including his portrait, as a head seen in profile and as a standing figure blessing a kneeling cleric, both in stucco relief.[93] Other references appear throughout in the form of family and personal emblems, illustrations of Leo X's interests and pastimes, which are sometimes given a veneer of moralizing exculpation, and symbolic figures of the virtues and attributes of his person and reign. Innumerable Medici family and personal devices are scattered among the frescoes and stuccoes: the Medici *palle*, yokes, diamond rings with or without the three feathers, and, of course, lions in every posture and size. It was said that Leo's mother, Clarice Orsini, dreamed when pregnant of giving birth to a lion of "estrema grandezza e di maravigliosa humanità," which inspired her son's choice of papal name.[94] The tale has a familiar ring of the legendary;[95] it seems more probable that Giovanni de' Medici particularly admired earlier incumbents known as Leo, most of whom were saintly and distinguished figures,[96] and, as was noted earlier, that he wished also to recall *Marzocco*, the Florentines' guardian lion. Whatever the motives for selecting the name of Leo, the lion was ideally suited for heraldic and allegorical tasks and symbolized many useful virtues to the pope. We have heard him referred to as the lion of Judah, a messianic appellation that was frequently applied to him.

The Vicar of Christ, called, as was Christ, the thirteenth apostle, would have known from bestiaries that among beasts the lion was considered the thirteenth apostle and provided a figure for the Sabbath and the Resurrection; the lion was the animal of the sun and therefore of "the day which astrologers call the sun."[97] To astrologers Leo as well was a favorable sign, under the charge of Jupiter, "a man most fit for the governing of Men and Gods, that is, fit to manage well both divine affairs and human."[98] In *God Creating the Animals* (Fig. 11), the king of the beasts stands proudly and prominently beneath God's right hand. Beside this tawny new lion lumbers another ferocious beast, the bear, a heraldic reference to the Orsini, the maternal, Roman side of Leo X's family. It was not filial love alone that prompted the pope to stress his Orsini connections, but rather a desire to strengthen his ties with Rome by presenting himself as a pope who united Rome with Florence through his dual heritage. For that reason his deceased mother Clarice Orsini was particularly honored in 1513, the first year of Leo's reign, at the ceremonies on the Campidoglio, when the pope's brother Giuliano and his nephew Lorenzo received Roman citizenship. In one of her manifestations during the festivities, Clarice seems to have descended from heaven from the constellation Ursa.[99] No doubt the winged bears painted in roundels flanking the fifth bay Logge niche refer to Clarice as Ursa (Fig. 52). Other, more earthbound bears may be seen dispersed elsewhere among the decorations.

At the same 1513 performance, the resurrected Clarice addressed her son Giuliano with verses declaring that she bore his brother Leo like Latona, "producendo un nuovo sole al

93. Illustrated in N. Dacos, *Le Logge di Raffaello*, pls. cIIIa and cvb. J. Shearman, *Raphael's Cartoons*, 59–60.

94. P. Giovio, *Le vite di Leon Decimo. . . .* (1551), 154.

95. See, for example, other such fables in Cicero, *De Divinatione*, I, liii; and Tertullian, *Apologetical Works*, 282.

96. J. Shearman, *Raphael's Cartoons*, 18 ff.

97. *Physiologus, A Metrical Bestiary of Twelve Chapters by Bishop Theobald*, 5. Giovanni Pico della Mirandola, *Heptaplus*, 163.

98. *Marsilio Ficino's Commentary on Plato's Symposium*, 181. See also P. Meller, "Physiognomical Theory in Renaissance Heroic Portraits," 63 ff.

99. F. Cruciani, *Il teatro del Campidoglio*, 120. B. Mitchell, *Rome in the High Renaissance: The Age of Leo X*, 72.

mondo."[100] Among the various ancient gods and Old Testament heroes flatteringly compared with the pope, the most ubiquitous was Apollo (Fig. 66), who appears throughout the panegyric literature and festivals of Leo's reign and several times in the Logge decorations (see bays 7, 9, 11, and 12). Mindful perhaps of Socrates, who, anticipating the joys of imminent death, composed a hymn to Apollo and often dreamed that he should "make music and work at it,"[101] Leo X paid frequent homage to the god of music and medicine. Apollo and his laurels were treasured subjects of Medici family iconography, both before Leo X's birth and long after his death.[102] At the 1513 Campidoglio festival, the Arno says to Leo's mother that her son was "Inter Apollineas lauros et lilia natus."[103] Apollo, as god of healing, was adopted by generations of the Medici through convenient etymological genetics.[104] The use of medical terminology for treatment of the soul and references to the priest as physician, sanctioned by Scripture (such as Mt 9:12) and endorsed through patristic writings, was applied frequently as well to the heroic leaders of the Old Testament, among them, those painted in the Logge vaults. According to theological tradition, the race fell ill through Adam's sin, but now and then God designated specially holy persons to cure his people of their spiritual sickness, Christus medicus being the most effective of this line. A similar argument may be found in literature by pagan authors, at a time when Apollo was worshiped as high priest of medicine.[105]

Vatican exploitation of such metaphors, shifting from simple puns, which, however, may contain serious magical powers, to multiple interwoven layers of associations, occurs in many other works of art commissioned by or for the pope, such as Raphael's portrait of Leo X. This predilection for complex modes of thought also characterized the pope's musical tastes. Leo's ear was as sensitive as his eyesight was weak. He both composed and performed music, and he enjoyed discussions about harmony and numerical theories of music.[106] Not only did he particularly favor the dense structures of motets and masses, but he himself was capable of arranging difficult and ingenious four-part counterpoint.[107] Castiglione's letter reporting the completion of the Logge decorations commented "nostro S.re sta su la Musica più che mai."[108]

Musical symbolism, an always tempting topic to theologians and philosophers, assumes many forms in the Logge.[109] To summarize with a few sentences a subject so extensive that it alone might fill a volume is unwise but irresistible. Again, a Neoplatonic cast of thought seems to guide the imagery of music in the Logge. Apollo and Orpheus plucking their stringed instruments, the Bacchic troupes of pipe-playing creatures—Silenus and Marsyas, centaurs, satyrs, and Pans—the splendid bouquets of musical instruments suspended from lions' heads in the central bay, all sound a medley of tunes that provides a foretaste of the heavenly harmony

100. F. Cruciani, *Il teatro del Campidoglio*, 56.

101. Plato, *Phaedo*, 61.

102. B. R. Hanning, "Glorious Apollo: Poetic and Political Themes in the First Opera," 485 ff.

103. F. Cruciani, *Il teatro del Campidoglio*, 92.

104. See chap. 1, notes 72 and 75.

105. For Apollo and other ancient gods associated with medicine, see W. A. Jayne, *The Healing Gods of Ancient Civilizations*.

106. P. Giovio, *Le vite di Leon Decimo. . . .* (1551), 225.

107. A. Pirro, "Leo X and Music," 4, 7 ("there was, in the Pope's predilection for motets and masses, a mixture of humanism and piety"). "Leone X e la

musica," in *L'Estasia di Santa Cecilia di Raffaello da Urbino*, 241–43.

108. V. Golzio, *Raffaello nei documenti*, 100.

109. Most helpful on the subject of musical symbolism are K. Meyer-Baer, *Music of the Spheres and the Dance of Death*; and E. Winternitz, *Musical Instruments and Their Symbolism in Western Art*. Both books have much information on ancient and Neoplatonic philosophies involving music and on individual instruments, such as the lyre and cithara. See also A.C. Esmeijer, *Divina quaternitas*, 117 ff. A. Chastel's many publications dealing with the Florentine quattrocento also refer frequently to theories about music.

of the spheres (Fig. 67). [110] The lyre, or cithara, which appears often as a decorative motif in the Logge, had a lengthy history of symbolic meanings (frequently involving the number of strings), but most often it represented virtues and the divine harmony of the universe, in contrast to the uncivilized nature of pipes, which appealed to low tastes and excited the passions.

References to two classic tales of this esthetic and moral contrast and of the punishment that awaits those who defy a deity are found in the eleventh bay of the Logge, again offering a pagan parallel to the lessons on obedience in the Old Testament scenes of the vault. A stucco roundel on a pilaster between bays ten and eleven depicts Apollo standing beside the unfortunate Marsyas, who had presumptuously claimed that his piping equaled the celestial harmonies Apollo produced with his lyre. [111] In a pendentive roundel of the eleventh bay, Marsyas appears alone, again bound to a tree. A fresco scene in the vault above him, *David's Victory over the Ammonites* (Fig. 94), contains allusions to a similar confrontation, but here disguised in the playful spirit typical of the Logge. King David, composer of the Psalms and inventor of musical instruments (Am 6:5), rides his triumphal chariot, which is decorated with lion-head reliefs, and holds a psaltery. Carried on poles before him are the trophies of his victory, among them two fantastic helmets. One, with a crown and long ears, refers to foolish King Midas, who preferred Pan's pipes to Apollo's lyre and was rewarded for his poor judgment with ass's ears. The second helmet is winged and might represent Mercury, who invented and gave the lyre to Apollo. Implied is not only the moral superiority of the stringed instrument over pipes but also that of the biblical musician over his pagan counterparts. The half-hidden relief on David's golden chariot may represent Daphne fleeing the hand of Apollo, with a fragmentary glimpse of Daphne's river god father, Peneus, reclining at right. King David's location in the eleventh bay, a number of great superstitious significance to Leo X, doubtless reinforced the parallel between the musical pope and this Old Testament king, the lion of Judah. [112]

Perhaps even more numerous than lyres, and also related to musical themes, are the swans of the Logge, which appear among the stuccoes and grotesques of at least eight or nine of the bays. This graceful bird, like the lyre, is sacred to Apollo. The swan, moreover, shares the god's gifts of prophecy (a recurrent motif of the Logge) and of music. The swan was believed to voice its most melodious song before dying (the "swan song"), which, according to Plato, expressed the creature's joy at the prospect of release from its bodily prison to join its god in the next world. [113] In Neoplatonic terms, the behavior of the swan was admirably Christian; its bright, pure white plumage further testified to the swan's Christian virtues. [114] Dolphins, also dear to Apollo, and stags, both said to be charmed by music and, like the pope, to possess sensitive hearing, appear in the Logge decorations, although much less often than swans. [115]

The stag in addition relates to a passion of Leo X that was considered even by contemporar-

110. *Cristoforo Landino: Scritti critici e teorici* (Proemio al commento dantesco), I, 144. For Leo X's supposed (or desired) gift for *concordia*, said to derive from his musical talents, see J. Shearman, "The Vatican Stanze," note 149.

111. Both reliefs are illustrated in N. Dacos, *Le Logge di Raffaello*, pls. LIXb and CXXXIIc. For the importance of this fable—often Christianly moralized in medieval and Renaissance literature—see especially E. Wind, *Pagan Mysteries in the Renaissance*, 151 ff.; and A. Chastel, *Art et humanisme à Florence*, 48 ff.

112. For a discussion of the various musical instruments associated with David and their symbolism, see H. Steger, *David Rex et Propheta*, 41 ff.

113. Plato, *Phaedo*, 85. K. Meyer-Baer, *Music of the Spheres and the Dance of Death*, 68–69.

114. Leone Ebreo, *The Philosophy of Love*, 146.

115. F. Klingender, *Animals in Art and Thought to the End of the Middle Ages*, 166 ff. E. Winternitz, *Musical Instruments and Their Symbolism in Western Art*, 174, 222.

ies to be excessive: his love of the hunt. In his youth the portly pope had been warned by his father that clerics, being susceptible to infirmities, should exercise regularly.[116] Health may have offered an excuse for Leo's attendance at hunts—perhaps more often as spectator than as participant—but his devotion to hunting and fishing consumed more time and energy than was felt seemly or wise in a pontiff. Many varieties of game and many scenes of the chase are illustrated among the decorations of the Logge. A pilaster between the sixth and seventh bays offers a pastoral intermezzo on the subject, a description of bird snaring (Fig. 59). Screened by bushes at the base of a tree that grows to the height of the pilaster, a youth crouches, holding a fistful of captured birds. He stares intently up at the owl decoy perched on a branch above him and waits for other birds to alight on twigs, which were probably coated with birdlime, a sticky substance that will entrap them. A contrast may be implied here between courtly and peasant pastimes, but quite possibly a Christian sermon is hidden within this rustic divertimento, for depictions of the owl as a decoy attacked by small birds usually did convey moral lessons. The owl had evil connotations of heresy and uncleanliness, while the small birds symbolized the soul aspiring to heaven, which, according to St. Bernard of Clairvaux, must struggle against earthly ties, like a bird trapped in birdlime.[117]

Leo X enjoyed fishing almost as much as hunting. The abundance of marine species illustrated in the Logge, both in stucco and in fresco, allude to this passion. The grotesques of bay eleven (Fig. 96), the bay of King David, who was variously associated with Leo X, include a tasty selection of game birds and particularly splendid strings of iridescent fish. Most of these marine specimens are treated simply as marvelous exhibits from the collection of an enthusiastic sportsman, but occasionally one is reminded that the fish too has a long history of symbolic significance, not only as an emblem of Christ, but as a figure for baptism and for the sinner who turns to Christ, as do "we, little fish, we are born in water."[118] This traditional figure was paraphrased in a small vignette, now vanished, at the base of a pilaster between bays five and six, which was totally misunderstood by restorers, who made nonsense with their reconstruction. The original concept (Fig. 52), recorded in the Vienna codex (f. 40), depicted a tank filled with fish, which receive the life-giving water through two streams poured from above by small winged figures of Amor.

References to the pope's lineage, emblems, his cultural interests, and his recreations account for a greater number of the Logge decorative motifs than do tributes to the moral or spiritual virtues of his character and rule. Standard types of such virtues and attributes appear most lavishly among stuccoes of the first two bays (see Fig. 12) and the last bay of the Logge, where Faith, Hope, Charity, Justice, Fortune, Fame, Peace, Liberty, and other allegorical figures probably are intended to eulogize the golden reign of pope and Church. Their roles are familiar through the iconography of triumphal processions and carnival carts, as well as through litera-

---

116. See chap. 1, note 7.

117. See B. Davidson, "The Landscapes of the Vatican Logge from the Reign of Pope Julius III," 601, for the owl decoy both as a type of venery and as a moral tale. Plato condemned bird snaring as ungentlemanly (and angling as lazy), in contrast to more commendably active forms of hunt (*Laws*, VII, 823–24). See *St. Bernard's Sermons for the Seasons* (On the Sleep of Adam), II, 66. See also Ps 124:7, and Jer 5:26. The devil portrayed as bird trapper was common in the late fifteenth and sixteenth centuries (L. and G. Bauer, "The

*Winter Landscape with Skaters and Bird Trap* by Pieter Bruegel the Elder," 145–50). For the symbolic roles of birds in another work by Raphael—*The Miraculous Draught of Fishes*—see J. Shearman, *Raphael's Cartoons*, 54–55. In the loggia of the Villa Farnesina, the pendentive with a putto carrying Pan's pipes includes an owl attacked by small birds, a motif that here too doubtless conveys a moral significance.

118. *Tertullian's Treatises, Concerning Prayer, Concerning Baptism*, 46. J. Daniélou, *Les symboles chrétiens primitifs*, 56.

ture and art.[119] Less obvious tributes to the pope's virtues, background, and attainments can be found elsewhere in the Logge, most notably in the central bay, the seventh, where, as we shall see, the character, role, and history of Joseph are intended to be compared with Leo's. Certain scenes depicting the qualities and accomplishments of other Old Testament heroes, like David's fame as a musician, were also intended to compliment those of the pope.

## Bay 3: Noah

If we now return at last from this survey of the grotesques to the Logge vault and to the Old Testament heroes of faith, we will find that the principal themes of the first two bays and the last bay, which predicate fundamental doctrines of the Church, are reiterated in every chapter of the Logge history of salvation that lies between the beginning and the end. The third bay recounts the story of Noah (Figs. 30–35; Gn 6–9), the only bridge God preserved between obliteration of the human race and survival of the messianic line. Considered saint and prophet, an antetype as well as ancestor of Christ, whose very name, according to some, meant "rest" (that is, Sabbath),[120] Noah was one of the greatest heroes of the Old Testament. The four vault scenes of this bay depict his construction of the ark, the Deluge, the safe landing of the ark's passengers, and Noah's thanksgiving sacrifice. Together, the frescoes summarize the first of the epics of salvation, while in various ways each scene prefigures forms and tenets of the Church. Like Eve, the ark was a figure for the Church, and the first scene (Fig. 31) conveys through visual means and metaphor the concept that the Church is built by faith. Noah, bowed and isolated by his fearful responsibility, directs his sons, who busily (and perhaps blindly) construct the vehicle of their salvation. The skeleton of the ark looms over the landscape in which it is stranded, seemingly a monument to futility to all those who lacked Noah's faith. In the second fresco (Fig. 32) that faith is justified as the ark, bathed in a golden light, towers above the storm-dark waters. The Deluge is a drama of great pathos told through the most affective scenes of violence and despair. Whether selfish or selfless, the desperate figures who struggle to escape the mounting flood waters are doomed; only those admitted to the ark will survive the sea of death, just as those who pass through the ritual death of baptism will be delivered through the intercession of the Church. God's power over the blessed waters of Creation, the first element to give forth life, made the Deluge one of the earliest figures for the sacrament of baptism.[121]

This vision of cataclysmic punishment and God's sparing grace for the few is contrasted with the next scene (Fig. 33), a peaceful image of the salvation that rewards the faithful and obedient survivors, who cling to each other as they watch the animals—lions prominent among them—debark. The fourth scene (Fig. 34), in which Noah offers grateful sacrifice to God, was regarded, like so many Old Testament sacrifices, as a type for the sacrament of the Eucharist. In the monochrome fresco of the basamento (Fig. 35), God appears to Noah and points to a rainbow, sign of the covenant he establishes with Noah and his descendants.[122] This covenant is one of several depicted in the Logge, where particular emphasis is given to the pacts made between God and the messianic race, pacts that are to be replaced by the New Covenant of the Last Supper.

119. See chap. 1, pp. 21 and 24.

120. Origen, *Homélies sur la Genèse*, II, 3 (98).

121. As with virtually all of the typology and exegesis involving Old Testament heroes of the Logge Bible, the bibliographical sources for interpretations of Noah's history stretch back to the New Testament.

Among numerous useful modern studies that discuss baptismal imagery, see P. Lundberg, *La typologie baptismale dans l'ancienne église*; and H. M. Riley, *Christian Initiation*.

122. D. R. Hillers, *Covenant: The History of a Biblical Idea*, 101.

The next three bays of the Logge, bays four through six, represent the period of the patriarchs, founders of the Hebrew nation: Abraham, Isaac, and Jacob, whose twelve sons were progenitors of the twelve tribes of Israel. With the sixth bay, the placement sequence of the fresco scenes is finally firmly established: west, north, east, south, and back to the west with the basamento fresco. This pattern will be followed without deviation in all the remaining bays, although in one bay, as we shall see, the sacramental significance of two scenes takes precedence over a strictly chronological order. Possibly, some such reasoning would account for the sequential aberrations of the scenes in bays four and five, but I am tempted to theorize that the explanation may be more practical than spiritual. It seems plausible to argue that the first section of scaffolding—which by bay five would have covered one-third of the vault plus the one odd bay—was dismantled and moved when the artists reached the sixth bay. It would then have become obvious that the lack of consistency in arrangement of scenes was not only confusing but also forced on the viewer an uncomfortably erratic pattern of movement, a sensation that would have been less evident while scaffolding blocked the way and difficult to forsee when designing the vaults.

From the sixth bay on, the viewer learns to turn first to his left, toward the west wall, from which position he may see the central stucco motif of an angel bearing a Medici device and below this the first fresco history. He then rotates clockwise until he turns back to the basamento, again on the west wall. The Noah bay was arranged in this manner, as was the first bay except for the basamento, which was of course placed at the south end rather than on the west wall because the entrance door occupied the west wall. The narrative of the second bay begins in the south segment of the vault, perhaps because that was the direction where the history of the preceding bay concluded, and the narrative sequence ends normally with a basamento on the west wall.

## Bay 4: Abraham

The arrangement of the pictorial chronicle in the fourth bay (Figs. 36–43), relating the history of Abraham, "our father in faith," is especially confusing because one scene is not surely identified, and no matter which of two possible episodes it may illustrate, the sequential order of the biblical text is disrupted. This chapter begins, as is customary, at the west side, with the meeting between Abraham and Melchisedec (Fig. 37), who was king and high priest and who blesses Abraham, offering him the bread and wine that make this act of homage one of the chief Old Testament types for the Eucharist (Gn 14:17–20). Melchisedec, priest forever, was also an antetype for Christ and the pontiffs and a spiritual father of the Church. At the north side of this bay is the scene wherein the three men visit Abraham and his aged wife Sarah (Gn 18:1–15) to announce that she shall bear a son, a miracle that will perpetuate the messianic line (Fig. 38). In traditional exegesis the three visitors prefigure the Trinity, and Sarah is seen as an antetype for the Virgin, a symbol of the Church and the Heavenly Jerusalem. Sarah hides behind the half-open door, while Abraham, the man of perfect faith, kneels in recognition and acceptance.

The badly damaged fresco of God appearing to Abraham (Fig. 39), at the east side of the vault, is the source of difficulties with identification and narrative sequence. If the scene represents God's first covenant with Abraham (Gn 15), it should precede the announcement to Sarah and Abraham that she is to bear a son. If, instead, the second covenant with Abraham (Gn 22:15–18) is intended here, this scene should follow the basamento monochrome of the

sacrifice of Isaac. The confusion is aggravated by the poor condition of the fresco, which has long been exposed to the blight of humidity. At right in the fresco may be seen dimly the altar with a flame upon which the ram was sacrificed in place of Isaac. However, the Vienna codex copy of the vault (f. 32) does not include an altar. Either the codex copyist overlooked this essential feature of the second covenant with Abraham or the altar was added to the fresco in some early restoration, thus transforming an illustration of the first covenant into the later, more prophetic version. The difference in meaning between the two covenants was stressed by Origen.[123] For him, and for other theologians, the second promise, which follows the father's sacrifice of his son, clearly prophesies Christ's sacrifice and assures God's blessing to all those who belong through their faith to Abraham. God's promise to Abraham to join many nations in one patrimony was to be fulfilled by Christ.

In the south segment of the vault, opposite the visitation to Sarah and Abraham, is the flight of Lot and his family from Sodom (Fig. 40; Gn 19). The confrontation of these two events may be deliberate, for comparisons are often made in patristic literature between Abraham and his nephew Lot, a just man but not of Abraham's stature. The fact that only two angels visited Lot while a trinity of holy messengers appeared to Abraham was thought to reveal their relative standing, but more important was the contrast between Sarah and Lot's wife, who, like Eve, yielded to temptation, turned backward, and became a monument to impiety, disobedience, and the body's sinful reluctance to abandon earthly pleasures. Her salt-white figure, frozen between the fiery reds of the burning city and the strong primary hues of the garments worn by her more resolute family, reappears in stucco, forever exiled to our mortal world, on the arch between bays four and five, where she may be seen as we look south to the fresco depicting her downfall.

The basamento of the fourth bay illustrates the supreme Old Testament example of man's faith and his obedience to God's commands, the sacrifice of Isaac (Fig. 41; Gn 22). As a prefiguration of God's own sacrifice of Christ, Abraham's acceptance of the sacrifice of his son Isaac is one of the most significant events of the Old Testament. In terms of the Logge program, as in the liturgy, this scene points ahead to the sacrament established at the Last Supper.

The stucco pendentives of this bay, like those of the first two bays, contain human figures, and here too their meaning is related to the biblical narrative. Providing contrast to Abraham's saintly offering, the pendentives illustrate sacrifice and worship at pagan altars, including one to the fertility god Priapus (Fig. 42), an important deity for the fertile world of the Logge.[124] Here again, as so often in the Logge decorations, one perceives the "continuous alternation of life and death in the offerings and living sacrifices" that was described by Pico della Mirandola as characteristic of this sublunar world.[125] In this bay and in other bays, the many figures who appear to be dancing may exemplify quasi-liturgical pagan forms of *furor divinus*.[126]

## Bay 5: Isaac

The biblical history continues in the fifth bay with God renewing the covenant he had made with Noah and Abraham (Figs. 45–50). Isaac kneels in acceptance of God's command to leave

123. Origen, *Homélies sur la Genèse*, IX, 1 ff. (174 ff.).
124. F. Saxl, "Pagan Sacrifice in the Italian Renaissance," 362.
125. Giovanni Pico della Mirandola, *Heptaplus*, Second Proem, 76.
126. See A. Chastel, *Marsile Ficin et l'art*, 146.

his native land and receives the promise of a blessed future for his issue (Fig. 46; Gn 26). Isaac, the son offered in sacrifice, is again a type for Christ. His role as sacrificial offering obviously qualified him for this honor. Further evidence was found in the circumstance that Isaac carried firewood to his altar, as Christ carried the cross, and the ram that served as victim in his place was identified with the Lamb of God. Isaac's mother, Sarah, was a type for Mary and the Church, and so too was his beloved wife Rebekah, ancestress of the men of Israel and a vital link in the chain of salvation. The dark, moonlit scene of Isaac embracing Rebekah (Fig. 47; Gn 26:8), while Abimelech watches from a window, seems deliberately to recall the allegorical translation as well as the sensuous poetry of the Song of Songs. The fountain supported on dolphins, "fountain of gardens, a well of living waters" (Song 4:15), suggests the same literary source for this image of Christ embracing the Church. The fountain refers simultaneously to Rebekah, chosen when she drew water from the well, to the new wells dug by Isaac, which were interpreted to signify the New Testament and to prefigure baptism,[127] and to such New Testament parallels as Christ and the Samarian woman at the well (Jn 4:9ff., 7:38). The painting, like the poetry of the scriptural sources, may be read on many levels, from a lyrical paean of love to a detailed exegetical argument.

The pair of closely related scenes in which Isaac, now old and dim of vision, receives his sons (Gn 27) should both follow rather than flank the preceding one of nuptial bliss (Gn 26:8). In the Logge vault they are placed opposite each other so that the chronological sequence of the narrative moves from west to east, and then from north to south. Possibly some undiscovered theological point lies behind this arrangement, but it may simply have seemed, before consistency was found desirable, that the two nearly identical compositions would look better facing each other rather than side by side. In the earlier of the two scenes (Fig. 48), Jacob, at Rebekah's command, obtains his father's blessing by pretending to be his brother Esau, the first-born of these twins, who is seen approaching from the doorway. Another three of their "mother's sons bow down" (Gn 27:29) by the bedside. In the sequel to this deception, Esau returns and, laying the carcass of venison before his father, discovers that he has been displaced by his brother Jacob, who watches beside Rebekah from the background (Fig. 49). As with other Old Testament events that seem unjust to modern minds, this act of chicanery has been interpreted endlessly, both by historical and allegorical methods, which need not be examined here. For the Logge program, it is significant to note that Jacob and his future wife, Rachel, were destined to perpetuate the messianic line, while Esau, who had basely sold his birthright and would marry out of the tribe, was not elected to be one of the chosen ancestry.

The present basamento of the fifth bay is a later addition, a pastiche derived from the vault compositions of Isaac blessing his sons, which, according to the quotation (Gn 27:4) inscribed on the Bartoli print after the monochrome, should precede them in the narrative.[128] Originally, a door that offered access to the papal apartments opened into the fifth bay. Later replaced by the existing niche and basamento, this entrance perhaps provided the motive for including the double heads of Janus, Roman god of portals, among the motifs in the painted frames surrounding the fresco scenes.[129] Also included among these frame designs are animal carcasses closely resembling the venison carcass presented by Esau to his father. Many of the frame ornaments of the Logge vaults can be related to the subjects they surround. Sometimes the

127. Origen, *Homélies sur la Genèse*, x, 2 (186), XIII (218), XIV, I (219).

128. B. Davidson, "Pope Paul III's Additions to Raphael's Logge," 393–94.

129. Janus, with his Etruscan and Golden Age pedigree, was particularly eligible to guard Leo X's door. See chap. I, notes 69 and 70.

connection is as clear and direct as the tablets of the Old Law underlining the Moses scenes of the ninth bay, or the ox and ass of the Nativity and eagle of the Resurrection decorating frames of the christological scenes in the last bay. Others, such as the grapevines on top of frames of the third bay, which narrates the story of Noah, legendary discoverer of wine, are less obvious. Such attention to detail and such inventive blending of diverse iconographic traditions enriches many seemingly purely ornamental designs with deeper meanings.

Among the stucco reliefs of the fifth bay are two representing magi subduing demons. In a roundel a crowned magus, enthroned within a magic circle, points his wand at a creature flying toward him (Fig. 51). Beneath this relief is a rectangular one depicting a similar conjuration. Here the sorcerer stands in the enchanted circle, while winged devils kneel docilely beyond its border. Although neither magus is identified, these scenes of thaumaturgy derive from the ancient lore and medieval imagery that encrusted such venerated oracles as Hermes Trismegistus and Hostanes, perhaps the two represented here, or Zoroaster, who is portrayed—and identified by inscription—in a stucco scene of divination farther along, in the tenth bay (Fig. 89). These exotic wise men, some of them wholly legendary, were believed to have taught and written cryptic but penetrable prophesies of Christian truths. They held places of great respect in art and literature. The Florentine *Picture-Chronicle* includes several of them as esteemed contemporaries of Old Testament heroes and as companions to famous gods, poets, sages, and kings of profane history.[130] The "prisci theologi"—Orpheus rated high among them—were particularly attractive to Florentine philosophers who could accommodate all, from Aglaophemus to Zoroaster, within their syncretic histories. In the Logge they play a role similar to that of Orpheus or the pendentive oracles, as inspired prophets who belong to the lower, gentile world of shadows and mortality, yet who were given prescient glimpses of Christian mysteries.

## Bay 6: Jacob

Among the various Logge figures possessing the inner sight associated with sleeping or with inspired visionaries was Jacob, subject of the sixth bay (Figs. 53–58).[131] In the first scene, *Jacob's Dream* (Fig. 54; Gn 28:11 ff.), he is couched against a stone and dreaming of rainbow-robed angels who lightly mount and descend a broad staircase reaching to heaven. God appears to Jacob in his dream and affirms the covenant, blessing his seed and the land whereon he lies. Jacob turns in his sleep, his soul drawn upward to the golden vision that parts the dark clouds of night around him. Like the episode of the preceding bay, where Jacob's parents embrace in the moonlight (Fig. 47), this scene is intensely poetic, filled with the hushed, mysterious portents of impending drama. And like that earlier scene, the dream of Jacob did indeed contain many hidden portents of the future. Again, this Old Testament leader was seen as an antetype for Christ (Jn 1:51). The ascension of his soul, freed from its earthbound prison in his sleeping body, prefigured the ascension of Christ after death. The stone that pillowed Jacob, and that after waking he anointed and set up as a pillar of God's house, was interpreted as the stone of unction, the stone of Peter, the cornerstone of the Church.

The next vault fresco illustrates the meeting of Jacob and Rachel (Fig. 55), followed by Jacob

130. See notes 53 and 66 above. In addition, see the section on "Astrologia, magia e alchimia nel rinascimento fiorentino ed europeo," in the catalogue *La corte il mare i mercanti.* . . .

131. See, for example, Giovanni Pico della Mirandola, "Oration on the Dignity of Man," 229.

asking for Rachel's hand in marriage (Fig. 56). Both compositions contain particularly fine landscapes, the first based on Dürer's engravings.[132] The second is severely damaged. As with earlier nuptial scenes, going back to the meeting of Adam and Eve, this union, which was celebrated only after seven years of servitude, was believed to prefigure the union of Christ with the Church. In the fourth vault scene (Fig. 57), Jacob, riding an ass, like Christ entering Jerusalem, returns with his family to the Promised Land of Canaan. Among the caravan are three camels, beasts obviously less familiar to the artist than the ass and sheep. The camels look like stiffly stuffed toys. On the way, Jacob stops for a night that will mark a turning point in his character and life, the night of wrestling with an angel, illustrated in the basamento mono-chrome (Fig. 58). With the angel's blessing, Jacob received the new name of Israel, or "he who sees God," as it was translated by Philo, Augustine, and many others who analyzed this tale of man's struggle with spiritual forces that were almost beyond his ability to grasp.[133] The change of name introduced a new meaning and a sacred mission to Jacob's life—as the designated father and leader of the Chosen People. This divine election, so deeply significant for the history of salvation, would have held a personal meaning for any pope, whose name by tradition changed when he too was divinely appointed father and leader of the Church.

## Bay 7: Joseph

Joseph, the next subject of the Logge vault, was not only considered a type for Christ but a prototype for the Medici pope. In this central bay (Figs. 60–67), as in the beginning and end bays, the paramount themes of the decoration are drawn together to form a miraculously complex, subtle harmony. Like a great festive bowknot at the center of the Logge, this mid-point of the arcade is distinguished from the other bays by differences in the design of the more richly ornamental vault stuccoes. In place of the usual motif of a stucco angel bearing, alterna-tively, the Medici yoke or the ring with three feathers, the centerpiece is here composed of the Medici arms surmounted by the papal tiara and keys. Instead of the painted grotesques or illusionistic architectural structures that fill the corners of other vault bays, the corners here are composed entirely of brilliant white and gold stucco reliefs representing graceful maidens, garlands, columned porticos, candelabra, and other elements of the classical vocabulary. Ele-gance and firmness, chaste restraint and richness of effect combine to give dignified emphasis to this wholly compatible but special bay of the Logge. If we look back from this mid-course toward the first bay, we can see that the uppermost stucco panel on the intrados of each arch spanning the width of the Logge, and separating one bay from the next, is designed to be viewed from the center bay. If we turn next toward the north end, we observe that the uppermost panels of the succeeding arches are now reversed so that they too will be oriented toward the viewer at center and thus also frame the center bay, setting it slightly apart from all others. The center bay becomes, thereby, a halting place and a fresh commencement.

Here at the core of the Logge, symbols of the papacy and of the Medici spread out from the crowning armorial stucco to every level, both spatially and metaphorically. The flanking strips of the pilaster between the sixth and seventh bays (Fig. 59) herald the papal presence in every painted device. At the top, balanced on a Medici yoke, is an Amor holding up the ring with

132. N. Dacos, *Le Logge di Raffaello,* 176. For her discussion of landscapes in the Logge, see 77–80.

133. Philo, *On the Change of Names,* XII. St. Augus-tine, *Concerning the City of God Against the Pagans,* XVI, 39. See also Origen, *The Song of Songs,* 45, and note 79 for other references.

three feathers. Below him is the papal tiara, followed by a lively lion, laurel branches, then Pegasus—that emblem of Apollo and the muses so dear to every proud patron of the arts. Next is a pair of Apollo's swans, and finally, appearing twice in each dado strip, the papal umbrella with crossed keys. Leo X's wisdom and his patronage of learning receive acknowledgment from the central stucco figure on the intrados of the arch between bays seven and eight. If this winged, helmeted female who has shot an arrow from her bow is indeed Pallas Athena, she had been acclaimed the presiding goddess over Leo's reign from the day of his coronation procession.[134] She was the goddess associated with the month of March, the month of his election, and with the number seven, especially in Pythagorean writings.[135] In the vault of the Sala dei Pontefici, decorated toward the end of Leo's pontificate, the goddess appears again in stucco in the corners of the room, balancing lightly on her helmeted head a lofty concoction composed of various papal emblems, including Leo's name and the *palle* of his coat of arms, which inevitably were associated with Pallas. Appropriately, Leo X is entombed in the church that was built over the remains of a temple to the goddess, S. Maria sopra Minerva.

The frescoes on the pilasters framing the open east arch of the seventh bay (Figs. 66 and 67) are composed of luxuriant clusters of musical instruments suspended like trophies on ribbons from painted lion's-head bosses. The *concetto* reminds one how much Raphael owed to, as well as diverged from, the examples provided by his elders of the preceding generation. Similar pilaster motifs, including instruments hanging from ribbons, appear among Pinturicchio's decorations for the Rovere chapel in S. Maria del Popolo, Rome, but with far less vigorous illusionism. With Pegasus and the swans, these instruments and the stucco figure of Apollo playing his lyre in their midst, on the southern of the two fresco strips of the seventh bay, pay compliment yet again to Leo's musical talents.

To Ficino, all music pertained chiefly to Apollo and all musicians tended to be especially influenced by the beneficent powers of the sun;[136] for Leo X, the combined assets of Apollo were irresistibly suggestive. Among all the pagan gods, Apollo was the most nearly reverenced by Christian writers.[137] Sun god, god of the Sabbath day, god of rising light, of healing, of prophecy and inspiration, Apollo was the preferred pagan type for Christ. The identification of both with the number seven seemed to offer numerical proof of their affinity. As seventh god, Apollo, with his seven-stringed lyre, became associated by birth and other circumstances with this mystical number.[138] The feast day of the sun coincided with the day of Sabbath rest, the day of the resurrection of Christ, whose birth began the seventh age of history.[139] Numerology has always fascinated philosophers and theologians.[140] "I doubt whether anyone could adequately celebrate the properties of the number seven for they are beyond all words," says Philo,

134. A detail of the stucco is illustrated in N. Dacos, *Le Logge di Raffaello*, pl. LXXVd. As in the relief of a "Mercury" holding a bow and arrow in a pendentive of the twelfth bay, Pallas Athena shooting a bow is not the usual image of the deity and must—if it is she and not some exotic Nike type—have a special significance. See D. le Lasseur, *Les déesses armées dans l'art classique grec et leurs origines orientales*.

135. A. Chastel, *Art et humanisme à Florence*, 264. *Pitagorici testimonianze e frammenti*, II, 239. K. Seligmann, *The Mirror of Magic*, 80.

136. D. P. Walker, *Spiritual and Demonic Magic from Ficino to Campanella*, 18.

137. For Egidio da Viterbo's elaborate association of Apollo with Christ, see H. Pfeiffer, *Zur Ikonographie von Raffaels Disputa*, 190, 212–15.

138. Macrobius, *The Saturnalia*, 135. R. Flacelière, *Greek Oracles*, 39.

139. J. Daniélou, *The Bible and the Liturgy*, 228. The mysterious powers of the number seven permeate both the Old and New Testaments, as well as the writings of Hebrew, Christian, and oriental mystics. See, for example, F. A. Yates, *Giordano Bruno and the Hermetic Tradition*, 24.

140. For bibliography on numerology, see V. F. Hopper, *Medieval Number Symbolism*.

who then proceeds to many pages of words in praise of seven, which like the Sabbath, he explains, is a peaceful number, the delight of nature, chief among numbers.[141]

Augustine also succumbed to the seductions of seven, in which the Sabbath and "the perfection of the universal Church is symbolized," and about which he could say a great deal were he not "afraid of seeming to seize an occasion for showing off my trifles of knowledge, for idle effect rather than for any advantage to the reader."[142] Despite this declaration of modesty, he discusses at length, and repeatedly, the mystical properties of various numbers and the special virtues of seven. Although the architecture of the Vatican palace logge obviously had not been designed with that purpose in mind, the number seven was a highly auspicious symbol for the dignity and honor of its central bay, replete with its papal insignia. Leo X would have been quick to seize the multiple implications of the mystical number seven, numerology being a form of divination that influenced many of his decisions. His faith in its powers had earlier been commemorated on one of the arches designed for his *possesso.*[143] It would not have escaped the Logge planners either that if one began counting bays anew, from the accented pause of the central bay, the last bay would again appropriately become the seventh, illustrating the age of Christ and the second Sabbath.

The life of Joseph, subject of the seventh-bay narrative frescoes, was seen as a type for Christ's Passion but also, like the decorative motifs of the bay, made particular reference to the Medici pope. Later Medici were to find similar analogies.[144] Joseph was considered an example of the ideal statesman and bishop, spouse of the Church, like the future Joseph and his Son. Philo's allegorized Old Testament account of Joseph's life was adapted by Christian writers, who endowed him with all the highest virtues.[145] The dreams Joseph tells to his brothers in the first scene (Fig. 61; Gn 37:5–9), which hover like balloons in traditional medieval fashion,[146] predict Joseph's priestlike dominion over earth and heaven. In the second scene, the helpless blond youth, surrounded by muscular, darkly hirsute villains, is sold by his jealous brothers to strangers (Fig. 62; Gn 37:28), a transaction that was compared in exegetical literature to Christ's betrayal and to the payment made to Judas. The betrayal and exile that followed rendered Joseph's tribulations especially meaningful to Leo X, who had been compelled to flee his native Florence and who spent years traveling in unhappy exile.

The third vault scene (Fig. 63) celebrates the triumph of chastity, with Joseph racing from the clutches of Potiphar's wife, whose false accusations will condemn Joseph to prison, as Christ was falsely imprisoned. Chastity was regarded as the supreme triumph of the spirit over flesh and as a primary requisite for priesthood. In an age when virginity was more praised than practiced, Leo's purity was universally acknowledged to be one of his chief virtues, and it had been extolled on an arch made for Leo's entry into Florence.[147] In the fourth scene (Fig. 64; Gn 41:14), Joseph, brought from prison, interprets the pharaoh's dreams, illustrated by more floating bubbles, now golden rimmed. His performance is better appreciated this time. Joseph's prophetic gifts rescue him from disgrace and exalt him to a position of honor and power in Egypt. For Leo this miraculous restitution must have offered a reminder of his own capture and miraculous escape from the French after the battle of Ravenna, less than a year before he was elevated to the papacy.

141. Philo, *On the Creation,* xxx; *On Abraham,* v, and many other passages.

142. St. Augustine, *Concerning the City of God Against the Pagans,* XI, 31, XVII, 4.

143. See chap. I, p. 21.

144. See, for example, the Joseph tapestries designed for the Palazzo Vecchio, Florence (*Palazzo Vecchio: committenza e collezionismo medicei,* 52 ff.).

145. Philo, *On Joseph,* I ff. M. Schapiro, "The Joseph Scenes on the Maximianus Throne in Ravenna," 27 ff.

146. N. Dacos, *Le Logge di Raffaello,* 178.

147. See chap. I, p.25.

This fourth fresco, which occupies the south segment of the vault, is peculiar in its lighting. All other scenes in south- or north-vault segments are illuminated from the east, the direction of the natural light cast through the open arches of the Logge, which also determines the lighting of the illusionistic frames of the scenes. Frescoes on the west wall appear to receive light from the southeast, as do the east-side frescoes from the sixth bay onward. In this respect, it again seems that once the artists reached the sixth bay, they must have realized the advantages of consistency and therefore designed the remaining scenes so that as one walks along the Logge, the light side of each scene faces one. The exception is the fresco of Joseph interpreting the pharaoh's dreams (Fig. 64), which, although it should receive light from the east, instead is illumined from the west, a deviation from the normal that is surprisingly disturbing once one becomes aware of it. Given the meticulous planning of the Logge, this anomaly is unlikely to be the result of carelessness, especially in so prominent a position as the central bay.[148] Despite lack of proof, I am tempted to speculate that the lighting is conceived here as radiating from the papal presence at the heart of this bay: a supernatural aura, such as comes in Raphael's portrait of Leo X from the mystical window, which supersedes any natural source of light.

The concluding episode of the Joseph cycle, placed in the basamento (Fig. 65), depicts Joseph honored by his brothers (a prefiguration of the Adoration of the Magi)[149] and sets in motion one of the most important migrations in the history of salvation. Joseph reveals his identity to his kneeling brothers (Gn 45:1 ff.) and absolves them from guilt because God's mercy—not their treachery—sent him to Egypt in order to preserve their people. He exhorts them to return to their father, Jacob, and to bring him with all their families back to Egypt. The Israelites are thus to be preserved from famine, and the nation will be saved for Redemption.

## *Bay 8:* Moses

The prominent role of Moses in ecclesiastical history and the liturgy has been expounded through centuries of exegetical writings, from apostolic days to the present. The deliverance of the Israelites from Egypt, all of the dramatic history of Exodus, prefigured the liturgy of the Paschal week and man's Redemption through Christ. Because of this rich liturgical, sacramental, and christological typology, Moses has always received greater homage—from artists as well as writers—than any other Old Testament figure. The two bays devoted to Moses (bays 8 and 9: Figs. 68–80) in the Logge acknowledge his consequence for the history of salvation, for the institution of the Church, and for the authority of the papacy. Sixtus IV had expounded these doctrines in the Sistine Chapel; Pius IV was to present similar points in the frescoes of his Casino.[150] The ideas were not original; they derive from the New Testament and the earliest church fathers and were already illustrated in catacomb paintings, early Christian sarcophagi, and mosaic cycles. The ten scenes of the two Logge bays would appear to devote twice the attention to Moses than is accorded Christ, but such reckoning would be, from a theological viewpoint, misguided and inaccurate; the story of Moses *is* the story of Christ. The spiritual prefiguration of Christ, the Church, and the sacraments is the true story unfolded from within the coverings of the Old Testament narrative and determines both the choice and the order of

148. Sinding-Larsen once warned ("A Re-reading of the Sistine Ceiling," 144) that if a problem is attributed to the artist's carelessness "such an expedient on the part of the art historian usually means that his method is wrong."

149. G. Schiller, *Iconography of Christian Art*, I, 110.
150. L. D. Ettlinger, *The Sistine Chapel Before Michelangelo, passim* (with extensive bibliography on interpretation of the story of Moses). G. Smith, *The Casino of Pius IV,* 90 ff.

the events depicted. In one way or another, every scene relates to the deepest significance of the frescoes in the last bay of the Logge.

The first gentle scene of the infant Moses taken from the calm, shining river waters by the pharaoh's daughter (Fig. 69; Ex 2:5) illustrates a subject that is often said to prefigure the Nativity and the Adoration of the Magi. The princess is the Church who takes the child from the purifying waters or receives the Law, represented by Moses and later by Christ. When God first speaks to Moses—as illustrated in the second scene (Fig. 70)—from the bush that burns but is not consumed (Ex 3), the Lord promises to deliver the Israelites from bondage. This miracle of the burning bush was taken as a type for the Incarnation and as a promise of Redemption. The scene of the turbulent, frothy Red Sea (Fig. 71; Ex 14:15–31) is placed opposite that of the slow reflective stream that floated the infant Moses to safety. Among the Israelites clambering to the banks of the sea is one who kneels to kiss the ground and another who lifts an infant, like Moses, safely to shore in a basket. Behind the fugitives, a whirlpool of violence and destruction swirls about the commanding figure of Moses, at center, and the fiery column that penetrates the dark clouds. The scene recalls Noah's Deluge and evokes much of the same symbolic imagery of baptism and deliverance from sin and death.

Baptism is again the subject of the fourth scene (Fig. 72). In the presence of the elders (Ex 17:5–6) and beneath a ghostly image of God framed by glowing clouds, Moses strikes a silvery stream of water from the rock at Horeb. This miracle of salvation in the wilderness was a fertile source of typology and the Old Testament event most frequently represented in the catacombs.[151] The rock was seen as Christ (1 Cor 10:4) from whose side flowed the water and blood of the sacraments (1 Jn 5:6); it referred as well to St. Peter, and hence to the Church, the source of sacramental blessings. Although the miracle of the waters of Horeb could symbolize the two sacraments, baptism and the Eucharist, it appeared far more commonly as a type for baptism alone, the rite ordinarily celebrated during the liturgy before the catechumen could receive Holy Communion. For this reason, the miracle of the water is narrated and interpreted by some church fathers before the miraculous fall of manna in the desert, which actually occurs earlier in the Exodus history (Ex 16) and which was universally considered to prefigure the sacrament of the Eucharist.[152]

Psalm 78 offered the fathers hallowed precedent for this inversion of events. "The manna came after the spring of Horeb," St. Ambrose declared,[153] and St. Gregory of Nyssa in his life of Moses adheres to this same sequence, enlarging its meaning with many fuguelike repetitions of the Exodus epic.[154] Because the sacramental significance of the two scenes takes precedence over the chronological order of the text, the gathering of manna is illustrated in the basamento of this Logge bay (Fig. 73), following the vault scene of Moses striking the rock. The two frescoes prefigure the last two vault scenes of the Logge: the baptism of Christ and the institution of the Eucharist.

The *finto* bronze basamento frieze of the Israelites gathering manna, presided over by Moses and his brother Aaron, their first high priest, prefigures the sacrament of the Eucharist and,

151. R. P. C. Hanson, *Allegory and Event*, 67. For a catalogue of early representations of the miracle, see E. Becker, *Das Quellwunder des Moses in der altchristlichen Kunst*. Water, so important an element of the Moses saga, was thought to have been the source of his name (Ex 2:10; St. Ambrose, *Hexameron, Paradise, and Cain and Abel*, 6). On the presence of the elders as a sign that not only Moses but also prophets, patriarchs, and all

"ancients" herald Christ, see Origen, *Homélies sur l'Exode*, 233.

152. F.-M. Braun, "L'eau et l'Esprit," 20 ff.

153. J. Daniélou, *The Bible and the Liturgy*, 196.

154. St. Gregory of Nyssa, *La vie de Moïse*. Lactantius was another who reversed the biblical order of the water and manna miracles (*The Divine Institutes*, II, 4: 264).

with it, the institution of the New Covenant. This monochrome fresco, of pivotal significance, also leads to the subject of the ninth bay vault: the establishment of the Old Law, which is to be replaced by the New Covenant, as illustrated in the last vault scene of the Logge.

## Bay 9: Moses

If the first of the two Moses bays of the Logge offers primarily baptismal prefigurations, which then shift toward eucharistic types, the second bay (Figs. 75–80) is chiefly concerned with the covenant of the Old Law, not only as spiritual preparation for the new dispensation, but, in a somewhat legalistic vein, as a vital step toward the foundation of the Church. In each of these frescoes Moses is represented as the direct intermediary between God and the Israelites, the leader who communes with God and who transmits God's commands into the laws that shall govern his people. The precedent for papal authority is of course emphasized by this selection, as in the Sistine Chapel Mosaic cycle, even though Moses was not, strictly speaking, a priest.[155]

In the first scene—one of the most daring and dramatic compositions of the Logge (Fig. 76; Ex 24:15 ff.)—Moses kneels amidst black and gold clouds at the summit of the mountain, above his followers and high above the Israelite encampment. Transcending the restricted boundaries of the vault fresco format, the artist unfurls a virtuoso panorama of mass against space, of tumultuous lighting effects, of human and supernatural beings, all orchestrated to create, like the triumphant last chords of an overture, the anticipation of tremendous events about to burst into view on the stage. Although Moses has climbed to the pinnacle of spiritual life, he hears the voice of the holy spirit only indirectly, through angelic trumpets, and never sees God, who remains veiled behind clouds.[156] After forty days and nights on the mountain, Moses receives from God, as depicted in the fresco, the tablets of the Law.

Descending with the stones, Moses returns to his people, whom he discovers worshiping a golden calf (Ex 32:17–19). This lapse into idolatry is illustrated in the second vault scene with vivacity tempered by moralizing passages (Fig. 77). In the foreground a grizzled elder, who should know better, kneels beside a young mother who is urging her child to heresy. In the background, Moses, accompanied by Joshua, smashes the tablets of the Law. The true meaning of this scene lies less in the confrontation of the shepherd with his delinquent flock than in the relation between the two background figures. As he destroys the tablets of the Old Law, Moses looks not to the sinners, but to Joshua, his successor, whose very name was thought to be a form of Jesus and who prefigured the New Testament, in contrast to Moses, supposed author of the Old Testament Pentateuch.[157] Moses, the greatest Jewish saint and prophet, seems to foresee the covenant that is to come as he destroys the Old Covenant.

Like so many frescoes on the east side of the Logge, those most exposed to humidity, the scene of God speaking to Moses from a pillar of cloud (Fig. 78; Ex 33:8–34:3) is much deteriorated. Yet even in its diminished state, this composition is remarkable. By the shores of a sea, colorfully striped tents form a semicircular stage about the glowing column, which appears to Moses, who kneels in the shadow of the tabernacle, at a diagonal across the central

155. L. D. Ettlinger, *The Sistine Chapel Before Michelangelo*, see especially 65, 102, 104 ff., 116 ff. E. O. James, *Origins of Sacrifice*, 241.

156. The complex allegorical interpretations of Moses' ascent of the mountain go back to Scripture, to Philo, and especially to the early Greek fathers. See, for example, J. Daniélou, *Platonisme et théologie mystique: Essai sur la doctrine spirituelle de Saint Grégoire de Nysse*, 185 ff.

157. See J. Daniélou's notes to St. Gregory of Nyssa, *La vie de Moïse*, 75.

gap. The Israelites emerge from their tents to watch in awe this extraordinary dialogue, as Moses hears the Lord again assure him that his people will be set apart and will find grace in his sight. Moses is then told to return to the mountain for the two tablets that record the commandments. In the fourth vault scene, Moses presents the testimony of the Law to the Israelites (Fig. 79; Ex 34:29–32), and in contrast to the scene on the opposite side of the vault, this time he is received by his people with reverence. Perceiving a radiance about his face, they kneel in wonder, as Joshua, and perhaps Aaron, witness the solemn pact, which Joshua will ratify in the next chapter of the Logge Bible.

The frescoes of the two Moses vaults include, as we have seen, a number of the most imaginative and daring compositions of the Logge, indeed of Raphael's entire career. They parallel the expressive experiments with formal structure seen in his portrait of Leo X and the Stanza dell'Incendio. Some of the scenes were inspired by Byzantine and early Christian illustrations of the Moses history, but, as Dacos has demonstrated with similar examples, Raphael recasts each traditional model, whether antique or medieval, into a freshly experienced, eloquently expressed response to the biblical text.[158] Both the human and the Christian meanings of every scene are so intensely felt that even the most unpromising subjects, such as Moses communing with the pillar of light, are filled with dramatic excitement, achieved through mastery of the visual medium and a genuinely sympathetic understanding of and belief in the history to be recounted.

These eight vault scenes describe Moses as the supreme leader, who mediates between God and the Chosen People, who preserves them from sin and destruction by miraculous acts and gifts sent by God, who guides them on their pilgrimage from bondage toward freedom in the Promised Land, which Joshua will win for them. Through Moses the legislator, his people receive God's commandments, the institution of the priesthood, the rules of religious observance, the plan of the tabernacle: in fact, the basic codes and structure of the religion that would prevail until the Incarnation. The rewards for obedience and the punishment for disobedience to the commands God delivers through his holy and faithful representative also are stressed, especially in the basamento monochrome of the ninth bay.

This fresco (Fig. 80) was partly demolished by the insertion of a door sometime before the Vienna codex copies were made. Vasari mentions the subject and may have seen the fresco, although the door had already been cut long before the second edition of his work was published.[159] According to Vasari, the scene depicted "il fuoco che scendendo dal cielo abbrugia i figliuoli di Levi." No original study for the fresco is known. One drawing, by Girolamo da Carpi (Fig. 81), after the entire composition exists, but it is sketchy and omits some of the figures known through other copies made from the fresco fragments that were left at either side of the door.[160] These fragmentary copies include the Vienna codex, the Bartoli print (which the codex shows to be unreliable), and a drawing in Christ Church after the two fleeing figures at left.[161]

From this evidence we may choose one of two possible subjects, but since they are closely similar in meaning, it is not absolutely essential to distinguish between them. The destruction

158. N. Dacos, "Les Loges de Raphaël: Répertoire à l'antique, Bible et mythologie," 325 ff. See also the many references to Raphael's treatment of sources in her *Le Logge di Raffaello*.

159. Vasari, v, 594. The subjects of the basamenti are not named in the 1550 edition.

160. The Rosenbach Museum and Library, Philadelphia, R 133: 402 x 120 mm., pen and brown ink (N. W. Canedy, *The Roman Sketchbook of Girolamo da Carpi*, 67).

161. J. Byam Shaw, *Drawings by Old Masters at Christ Church, Oxford*, I, 123, No. 380 (0678); II, pl. 257.

of Korah (Nm 16) was a subject often illustrated—by Botticelli in the Sistine Chapel, among other places. It is a cautionary tale of the punishment dealt rebels who disobey God and his priests, an example that popes and the Church found useful to revive as a reminder now and then. In this story, hundreds are burned by the holocaust that descends when, in defiance of Moses and Aaron, the Korah faction offers a forbidden incense in its censers. An earlier account of a similar rebellion against priestly authority (Lv 10) concerns the two oldest sons of Aaron, Nabad and Abihu, who made the same mistake and were devoured by flames.[162] Since there are only two falling figures with censers in the Girolamo da Carpi sketch and no additional victims visible in the other copies, it seems possible that the latter subject was illustrated here. Vasari's mention of the sons suits this subject slightly better than the Korah tale. The fact that Aaron's own sons were the punished transgressors, "And Aaron held his peace," makes the lesson more poignant, if less spectacular, than the destruction of Korah.

## Bay 10: Joshua

Joshua, hero of the tenth bay (Figs. 82–89), has already been introduced in the preceding bay as eponymous archetype of Jesus and as symbol of the New Testament, which will succeed the Old, just as Joshua takes the place of Moses. This chapter from the Book of Joshua commences in the Logge with a scene of the Israelites crossing the Jordan to enter the Promised Land (Fig. 83; Jos 3), an event that reverberates with auguries of the future. Like the crossing of the Red Sea, the miraculous passage through the River Jordan was seen as a figure for baptism, while the Promised Land reached after this transition represented a second Sabbath, following that of Genesis, and offered a foretaste of the Paradise a Christian might attain after baptism into the Church.[163] In the fresco, the Jordan—inhabited by a helpful, blue-robed river god—rolls back in a foaming wave when the priests carrying the ark first set foot in the water. The white feathers worn by the soldiers and the white horse's mane curl like the spume of the river. Joshua is seen at far right behind the ark praying for this miracle, which also established him as the legitimate successor to Moses.

If Joshua seems inconspicuously placed in the first scene, he is scarcely visible in the second (Fig. 84). At the fall of Jericho (Jos 6), Joshua may be identified only because he again rides a white horse and follows the ark carried by priests. He points to the mighty stone-gray walls of Jericho, which crumble before him on the seventh day as the priests lead the people in a circle about the city for the seventh time. Naturally, this event too held eschatalogical implications for exegetes. It also served as an example of the efficacy of prayer, which brings victory when the sword is helpless: "By faith the walls of Jericho fell down, after they were compassed about seven days" (Heb 11:30). Three of the Joshua scenes, in fact, make a point about the force of prayer and God's ability to upset the normal course of natural events, which undoubtedly held comfort for a pope who wished to lead a crusade against the formidable Turks. After the defeat of the papal armies in 1512 at Ravenna, where Leo, then cardinal, had been taken prisoner, Egidio da Viterbo had addressed the Fifth Lateran Council, using an argument based on Joshua in favor of prayer over weapons as the true armor for the Church.[164] Leo X may have thought

162. Josephus, *Jewish Antiquities*, III, 209.

163. P. Lundberg, *La typologie baptismale dans l'ancienne église*, 146 ff. J. Daniélou, *The Bible and the Liturgy*, 229.

164. J. C. Olin, *The Catholic Reformation: Savonarola to Ignatius Loyola*, 51.

of himself as another Joshua, the humble soldier in the army of the Church, who serves God in his performance of miracles for the salvation of his people.

Joshua's victory over the Amorites (Fig. 85; Jos 10:12–14) offered an extreme proof of God's powers and favor. In the midst of battle, Joshua prayed to God to halt the sun and the moon in their course, and he did. The terrified Amorites are seen cowering beneath their shields as Joshua with outstretched arms points to a blazing sun and pale moon. Here again we are reminded that Joshua prefigures Jesus. His extended arms anticipate the Crucifixion, as does the simultaneous appearance of sun and moon in the heavens, the traditional signs by which artists depicted the darkness that descended at midday, when Christ was crucified.[165] These supreme miracles had already been announced by the creation of the sun and moon in the first Logge bay.

The distribution of lands among the tribes occupied Joshua's old age and provides the subject for the fourth vault fresco (Fig. 86). Joshua, enthroned at left, is accompanied by the priest Eleazar (Jos 17:4, 14–18), who wears vestments of pale lavender, rose, gold, and green, which in style seem more suited to a Catholic bishop (with his mitre on sideways) than to an Israelite priest. A link between the Hebrew priesthood and that of the Christians seems to be implied by the choice of this costume over more distinctively exotic vestments, such as those depicted, for example, in the wall frescoes of the Sistine Chapel. Gathered before Joshua are the descendants of Joseph, who point to the hill in the background, protesting that it is an insufficient portion for a great people blessed by the Lord. Joshua, supporting his weary head on his hand, answers their complaint with promise of great power and lands in the future. The presence of the "bishop" and the subject of territorial rights and powers suggests that the scene may refer to contemporary political struggles, but a precise parallel would be difficult to establish. It is a curious composition, uneasy with conflicting movements and unresolved tensions, which are highly expressive of the confrontation described in the text.[166]

The covenant illustrated in the basamento monochrome (Fig. 87; Jos 24) was almost as significant to the history of Israel as the tablets received by Moses on the mountain.[167] Shortly before his death, Joshua gathered all the tribes of Israel at Shechem, a mountain pass long associated with pacts and sacred covenants. On that holy site he reviewed for the Israelites their privileged history from the days of Abraham. Joshua then swore the tribes to a formal covenant with God, thus confirming the tradition of periodic renewal of that ancient covenant between God and the Chosen People. As we have seen, the Logge program repeatedly emphasizes these covenants and the legitimacy they afforded the Judeo-Christian foundations of the Church. Indeed, the symmetrical tedium of the frieze *al antico* in this basamento composition suggests the dry, set formulas of a legal document.

The triumphant return of the Israelites to the Promised Land is celebrated by stucco Victories, or angels, in the pendentives of this bay (Fig. 88). In rushing flight, toe poised on a globe, the winged figures sound trumpets or flourish victory wreaths, palms, or *palle*. A cleverly designed perspective roofs the figures of the north and south arches with a *trompe l'oeil* stucco coffering. Among the other stuccoes of this bay is one mentioned earlier in connection with the two magi on the pilaster between bays four and five (Fig. 89): Zoroaster, who is identified by inscription. Most renowned of the ancient magi, Zoroaster had been included among the philosophers of the School of Athens in the Stanza della Segnatura.[168] The stucco portrays him

165. St. Gregory of Nyssa, *La vie de Moïse*, 76. See also notes 38 and 39 above.

166. Unusual features of the design of this vault are mentioned in chap. 2, p. 36.

167. D. R. Hillers, *Covenant: The History of a Biblical Idea*, 47. H. Swanston, *The Kings and the Covenant*, 1.

168. Vasari, IV, 332.

seated before an altar, evidently summoning with a serpent-encircled wand two hovering birds. A skull burns in the flames on the altar. Prophecy (by interpreting the behavior of birds) and perhaps medicine (making use of human bones for therapeutic treatment),[169] both recurring themes of the Logge, are here traced to their origins in Zoroaster, believed by many to have been the earliest of the ancient gentile prophets.[170] By placing him in the bay where Joshua halts the sun and the moon—probably the most stunning miracle of the Old Testament—a contrast may be implied with the lesser powers of gentile gods and their magic.

## Bay 11: David

At the eleventh bay (Figs. 90–96), we enter the period of monarchy and of the royal messianic line that will grow from David, king and musician, lion of Judah, and antetype for the promised deliverer who is to descend from the house of David. David, as the musician who composed the Psalms, prophesies the triumph of Christ, described as "a priest for ever after the order of Melchisedec" (Ps 110), and the events of his own career were seen as prefigurations of Christ's triumphs. In the first scene of the vault (Fig. 91), David the Good Shepherd is anointed by Samuel, "and the Spirit of the Lord came upon David from that day forward" (1 Sm 16:13). As in the opening act of the following chapter, where Solomon is anointed, the Anointed One signified the Messiah in the language of the prophets, and the rite of unction itself was related both historically and symbolically with baptism and confirmation.[171] The very words describing David's state of grace after anointment are echoed in the accounts of Christ's baptism, just as the pose of the figures suggests that sacrament.

Young David's triumph over the giant Goliath (Fig. 92; 1 Sm 17:49–51), a victory that delivers the Israelites from the Philistines, was interpreted as an augury for Redemption and Christ's victory over Satan and death.[172] His marriage with Bathsheba was yet another nuptial prefiguration of Christ's union with the Church. The third vault scene, when David spies Bathsheba bathing (Fig. 93; 2 Sm 11), is as willful in its extraordinary composition as is the Christian interpretation of its significance. David, just risen from an afternoon nap while his armies march off to war, stares down in excitement at the wife of Uriah the Hittite. On her terrace, a water basin beside her, Bathsheba combs out her long hair. Vulnerable, unaware, yet provocative, Bathsheba is the age-old image of feminine allure: another Eve, another Venus.

The two protagonists, David and Bathsheba, are divided by the faceless ranks of armed warriors, whose threatening aspect is echoed by the carved reliefs of a combat and a disturbingly headless frieze that fence Bathsheba's terrace. This tense melodrama of sex and violence brilliantly captures the flavor of the Old Testament narrative. Determined exegetes, such as St. Augustine, were able to see in this scriptural tale a parable of Christ, the Church, and Satan.[173] Undoubtedly, Leo X and his contemporaries were perfectly familiar with the equation, which would not have prevented their enjoyment of the more down-to-earth, universal themes portrayed by the artist with such inspired originality and understanding.

169. N. Dacos, *Le Logge di Raffaello,* 289.

170. K. H. Dannenfeldt, "The Pseudo-Zoroastrian Oracles in the Renaissance," 7 ff. F. A. Yates, *Giordano Bruno and the Hermetic Tradition,* 18. Zoroaster was said to have been a contemporary of Noah (see, for instance, Annius of Viterbo, *Le antichita di Beroso Caldeo sacerdote . . . ,* 9v).

171. Among the many analyses of this ceremony and its significance, see E. O. James, *Origins of Sacrifice,* 154 ff., and *Christian Myth and Ritual,* 100 ff.; L. L. Mitchell, *Baptismal Anointing,* 23 (on David and other kings); and J. Daniélou, *The Bible and the Liturgy,* 114 ff.

172. A. N. Didron, *Christian Iconography,* II, 199.

173. A. G. Hebert, *The Throne of David,* 35.

The fourth vault scene, which describes the old king's triumphant return to Jerusalem after victory over the Ammonites (Fig. 94; 2 Sm 12:30–31), is usually confused with earlier triumphs of David's youth. Both the biblical description of the march and the narrative order of scenes in the vault point to the later occasion. As we have seen, this triumphant procession, in which the gray-bearded king rides his golden chariot, hides playful allusions to legends of musical contests and implies the supremacy of the biblical musician over pagan performers.[174]

In the basamento fresco, David secures the continuity of the royal messianic line with the promise to Bathsheba that their son Solomon will rule (Fig. 95; 1 Kgs 1:30 ff.). She kneels before the dying king, while behind her Zadok the priest, Nathan the prophet, and Benaiah, chief of the king's guard, witness his commands. At the far right a figure, probably the usurper Adonijah, seems to slink from the steps of the throne. David's choice of Solomon, "the beloved of God," and his charges to him are amplified in 1 Chr 28–29. Before his death, David confesses that because he has been a soldier and has shed blood, God did not permit him to construct a house for the ark of the covenant, but Solomon is to build this house, using his father's treasure and following his detailed plans.

## Bay 12: Solomon

The last Old Testament bay of the Logge relates the history of David's son Solomon (Figs. 97–108). According to popular etymology, Solomon's name meant "peacemaker,"[175] and because he was also rich and wise and built the Lord's temple, Solomon was much favored as a model and type for princes, both secular and ecclesiastical.[176] Leo X was often compared to Solomon, and the temple was equated not only with Ecclesia and the Heavenly Jerusalem but also with St. Peter's.[177] As in the preceding chapter, this vault begins with an anointing (1 Kgs 1:39), when Zadok the priest pours a horn of oil upon Solomon while the people rejoice and a river god looks on, "keeping the usual posture of resting on his elbow (since it is not customary for a river to stand erect)."[178] The composition as well as the iconography of this scene not only allude back to David, but ahead to the baptism of Christ.

The subject of the second fresco, the Judgment of Solomon (Fig. 99; 1 Kgs 3:16–28), was a perennial favorite, and with reason. The tale contains all the elements of the perfect fable: touching human drama, suspense, a frightening crisis, a clever resolution, and a satisfying conclusion wherein justice triumphs. Solomon emerges from the incident covered with glory in the eyes of Israel, "for they saw that the wisdom of God was in him." Solomon the wise ruler is followed by Solomon the devout builder of the house of the Lord (Fig. 100; 1 Kgs 6). This fresco is painted in the east vault segment and like so many others on the outer wall, it has suffered badly from humidity. Today, the scene is barely legible, but to judge from the Vienna codex copy it could never have been as impressive as the earlier, typologically related composition of Noah building the ark. Possibly the greater allegorical complexity of Solomon's construction of the temple, which refers no doubt to Leo X and St. Peter's as well as to biblical

174. See p. 65.

175. St. Augustine, *Concerning the City of God Against the Pagans*, XVII, 8.

176. Vasari (VII, 709–10) later compares Duke Cosimo de' Medici to Solomon for being a Catholic prince dedicated to restoring and building churches.

177. J. W. O'Malley, "Giles of Viterbo: A Reformer's Thought on Renaissance Rome," 10, and *Giles of Viterbo on Church and Reform*, 125. J. Shearman, *Raphael's Cartoons*, 17, 20. N. Dacos, *Le Logge di Raffaello*, 64–65.

178. Philostratus, *Imagines*, II, 14.

temples, affected the design of this fresco, as did perhaps developments in Raphael's style and the varying abilities of the Logge executants.

In the fourth scene of the vault (Fig. 101; 1 Kgs 10), King Solomon collects rewards for the virtues displayed in the preceding scenes. The Queen of Sheba, having "seen all Solomon's wisdom, and the house that he had built," pays him homage, along with a great deal of gold and other valuable tribute, which may be seen trailing behind her in the fresco as she dashes up the steps of the throne. For obvious reasons, this incident of an exotic ruler who travels in search of wisdom and acknowledges the supremacy of a holier prince prefigured the journey of the magi. The meeting also served as yet another type for the marriage of Christ to the Church.[179] Solomon is portrayed successively in these four scenes as the anointed one, the wise ruler, the pious builder, and the antetype of Christ, who receives homage from the princes of the world. Solomon serves then both as a model for, or of, the pope and as a transition to the last bay, when the true Messiah will take his place.

In spite of their potentially stirring subjects, however, the histories narrated in the twelfth bay fail to move the viewer. The blame seems to lie chiefly with the inferior talent of the executants of this vault. True, the composition of Solomon building the temple does seem basically flawed and strained, an ill-favored offspring perhaps of the Incendio di Borgo, but the other scenes, were they not enacted by such stiff and unconvincing casts, hold unfulfilled possibilities. It is not the purpose of this study to discuss attributions, nor does it seem sensible to attempt to trace any stylistic development within the Logge itself or in relation to other works by Raphael of approximately the same period. Not only do we lack any precise documentation for a chronology of the Logge decoration beyond a probable terminal date in the late spring of 1519, but given the scope of the project and the number of persons involved, any tidy, abstract theory of evolution can only be misleading. Personalities, the weather, delivery of supplies, on-site experience, all the haphazard accidents of everyday life tend to make nonsense of schematic ideas about artistic development in the execution of such a large project.

While the odds are strong that the Solomon compositions were designed after the Creation scenes, it is unwise to assume that Raphael invented and drew all sixty-four scenes of the Logge in neat chronological sequence or that these studies never were reworked as the decoration progressed, although because of the practical factor of scaffolding, the vaults of the bays probably were executed in fairly consistent sequence. If the Solomon stories disappoint, it is unlikely that the problem lay with any diminution in Raphael's interest or in his powers of invention and emotion; more probably, this may be blamed on looser supervision, owing to the mounting pressure of his commitments and the addition of less-skilled assistants in an attempt to speed completion of the project.

The basamento of this bay was still intact at the time the Vienna codex copies were made (Fig. 102; f. 90). The fate of the fresco after that mid-century point is uncertain. No door opening to the twelfth bay is indicated on the plan of 1560/61, drawn by Pirro Ligorio, but this plan is not sufficiently accurate to provide reliable evidence.[180] A doorway does appear on a plan attributed to Mascarino, probably datable after 1578, when Mascarino began work in the Vatican palace.[181] Presumably, the basamento was largely destroyed before or shortly after that

179. For legends and Christian interpretations of the Queen of Sheba's visit to King Solomon, see A. Chastel, *Fables, formes, figures*, I, 53 ff.

180. Rome, Istituto d'archeologia e storia dell'arte. Illustrated in J. S. Ackerman, *The Cortile del Belvedere*, fig. 31.

181. Rome, Accademia di S. Luca, 2482. Illustrated in J. Wasserman, *Ottaviano Mascarino and His Drawings in the Accademia Nazionale di San Luca*, fig. 125.

date. Bartoli does not, in fact, include the fresco among his engraved copies made in the next century from the Logge monochromes. However, he did engrave the identical composition (Fig. 103) in the midst of another, miscellaneous group of fifteen copies after Raphael or Raphael school designs, and he identifies the subject as Joseph brought from prison before the pharaoh (Gn 41).

Now, all this apparently contradictory evidence is most perplexing. If the basamento had been penetrated by a doorway before Mascarino drew his plan, what was Bartoli copying? The fresco had not been removed from the wall and preserved elsewhere, for shadowy figures of the monochrome may still be seen *in situ* to the left of the door. The most reasonable explanation is that Bartoli made his print from a copy drawn or painted after the fresco but which by the seventeenth century was no longer correctly identified according either to subject or to original location. It is also possible, though less likely, that Bartoli based his engraving on a study for the basamento or on a copy of such a study.[182] Curiously, more drawings after this composition have survived than are associated with any other of the monochrome scenes, but these drawings have one detail in common that was ultimately eliminated in the fresco and does not appear in Bartoli's engraving: a vase standing at right on a step of the throne.

Obviously, Bartoli was mistaken in the identification of the subject. A basamento in King Solomon's bay would not return to the history of Joseph, narrated five bays earlier, for its plot. Not even the liturgy or a prefiguration of one of the New Testament subjects offers any reasonable excuse for Bartoli's title. The story, which might derive from any part of the Scripture between Sheba's visit to Solomon and the Incarnation, remains uncertain. Not enough clues are presented by the scene to enable one to determine securely its source or meaning, and no events from Solomon's own history seem applicable. The basamento as recorded in the various copies depicts a traveler, to judge from his staff,[183] kneeling before an enthroned king, while nine standing men react with surprise or consternation to the dialogue between the two central figures. The supplicant may be announcing unwelcome news to the king, who seems to shrink from him. However, the king's pose is virtually identical to that of Solomon issuing a command in the judgment scene of the vault above. In that fresco the recoiling posture conveys Solomon's understandable last-minute doubt about the wisdom of his stratagem and a horror of the possible consequences. To determine the precise sense of the actions in the basamento, one would need greater confidence in the copyists' abilities to depict complex emotions.

Any number of subjects suitable to the Logge program might be proposed for the last basamento before the New Testament bay, but the most plausible candidate would seem to be the story that follows in close chronological sequence after the last scene of the Solomon vault: Jeroboam kneeling before Solomon's son and successor, Rehoboam (Fig. 102; 1 Kgs 12:1–4).[184] Jeroboam, who has come from Egypt (hence a staff is appropriate), tells the king, "Thy father

182. N. Dacos, *Le Logge di Raffaello,* 301. In addition to providing a catalogue of these drawings, Dacos discusses the various subjects proposed as titles for the scene, none of which is convincing.

183. Such pilgrim staffs—as distinct from shepherds' crooks—are used in the Logge scenes to identify travelers, as in God appearing to Isaac, Jacob's Dream, the Adoration of the Golden Calf, Moses presenting the tablets of the law to the Israelites.

184. The subject, rarely illustrated, may be found in

*La Bibbia di Borso d'Este,* I, f. 183r; a drawing by Holbein in Basel, illustrating the response of Rehoboam (P. Ganz, *Hans Holbein: Die Gemälde,* No. 172, fig. 50); a sixteenth-century tapestry in Vienna, Inv. Nr. LXXVII/6 (E. Ritter von Birk, "Inventar der im Besitze des Allerhöchsten Kaiserhauses befindlichen Niederländer Tapeten und Gobelins," 188–89). I am grateful to Dr. Rotraud Bauer, Kunsthistorisches Museum, Vienna, for supplying reproductions of this tapestry series.

made our yoke grievous: now therefore make thou the grievous service of thy father, and his heavy yoke which he put upon us, lighter, and we will serve thee." This reference to a rule characterized by a lighter yoke might have been chosen for two reasons. The passage may be interpreted to allude to the easy yoke of Christ's reign (Mt 11:30), which would replace the heavy yoke of the Old Law and which will be celebrated in the frescoes of the next bay. In addition, this light yoke refers simultaneously to Leo X's family impresa, the yoke with the motto SUAVE, derived from the same Gospel passage, which crowns the last vault of the Logge. The ten men, including Jeroboam, who flank the enthroned king would represent the division of Israel into ten tribes after the death of Solomon. From this basamento the Logge chronicle leaps, as do apostolic sermons and histories, over events following Solomon's reign directly to the new age of the Messiah, and probably for similar reasons; in that period following the Babylonian captivity, no further covenants were made between God and Israel.[185]

## Bay 13: Christ

The last chapter of the Logge (Figs. 109–14) brings to consummation the themes of the history of salvation, yet itself, in eschatalogical terms, is only a midpoint of that history. Like a fountain, this climax of gathering streams feeds upon itself, the old sources merging with the new, the waters rising and falling to provide fresh nourishment. The end is the beginning, and in the beginning was the Word. The Old Testament had secreted the promise of Christ and the sacramental blessings that God would someday bestow on the elect. In the New Testament bay of the Logge, the prophecies of the Old Testament and of the pagan oracles approach fruition with the expectation of eternal rest in Christ. The true seventh day is Christianity, and the long line of covenants that began on the seventh day of Creation are ratified in the sacraments, which extend to the present the entire history of God's miracles and themselves prefigure the eternal Sabbath. Every hero and each story from the epic past narrated in the Logge frescoes leads directly, often in minute detail, to the divinely ordained triumph of Christianity proclaimed in the thirteenth bay. The Christian who has walked through the chapters of this Bible, who has interpreted and learned its lessons, arrives at the entrance to the pope's presence with renewed understanding that only through the Church may he partake in the Sabbath of Christ's Resurrection.

The four vault scenes of the last bay depict the Adoration of the Shepherds, the Adoration of the Kings, the Baptism of Christ, and the Lord's Supper, while the last scene of the basamento illustrates the Resurrection. The Christian meanings of the five events overlap, echo from side to side and back and forth, in tightly designed resonance. Even in its damaged condition, *The Adoration of the Shepherds* (Fig. 110; Lk 2) is an enchanted vision of Christ's first manifestation: the Child who appears to the shepherds.[186] The hushed, rapt mood of this scene, so delicately and swiftly brushed, is magically illumined with pearly strokes of moonlight. Angels bearing garlands of roses flutter above the Child, who is seated upon a linen cloth draped over a block of stone: table, altar, and cornerstone of the Church. Mother and Child, bathed in a different, miraculous light, gently reach toward each other, oblivious of the worshipful attendants who draw back in the course of their forward rush. One shepherd brings a lamb; another kneeling at

185. P. S. Minear, *Images of the Church in the New Testament,* 106–7.

186. On the subject of the Incarnation as it was interpreted by orators of the papal courts in the Renaissance, see J. W. O'Malley, *Praise and Blame in Renaissance Rome,* 138 ff.

the opposite side holds a crook. Between and behind the Child and his Mother appears the head of an ox, which, like the shepherds, represents the Jews, while the ass, seen behind Mary, signifies the Gentiles who have not yet arrived on their journey to acknowledge Christ's rule.[187]

Christ's second manifestation (Fig. 111; Mt 2:9–11), illustrated at the north end of the Logge, is again set in a rustic shelter, this time incorporating the heavy cornice of some classical edifice, perhaps Davidian ruins, projecting at left. Mary, with the Child enthroned on her knee, is seated upon a dais of rock. As the cortege curls around the stable door, the figures begin to kneel, and the foremost king kisses the foot of the King of Kings. Standing at left, with one foot on the rock, Joseph somewhat suspiciously inspects the gold contained in the first gift.[188] The gift of gold, the noblest of metals, a gift for kings, acknowledges Christ's royal rank. The incense proffered by the next magus is a symbol of prayer and a tribute to his divinity. The third gift, myrrh, a fragrant ointment used in embalming, testifies to Christ's humanity. Again the nuptial theme is sounded, as the "wise men run with gifts to the royal marriage," when "the Church is united to her heavenly Bridegroom."[189] These presents and the obedience offered by the kings established the supremacy of Christ over temporal rulers and completed the cornerstone of the Church, which was formed of two walls, Jews and Gentiles.[190]

Closely linked to the second of these two manifestations of Christ's divinity is the third, which also prefigures the first of the two major sacraments of the Church: baptism (Fig. 112).[191] "On the thirteenth day the boy Jesus manifested Himself to the gentiles, that is to the Magi, who were pagan," wrote a medieval Italian monk on Epiphany:[192] "Today He appears to the gentiles, or pagans, and this is the Church of the elect. . . . The Church is today wedded to Him, and truly united by Baptism, which he received on the same day when he was twenty-nine years old. Thus we sing joyfully, 'Today the Church is joined to the celestial Bridegroom.' Through baptism, souls are wedded to Christ, who received virtue through His Baptism."

The nuptial themes of the Old Testament and the innumerable types for baptism—so many of them illustrated in the Logge—explain and authorize this sacrament, which initiates the Paschal mystery and enables the new Christian to participate through the destructive and purifying waters in the death and rebirth of Christ. Christ was baptized not, of course, to cleanse him of sin, but as a sign of messianic investiture—an anointing as the Son of God through the Holy Spirit—and to provide an example for the Christian sacrament, the new birth. The Logge Baptism of Christ is placed opposite the Nativity, to which compositionally, as well as teleologically, it relates. Raphael's vision of Christ's baptism does not illustrate any

187. For the iconography of the ox and ass in Nativity scenes, see F. Klingender, *Animals in Art and Thought to the End of the Middle Ages*, 444–45.

188. The eighteenth-century traveler Charles de Montesquieu, generally enthusiastic about the Logge ("Ce n'est point de la peinture; c'est la nature même . . . ," *Voyages de Montesquieu*, 239), observed that "Raphaël a fait peu d'honneur à Joseph en le représentant recevant les présants de Mages et y regardant pour voir ce qu'on lui donne" (259). The motif of Joseph checking the contributions in his role of family guardian is not uncommon and sometimes is treated comically, as Joseph often was in medieval art. See L. Réau, *Iconographie de l'art chrétien*, II, 2, 247; III, 2, 753.

189. From the Antiphon for the Benedictus on the Feast of the Epiphany (J. Daniélou, *The Bible and the Liturgy*, 221).

190. St. Augustine, *Concerning the City of God Against the Pagans*, XVIII, 28 (based on Eph 2:14 ff.). The Proper for Epiphany describes the meaning of the kings' gifts (M. Britt, *The Hymns of the Breviary and Missal*, 100).

191. The meaning of Epiphany and its association with baptism was a controversial subject to the early theologians. See, for example, St. Leo the Great (*Letters*, 68 ff., 74), who distinguishes between the historic event of Christ's baptism and the sacrament. See also T. E. Mommsen, "Aponius and Orosius on the Significance of the Epiphany," 96–111, and many other authorities who write on liturgy or on baptism in particular (such as K. A. H. Kellner, *L'anno ecclesiastico e le feste dei santi nel loro svolgimento storico*, 153 ff.).

192. *Meditations on the Life of Christ, An Illustrated Manuscript of the Fourteenth Century*, 45 ff.

specific one of the Gospel accounts, but it comes closest in spirit to John (1:29–34). An aureate burst of light dispels the evening dusk on the banks of the Jordan. Rays stream from the invisible Holy Spirit, and the river's surface seems to glow. The silhouetted arcs of figures and outstretched arms move in waves toward the bowed head of Christ as he is baptized and anointed the beloved Son. Behind Christ, the first catechumens strip off their clothing, the garments of sin, in preparation for their own baptism. At right kneel the angel deacons, their hands veiled as a sign of respect.[193]

In the Nativity, the Virgin and Child occupy the center of the composition while the attendant figures draw back, creating for that brief moment a reverential distance that frames the two with space. In the Baptism of Christ, the inverse of this arrangement establishes a void at center, which is spanned like an electric charge by the miraculous act of baptism. The two compositions, both brilliantly planned and executed, form pendants that illustrate two aspects of Christian birth. The nocturnal settings and the extraordinary importance of their lighting recall the ceremonies for Holy Saturday, as do the themes of birth, baptism, and the approaching consummation of the history of salvation on the Easter Sabbath. In the liturgy for Holy Saturday, this history is reviewed, and the prophecies are traced from the beginnings of Creation in Genesis down the long, eventful route narrated by the Logge Bible scenes. The last bay of the Logge offers a visual parallel for the liturgy of the last days of Passion week; instead of an illustrated story of the Gospels, the scenes present the mysteries of the Proper of Time, which themselves invite the worshiper to experience once again the history of salvation. The liturgy, like the New Testament and the Logge Bible, refers constantly, often simultaneously, backward and forward.

The scene of baptism reflects back to the Nativity and the Adoration of the Kings and at the same time is paired with the subject of the last vault fresco of the Logge. These two scenes summarize Christian initiation to the mysteries of the Church, stages in a single process of participation in the death and Resurrection of Christ: "This is he that came by water and blood, even Jesus Christ; not by water only, but by water and blood. And it is the Spirit that beareth witness, because the spirit is truth. . . . And there are three that bear witness in earth, the spirit, and the water, and the blood: and these three agree in one" (1 Jn 5:6, 8). Together, the two sacraments represent the Church: as institution, as living history, as the prophesied fulfillment of all earlier religious aspirations, both pagan and Hebrew.

Like the sacrament of baptism, numerous Old Testament types, signs, and predictions heralded the ultimate sacrifice and offered evidence of God's intentions, which might be traced back to the beginning. From the fresco of the Lord's Supper in the south segment of the vault (Fig. 113), we do indeed face back toward the entire passage of history preceding the seventh age, the age of Christ, and are invited to recall, as in the liturgy, the many signposts observed along the way, which at the time may have seemed incomprehensible but now stand revealed. In the fresco of the Lord's Supper and throughout the Logge (most specifically in the many scenes of sacrifice), praise and thanksgiving for God's creations and for his redeeming grace are stressed. It is not the suffering of the Crucifixion, but the thanksgiving commemoration of that sacrifice—the Eucharist—that is represented in the Logge.[194] From earliest times, the Eucharist—the perpetual memorial of Christ's life-giving sacrifice, the "medicine of

193. The presence of angel deacons at baptism has a long history and suggests associations with Christ's Passion. See J. Daniélou, *The Bible and the Liturgy*, 132, 211–12.

194. A similar emphasis is found in the Sistine Chapel and in Vatican oratory (L. D. Ettlinger, *The Sistine Chapel Before Michelangelo*, 83; and J. W. O'Malley, *Praise and Blame in Renaissance Rome*, 138, 140).

immortality,"[195] which was observed on the Sabbath—celebrated the central mystery of the Church. It is this mystery that is illustrated in the last scene of the last vault of the Logge, in preference to a dramatic narrative based on one or another of the Gospel accounts.

Unlike most Renaissance paintings of the Last Supper, the scene in the Logge describes the appearance of the participants and their reactions to the event in minimal terms.[196] The apostles and their responses to Christ's words are barely individualized. Several figures are hidden or masked in shadow. Even Judas can be recognized only by his usual post at right front of the table and by a few telling clues. Judas is the only apostle to turn away from his companions. While rising to leave, he removes from the table his left hand, which has betrayed his treachery and which seems to reject the bread. Christ, red-robed, a blaze of golden light about his head and his lips parted in speech, no longer shares the meal. His hands are hidden and touch neither bread nor wine, which he declares he will not consume until the kingdom of God shall come.[197] He has announced that the bread and wine are his body and blood, to be taken in remembrance of him, and the wine that is his blood is the New Covenant. The meaning of the scene, then, is the establishment of the New Covenant, presented in as nearly abstract a form as possible while yet suggesting the historical occasion described by the biblical texts. The linen-covered table represents the altar and the sacrifice.[198] The Host of this table-altar is the new tabernacle, the Church of the Christian community, which will be brought together in Christ's death and Resurrection.[199] Priesthood, the Mass, and the sacrament are founded upon these words and acts.

Offered by Christ with this sacrifice was the promise of peace: "Peace I leave you. My peace I give you," a favorite and much-quoted testament from the Gospel of St. John.[200] Peace meant to Leo X and to his contemporaries—who hailed him in verse, pageant, and art as peacemaker—freedom from war, especially war with the Turks, but it referred primarily to the peace to be found in the Sabbath of the Resurrection. The final scene of the Logge Bible is the Resurrection, illustrated in the basamento (Fig. 114). As the three Maries approach from the right, Christ steps from the tomb, scattering the soldiers at left into scrambled flight. He rises after burial, as will all righteous Christians on the day of Judgment, to join him in the peace of perpetual Sabbath: "Come unto me, all ye that labor and are heavy laden, and I will give you rest. Take my yoke upon you, and learn of me; for I am meek and lowly in heart: and ye shall find rest unto your souls. For my yoke is easy, and my burden is light" (*Iugum meum suave est,* Mt 11:28–30). At the center of the vault overhead, a stucco angel bears the yoke that, together with the motto SUAVE, was the impresa of Leo X.[201] Centered in the painted frieze beneath each of the New Testament scenes of the vault is the emblem of the Resurrection and of St. John: the eagle.

195. St. Ignatius of Antioch. See J. Daniélou, in St. Gregory of Nyssa, *From Glory to Glory,* 22.

196. In its abstraction the Logge Lord's Supper differs strongly from the most famous representation of the event, although Leonardo also rejects a literal illustration of any single moment or passage from the Gospels. See L. Steinberg, "Leonardo's *Last Supper,*" 297 ff.

197. J. Jeremias, *The Eucharistic Words of Jesus,* 208 ff.

198. For an early explanation of this symbolism, see the *Commentary of Theodore of Mopsuestia on the Lord's Prayer and on the Sacraments of Baptism and the Eucharist,* 86.

199. P. S. Minear, *Images of the Church in the New Testament,* 37.

200. J. W. O'Malley, *Praise and Blame in Renaissance Rome,* 229, and his "The Discovery of America and Reform Thought at the Papal Court in the Early Cinquecento," 190.

201. On the yoke impresa of the Medici family, particularly favored by Leo X, see J. Shearman, *Raphael's Cartoons,* 88–89; R. Quednau, *Die Sala di Costantino im Vatikanische Palast,* 25, 76 ff., 230; and M. Perry, " 'Candor Illaesus': The 'Impresa' of Clement VII and other Medici Devices in the Vatican Stanze," 683.

From the Sabbath of Creation to the eternal Sabbath offered through the fulfillment of history in the last bay, the Christian who travels the length of the Logge would have learned many lessons from the past. As described by St. Augustine, the intention of the Scriptures "was to arrive at Abraham through the clearly defined succession of generations descended from one man; and then to pass from the line of Abraham to the people of God, which was kept distinct from all other nations and in which was prefigured and foretold all things which were foreseen, by inspiration of the Spirit, as destined to come."[202] This sacred history is summarized in the Epistle to the Hebrews, which provided the planners of the Logge—as well as theologians throughout the centuries—with a concise outline of the history of salvation, interpreted according to orthodox Christian belief. The letter, written to an unidentified community of Hebrew Christians, possibly in Rome, argues that the Old Testament Sabbaths, priests, sacrifices, covenants, and tabernacles were mere shadows, impermanent and imperfect figures of Christ, who is the perfect and eternal rest, the priest, sacrifice, testament, and temple: the first sinless Son of God.

In the letter the writer explains that neither Moses nor Joshua had brought their exiled people to the true resting place, which could be entered only in Christ. Old Testament priests of the Levitical line, those of the Hebrew tradition, have been rejected, he claims, in favor of the order of Melchisedec, the priest forever, king of righteousness and peace. In the eleventh chapter the letter writer summarizes the great things accomplished by that "cloud of witnesses," the Hebrew heroes of faith. His history embraces all of the heroes of the Logge, omitting only Solomon and his son, and adds to their number only Enoch and Rahab, the harlot spared by Joshua, although he concludes by merely naming others, including David, "for the time would fail me" to tell of all their acts of faith. But none of these Hebrew leaders was perfect, insists the writer to the Hebrews. None had been able to lead his people to the City of God. Christ, who was perfect, completed this unfulfilled mission. He assumed the flesh and blood of God's children in order to deliver them from fear of death and the bondage of this world. Through Christ they would enter at last into the Heavenly Jerusalem and join the company of angels. In the Logge, as in Scripture, the pilgrim crossing from the Old to the New Testament might escape this earthly imprisonment, might through Christ's loving sacrifice pass from *timor* to *amor*.[203]

A number of the stuccoes in the last two bays of the Logge seem in fact to illustrate pagan varieties of that love, which achieves perfect expression in the New Testament frescoes of the last bay. It is possible that the pendentive stuccoes of the twelfth bay (Figs. 104–8) are intended to exemplify pagan love, morality, and worship, which are contrasted with their pure and eternal forms brought with the age of Christ, whose reign commences in the next bay. Like the pendentives of the first bay, these subjects, one suspects, are drawn from literary sources, probably Neoplatonic in tenor, which have yet to be identified. Again, like those of the first bay, the twelfth bay pendentives house an odd group of characters, all of them mysterious in their meaning. Some are familiar personages, well known to classical literature and Renaissance philosophy, but as a group they cannot yet be marshaled into a coherent argument. The svelte androgynous creature in the north arch (Fig. 107) is associated in many cosmogonies, as we saw earlier, with the initial procreation of the human race. In pagan mythology Hermaphrodite was the child of Mercury and Venus, gifted with prophetic powers but also personifying unnatural lust (hence the possible presence of a fig tree in the background).

202. St. Augustine, *Concerning the City of God Against the Pagans*, XV, 8.

203. St. Augustine, *Contra Adimantum*, III, lines 27–28.

These allusions to creation, prophecy, and love, all themes important to the Logge, are suggestive but inconclusive. Jupiter and Ganymede (Fig. 105), above the east arch, could illustrate either carnal lust or spiritual love, depending on any given writer's bent. In another relief (Fig. 108), a youth wearing Mercury's winged helmet has not been given fleet Mercury's winged heels. Moreover, instead of the caduceus, he holds a bow and arrow, hardly standard equipment for this god.[204] Conceivably, some reference is intended here by the empty bow and the arrow clutched close against his body to the Platonic arrow of blind passion and the harmony of the bow, a *paragone* similar to that made between pipes and lyre.[205] But without better identifications of all the figures and more cohesive links among them, one can only hypothesize that examples of pagan love may be represented among these stuccoes, a lower form of love that will be surpeseded in the next—the last—bay by Christian love.[206]

The title of the last bay might indeed be *omnia vincit amor*. Love, it was declared at the pope's *solenne possesso,* had been restored with the reign of Leo X, as with Christ, and would rule forever.[207] In this closing chapter of the Logge's encyclopedic history, the promises, sacrifices, and faith—gentile and Hebrew—that all along the way have anticipated the Messiah, reach fulfillment in Christ's loving sacrifice. Through the sequence of love, death, and immortality, the mainstreams of pagan and Judeo-Christian traditions flow together, in the Logge decorations as in Renaissance philosophical thought. The intellectual acrobatics displayed in the imagery of the last bay are standard routines, common to art and literature of the period. An easy leap from premise to premise spans the range of world philosophies and religions. For Plato, the "Attic Moses,"[208] as well as for Christ, it was asserted by theologians of the Renaissance, God's love caused and ruled creation.[209]

The train of logic might then continue with the proposition that "Amore non è altro che morte."[210] But death offers entrance to the City of God; death leads the soul to immortality, and it is on the wings of divine love that the soul rises to God. "Let us therefore flee from here,

204. This aberration recalls the "Minerva" in stucco on the arch of the seventh bay, who also most uncharacteristically brandishes a bow. Her bow too is empty, but she may already have shot her arrow. See note 134 above.

205. A suggestive (but probably fortuitous and irrelevant) portrayal of Mercury with bow and arrow, playing the role of John the Baptist and heralding a pagan Trinity, is illustrated in the 1507 edition of Tritonius-Celtes, *Melopoiae* (E. Wind, *Pagan Mysteries in the Renaissance,* pl. 70).

206. In addition to the pendentives described above, the reliefs include a winged Victory attended by a wingless putto; a woman extending what could be a mask toward a putto with what might be a cornucopia (the condition is poor); a youth with a woman who holds an infant (Fig. 106); and a woman carrying a wreath and flaming bowl toward an altar. The left-hand pendentive of the west wall is a replacement for the original of unknown subject, which was destroyed, as may be seen in the Vienna codex (f. 50). The codex shows in its place a triangular ventilation duct guarded by an iron grill. The later addition of the Victory was noted by Shearman (see N. Dacos, *Le Logge di Raffaello,* 216). The color of this stucco Victory is much yellower than that of the original Leo X stuccoes, as are portions of the Jupiter and Ganymede pendentive (Fig. 105). In the Vienna codex (Fig. 104; f. 92) as drawn in the left pendentive, Jupiter's raised left hand brandishes a thunderbolt; his right hand is pressed to his heart. Traces of the thunderbolt may still be seen today in the fresco background, but a stucco *lira da braccio* was at some point unaccountably substituted for it, and a bow was inserted into Jupiter's right hand. Ganymede's head also has been replaced so that he now looks at Jupiter instead of turning from him. These stucco additions are yellower than the original portions of the figures. A rectangular stucco relief on the southeast pier face of bay 9 is temptingly related to the theme of earthly and spiritual love, but it is probably also a replacement. The existing relief seems intended to personify the terrestrial and celestial Venuses, each with an attendant Amor. The Vienna codex (f. 70), however, shows only Amors at play. The other three reliefs on this pier face are copied sketchily but correctly in the codex.

207. See chap. 1, p. 22.

208. Giovanni Pico della Mirandola, *Heptaplus,* 68.

209. J. C. Nelson, *Renaissance Theory of Love,* 115.

210. Ibid., 61. The most useful discussion of Amor and death may be found in the chapter "Amor as a God of Death," in E. Wind, *Pagan Mysteries in the Renaissance,* 129–41.

that is from the world which is established in evil; let us fly to the Father where there is unifying peace, truest light, best pleasure. But who will give us wings that we may fly higher? The love of the things that are above."[211] Only through the loving sacrifice of Christ's death could "the promise of eternal inheritance be realized, for where a testament is," explains the writer to the Hebrews, "there must also of necessity be the death of the testator" (Heb 9:15–16). Death leads not merely to Resurrection of the body. The immortality of the soul, thus significantly distinguished, first became official dogma with Leo X's bull of December 19, 1513, which declared this doctrine to be a philosophical as well as theological truth.[212] The influence of Neoplatonic thinking upon the papal proclamation was evident.

In Renaissance thought, all theologies and philosophies could be plaited to form a single cord composed of these separate strands through assimilating ideas and imagery of love, death, and immortality. Synthesizing treatises on love, for the most part but not exclusively Neoplatonic, were almost as plentiful then as is the twentieth-century literature that analyzes these Renaissance theories of love. A childhood friend of Leo X, Francesco da Diacceto, who visited him in Rome in 1513, was the author of several such treatises and one of many writers indebted to Marsilio Ficino, who, perhaps with Dante, was the most influential philosopher to study this interesting subject.[213] Other intimates of the pope, notably Bembo and Castiglione, both friends of Raphael as well, also made important contributions to the literature of love. Although even in the last bay of the Logge it is not yet possible to make a precise connection between any specific text and the decorations representing the gentile world below the tabernacle of the New Testament, a pronounced tinge of Neoplatonic views on the subject of love may be discerned.

The pendentives of the thirteenth bay (Figs. 116–20), like those of the second and fourth bays, with their oracles and sacrifices, seem to express a unified theme through repetition of motifs and settings. The figures all are seated on balustrades, beneath which runs a wavelike strip, possibly representing clouds of an oddly clotted consistency. Women appear in each of the eight pendentives, accompanied by infants or Amor in all but three. In two of the three childless reliefs (Figs. 116 and 118), the women huddle in attitudes of mourning; the third seems to depict a man or woman crowning another woman with a wreath. The figures in the two west-wall pendentives under the first scene, *The Adoration of the Shepherds*, are stationed outside a city (Fig. 118). Each of the two pendentives beneath the last scene, *The Lord's Supper*, contains a pair of women, one with her head resting in her hands; the other thrusts toward her companion an infant holding a palm frond (Fig. 117), which is scarcely visible now but is clearly defined in both scenes in the Vienna codex (f. 100).

The formative ideas behind this related series of scenes are far from clear. I can only hazard guesses that seem to fit the patterns of thought and of design displayed in earlier bays of the Logge and that offer suggestive parallels to the Sistine Chapel frescoes.[214] The palm fronds brandished by the infants in the pendentives below the scene of the Lord's Supper imply both victory and martyrdom. These children may also refer to the Holy Innocents who were

211. Giovanni Pico della Mirandola, *On Being and the One*, chap. 10, 61.

212. P. O. Kristeller, *Renaissance Thought and the Arts*, 95–96. See also S. Offelli, "Il pensiero del Concilio Lateranense V sulla dimostrabilità razionale dell'immortalità dell' anima umana," 3 ff.; F. Gilbert, "Cristianesimo, umanesimo e la bolla 'Apostolici regiminus' del 1513," 977 ff.; J. Shearman, *Raphael's Cartoons*, 72–73; V. L. Goldberg, "Leo X, Clement VII and the

Immortality of the Soul," 22 ff. The New Testament does not speak of the Redemption of souls, which is a Platonic, not a scriptural, concept (*New Catholic Encyclopedia*, XII, 143).

213. P. O. Kristeller, "Francesco da Diacceto and Florentine Platonism in the Sixteenth Century," 277 ff.

214. C. de Tolnay, *Michelangelo—II: The Sistine Ceiling*, 77 ff.

martyred in place of the infant Christ that he might be spared to bring salvation to future generations. The salvation not yet reached by the women in these stucco reliefs is to be granted to the children in succeeding generations, who will live in the era of grace.[215] "The woman being deceived, was in the transgression. [It was . . . the woman who was led astray and fell into sin.] Notwithstanding she shall be saved with childbearing" (Tm 2:14–15).

The city rising in the background of the reliefs beneath *The Adoration of the Shepherds* may be the Heavenly Jerusalem, which the birth of Christ, depicted above, makes attainable, but which members of earlier generations born too soon—if they lacked the prescient faith of the prophets, oracles, and sibyls—have little hope of entering. The figures of the childless mourners and the city that may be the City of God recall sepulchral motifs from early Christian sarcophagi. The bowed mourners also reflect, both in pose and in mood, the lunette and spandrel figures of the Sistine Chapel vault. Although they do not—unlike the weary pilgrims of the Sistina—carry the attributes of travelers, they also perhaps represent the sorrowful "regno de' peregrini," those who "fuori della città sono," and who must await in Limbo the final Judgment.[216] In the Logge stuccoes, the energy and joy of the woman who opens her arms to Amor (Fig. 119) and the protective intimacy of the woman who bends over each infant holding a palm frond (Fig. 117) contrast touchingly with the inert figures of the childless mourners (Fig. 116).

In one pendentive stucco of the east side (Fig. 120), at left below the Baptism of Christ, a seated woman holds a distaff. As she looks back over her shoulder toward her neighbor in the adjacent corner, who is about to embrace Amor, the distaff is stolen from her hand by another figure of Amor. Among the pendentives, this is the only scene whose meaning is clear and familiar. A similar pair of figures—a spinner thwarted by an interfering Amor—represents one of the three Fates in the border of Raphael's tapestry for the Sistine Chapel, *The Charge to Peter*. Possibly, the Fates represented on a triumphal arch welcoming Leo X to Florence in 1515 included an equally distracted goddess.[217] The woman in the stucco is Lachesis, who in Plato's vision of Er determines by lot the path of men's lives.[218] The Fates govern the corporeal world, but, as is so neatly illustrated in the stucco relief, Love will triumph over Fate; it is "L'Amor che move il sole e l'altre stelle."[219] To the Renaissance humanist, the Love that reigned in the pagan world was a figure for the same preeminent spiritual grace introduced in its perfection through the Christian gospel of the vault scenes above. Among the stucco Virtues of the pilasters in the last bay is Caritas, the Christian figure of Love.

215. The children may also be introduced here as prophetic figures because of the powers of revelation attributed to them, both by ancient authorities (see G. R. S. Mead, *Thrice-Greatest Hermes: Studies in Hellenistic Theosophy and Gnosis*, I, 283) and by the Old Testament (see Ps 8:2, quoted at the beginning of the mass for the Holy Innocents: "Out of the mouths of babes and sucklings. . .").

216. A. Chastel, *Art et humanisme à Florence*, 107 ff. (quoting from Ficino's translation of Dante's *De Monarchia*). On the subject of salvation for those born before Christ, see J. Daniélou, *Holy Pagans of the Old Testament*, I ff.; D. C. Allen, *Mysteriously Meant*, 18, 43; *The Catholic Encyclopedia*, XII, 680 ff. (under "Redemption"); and *New Catholic Encyclopedia*, XII, 995–97 (under "Salvation, Necessity of the Church for"). For an interpretation of the Sistine Chapel figures as pilgrims,

see E. G. Dotson, "An Augustinian Interpretation of Michelangelo's Sistine Ceiling—I," 224 ff. The mourning women may also recall another refrain found in the liturgy for the Feast of the Holy Innocents, quoted from Jeremiah 31:15. "A voice in Rama was heard, lamentation and great mourning, Rachel bewailing her children and would not be comforted, because they are not."

217. The motif is derived evidently from an antique relief wherein the woman holds a torch rather than a distaff. See a drawing attributed to G. A. Dosio (Uffizi 2565) and another among the Windsor Cassiano dal Pozzo copies after antiques (8360).

218. Plato, *The Republic*, bk. x, xv (505).

219. Dante, *Paradiso*, XXXIII, 145. See H.R. Patch, "The Last Line of the *Commedia*," 56 ff. Orphic doctrine confirmed that Love rules the three Fates (*Marsilio Ficino's Commentary on Plato's Symposium*, 180).

The triumph of Love, the Love that draws the soul safely through death to immortality, is further exemplified in the three larger stucco panels on the intrados of the last arch, at the north end of the Logge beneath the kings adoring the Christ child. In the central, uppermost panel (Fig. 121), Jupiter, his thunderbolt menacingly raised in his right hand, is deterred by an infant Amor, who takes his left arm and turns the mighty king of the gods from his wrathful purpose. Kneeling beside a tree stump in front of Jupiter is a wingless putto, who offers the god some small object. Unfortunately, this relief is too damaged to be clearly legible, but the headline message is unmistakable; Love's power rules even the king of the gods, just as the infant Christ brings the kings of this world to their knees in the fresco immediately overhead. The kneeling, wingless putto in the relief might represent Anteros, earthly love, or perhaps, in a similar line of thought, Castor, the mortal twin of Pollux, the immortal son of Jupiter. The celestial child deflecting his father's punishment would then be Pollux, who so loved his twin that he refused immortality unless his brother could share it. The potential parallels to be drawn between this ancient fable and Scripture are obvious, but without textual or visual prototypes, no firm identification can be made.[220]

The two large pendant side panels of this last arch of the Logge portray Leda, who was the mother of Castor and Pollux, and Amor with a woman, perhaps Venus, or possibly the mortal beauty Psyche (Figs. 122 and 123). Elaborations of the sequence of love, death, and immortality are elegantly packaged within these paired reliefs. In the panel at right, the seated woman wards off Love's approach with raised knee and a hand held protectively between her mouth and his face. Amor tries to pull her arm away as he bends to kiss her. In the scene at left, Jupiter disguised as a swan perches on a pedestal to kiss Leda—a mortal, like Psyche—while an Amor crouches with averted face beside them. Again, as in the case of the Jupiter relief, one can only guess at the links that might bind the Christian scenes of this bay to the subject of mortal women elevated to immortality through a god's love. Among many texts relevant to such analogies, one could cite a sermon by St. Bernard of Clairvaux for the dedication of a church— most appropriate in the context of this bay, which represents the foundation of the Christian Church—where he explains that the spouse of Christ signifies both the Church and the City of God. "But how can we suppose it possible for so great a Monarch to be transformed into a Bridegroom and for His city to assume the character of His bride? My brethren, the transformation is accomplished by that power to which nothing is impossible, I mean charity, which is 'strong as death' (Cant. viii, 6). What wonder is it that love should lift *her* up, seeing that it has already brought *Him* down?"[221] Once more, the nuptial imagery, so important to Scripture and to the ecclesiastical themes emphasized in the Logge, is echoed in the two reliefs.

These pendant scenes of Leda and Jupiter, Psyche (or the celestial Venus) and Amor, illustrate in addition another cherished Renaissance theme, the kiss of death, an image that brought into harmonious union ancient mythology, the Song of Songs, Christian Redemption, and such venerated mystery cults as the Cabbala and the Chaldean Oracles.[222] Among the many writers

220. For the various forms and aspects of Amor, see (among many): G. de Tervarent, *Attributs et symboles dans l'art profane, 1450–1600,* I, col. 15 ff.; A. Chastel, *Art et humanisme à Florence,* 269 ff.; E. Wind, *Pagan Mysteries in the Renaissance,* index; and C. Dempsey, " 'Et Nos Cedamus Amori': Observations on the Farnese Gallery," 363 ff. On Zeus and the twins, see A. B. Cook, *Zeus: A Study in Ancient Religion,* II, 436 ff. In Ovid's *Metamorphoses* (bk. v, lines 368–69), Venus concedes to Amor, "You rule the gods, and Jove himself."

221. *St. Bernard's Sermons for the Seasons,* II, 428. As early as the third century, Origen had transformed Amor and Psyche into figures of Christ and the Church (*The Song of Songs: Commentary and Homilies,* 16). See also note 42 above.

222. Most important on this theme is E. Wind's chapter "Amor as a God of Death," in *Pagan Mysteries in the Renaissance,* 129–41. See also Macrobius, *The Saturnalia,* II, chap. 2, 17 (165); and J. C. Nelson, *Renaissance Theory of Love,* 59 ff.

who described this mystical departure of the soul from the body through the kiss of death were Giovanni Pico della Mirandola and Castiglione. The former relates the kiss to the celestial Venus, whom the soul must kiss and embrace in a death that dissolves earthly bonds, a "morte di baccio," which rewarded for their faith such ancient fathers as Abraham, Isaac, Jacob, Moses, and Aaron.[223] Castiglione, like Pico, refers to the kiss of the Song of Songs—"Let him kiss me with the kisses of his mouth: for thy love is better than wine" (1:2)—which he interprets as a desire of the soul to be so transported through divine love to contemplation of celestial beauty that it abandons the body.[224]

This passionate union of the liberated soul with God may be anticipated in life through such inspired states as those induced, for example, by music or by the visionary sleep of the body, when mind and soul escape their prison for brief insights to heavenly truths. These prefatory mystic states are often alluded to in earlier bays of the Logge, as in the possessed musician Orpheus, the bacchic dancers, or the dreaming sleepers. Perhaps the most popular marriage of love with death was expressed in the tragic drama of Orpheus, who entered Hades to save his love. At the end of the 1513 Florentine edition of Poliziano's immensely successful *Orfeo*, a dialogue ensues with Echo, in which the last word or two of each line is repeated, deftly tying the bonds of love with death:

> Chi t'ha levato dal mio amore? *Amore.*
> Che fa quello a chi porti amore? *Ah, more!*[225]

Amor, Psyche, the celestial Venus, love, death, and immortality of the soul, were figures and topics illustrated an infinity of times and in many ways by Renaissance artists. Raphael often represented these interlaced subjects—variously, lightly, with inexhaustible imagination—in the Vatican Loggetta, Cardinal Bibbiena's *stufetta,* and in Agostino Chigi's loggia, to name but a few examples. Although something of a problem to resolve gracefully, Leda too was prized as a subject for Renaissance artists. The story harmonized cosmological myths with Christian theology through an image that combined birth and creation together with love, death, and immortality more succinctly, and usually more erotically, than any of the classic tales so often represented on sarcophagi—such as Amor and Psyche or Jupiter and Ganymede—in which, as in Christianity, a mortal is transported to immortality through the love of a god.[226] Most famous among the Renaissance Ledas were Leonardo's and Michelangelo's paintings, long lost but known through surviving preparatory drawings and through copies and descriptions. Typically, for Leonardo the ideas of birth and regeneration held the greatest attraction in the myth of Leda, while for Michelangelo, the association of Leda with death, sleep, and Night were to prevail.[227] But for both artists, as for Raphael, the creative cycle symbolized by the legend led beyond death to immortality. Leda, who appears more than once in the Logge, was, then, an ideal image for the last arch of the bay: a statement in pithy miniature of some of the greatest theological and philosophical concerns of the Logge designers and of their cultured patron, Giovanni de' Medici.

223. See his *Commento* on Girolamo Benivieni's *Canzona de amore,* 53v ff.

224. B. Castiglione, *Il cortegiano,* bk. IV, lxiv.

225. *Poesie italiane di Messer Angelo Poliziano,* 62.

226. E. Wind, *Pagan Mysteries in the Renaissance,* 129 ff. For antique and Renaissance representations of Leda, see E. R. Knauer, "Leda," 5 ff.

227. See M. Kemp, *Leonardo da Vinci,* 270 ff.; and C. de Tolnay, *Michelangelo—III: The Medici Chapel,* 206–7.

The Gospel of St. John, so purposefully displayed in Raphael's portrait of the pope, conveys in equally concise summary many of the same universal concerns that are developed in the Logge. This Gospel describes the life of Christ in terms of a history of salvation, which, as revealed by the opening line, printed so clearly in the portrait, began with Creation.[228] An extraordinary mystique evolved about that first line. Perhaps the most apposite exposition of the Alpha and Omega circle of reasoning was published by Giovanni Pico della Mirandola in his *Heptaplus, On the Sevenfold Narrative of the Six Days of Genesis.* This book was addressed, it will be remembered,[229] to Lorenzo de' Medici just after his son was made cardinal in 1489, and it sets forth a pattern of theological reasoning which in many ways resembles that visualized in the Logge, ultimately because both are founded on liturgy and traditional exegesis. Following two proems, the book is divided into seven expositions, which in turn are divided into seven chapters. The seventh chapter returns each time to Christ, "who is the end of the law and is our Sabbath, our rest, and our felicity"; felicity, Pico defines, "as the return of each thing to its beginning."[230]

Like so many Christians through the ages, Pico particularly revered the Gospel of St. John, which, he felt, "compared with the others revealed the secrets of divinity in greatest measure."[231] The last section of *Heptaplus,* a coda following the seventh chapter, claims to discover those deepest secrets. Pico returns here to an exposition of the first phrase: "In the beginning," the first words of the Bible and of the Gospel of St. John. He then proceeds, through a remarkable argument based on mystical etymology and numerology, to demonstrate, letter by letter, word by word, that "the whole plan of the creation of the world and of all things in it [is] disclosed and explained in that one phrase."[232]

Magic and cabbalism, ancient myths and medieval cosmology, *prisci theologi* and church fathers, are stirred together in this treatise with fervid Christian faith. Yet this exotic mixture is composed fundamentally of discrete, identifiable elements arranged in standard patterns that descend from venerable traditions.[233] Pico's account of Creation through the seventh day of Christianity is familiar to us, as are the tenor and structure of the book and his conclusion that "the end of all things is the same as the beginning of all: one God, omnipotent and blessed."[234] Leo X and his associates surely read *Heptaplus,* but its ideas, even including the streaks of mysticism, were known to the papal court from many other sources. They can be traced from the New Testament, from Plato and Aristotle, on through the Middle Ages to the Renaissance. Similar ideas were frequently expressed by many of Lorenzo de' Medici's circle and in much of the art and literature of his son's court. This same deeply felt, richly complex form of Christianity pervades and gives shape and meaning to Raphael's portrait of Leo X and to the Logge Bible.

---

228. J. Daniélou, "Les divers sens de l'Écriture dans la tradition chrétienne," 123, and *The Bible and the Liturgy,* 208 ff. O. Cullmann, *Salvation in History,* 156, 268 ff.

229. See chap. 1, p. 8.

230. Giovanni Pico della Mirandola, *Heptaplus,* 84 (Second Proem), 148 (Seventh Exposition).

231. Ibid., 70 (First Proem).

232. Ibid., 171 (Exposition of the First Phrase). For medieval schemata of comparable but even greater complexity, see H. Bober, "In Principio. Creation Before Time," 13 ff.

233. See the repeated *caveats* from H. de Lubac (*Pic de la Mirandole,* such as 99 and 110) against supposing that Pico syncretized without value distinctions pagan, Hebrew, and oriental traditions with Christian. Lubac argues that Pico was not an admirer of pagan beliefs and culture in themselves but saw them as visible traces planted in nature by means of which one could arrive at a better understanding of Christianity and the invisible God.

234. *Heptaplus,* 148 (Seventh Exposition).

# References Cited

Ackerman, James S. *The Cortile del Belvedere*. Vatican City, 1954.

Aelian (Aelianus Claudius). *On the Characteristics of Animals*, trans. A. F. Scholfield. Loeb Classical Library. Cambridge, Mass., 1958–59.

Agricola, Filippo. *Relazione dei restauri eseguiti nelle terze logge del pontificio palazzo Vaticano sopra quelle dipinte dalla scuola di Raffaello*. Rome, 1842.

Allegri, Ettore. In *Raffaello a Firenze*. Milan, 1984.

Allen, Don C. *Mysteriously Meant: The Rediscovery of Pagan Symbolism and Allegorical Interpretation in the Renaissance*. Baltimore, 1970.

d'Alverny, Marie-Thérèse. "Les anges et les jours." *Cahiers archéologiques*, IX, 1957.

Ambrose, St. *Hexameron, Paradise, and Cain and Abel*, trans. J. J. Savage. New York, 1961.

[Annius of Viterbo.] *Le antichita di Beroso Caldeo sacerdote . . .* , ed. and trans. F. Sansovino. Venice, 1583.

Arbesmann, Rudolph, O.S.A. "The Concept of 'Christus Medicus' in St. Augustine." *Traditio*, x, 1954.

Armellini, Mariano. *Il diario di Leone X di Paride de Grassi*. Rome, 1884.

Armenini, Giovanni Battista. *De' veri precetti della pittura* (1587). Hildesheim and New York, 1971.

Armstrong, Lilian. *Renaissance Miniature Painters and Classical Imagery: The Master of the Putti and his Venetian Workshop*. London, 1981.

Augustine, St. *Concerning the City of God Against the Pagans*, trans. H. Bettenson. Harmondsworth, 1972.

———.*Confessions*, trans. R. S. Pine-Coffin. Baltimore, 1961.

———.*Contra Adimantum*, ed. J. Zycha (Corpus Scriptorum ecclesiasticorum latinorum, XXVI). Vienna, 1891.

———.*Homilies on the Gospel of St. John*. In *The Nicene and Post-Nicene Fathers*, ed. and trans. P. Schaff, Rev. J. Gibb, and Rev. J. Innes, VII (1886–90). Grand Rapids, Mich., 1956.

Austin, H. D. "Dante and Mirrors." *Italica*, XXI, 1944.

Bauer, Linda and George. "The *Winter Landscape with Skaters and Bird Trap* by Pieter Bruegel the Elder." *Art Bulletin*, LXVI, 1984.

Beck, James H. "Raphael and Medici 'State Portraits.' " *Zeitschrift für Kunstgeschichte*, XXXVIII, 1975.

Becker, Erich. *Das Quellwunder des Moses in der altchristlichen Kunst*. Strassburg, 1909.

Bernard of Clairvaux, St. *St. Bernard's Sermons for the Seasons and Principal Festivals of the Year*, trans. by a Priest of Mount Melleray. Westminster, Md., 1950.

Białostocki, Jan. "The Eye and the Window." *Festschrift für Gert von der Osten*. Cologne, 1970.

*La Bibbia di Borso d'Este*, ed. A. Venturi. Milan, 1937.

Birk, Ernst, Ritter von. "Inventar der im Besitze des Allerhöchsten Kaiserhauses befindlichen Nieder-

länder Tapeten und Gobelins." *Jahrbuch der Kunsthistorischen Sammlungen des Allerhöchsten Kaiserhauses*, II, 1884.

Bober, Harry. "In Principio. Creation Before Time." *De Artibus Opuscula XL. Essays in Honor of Erwin Panofsky*, ed. M. Meiss. Princeton, 1961.

Boccaccio, Giovanni. *Amorosa visione di Messer Gio. Boccaccio*. Venice, 1558.

Boffito, Giuseppe. "L'occhiale e il cannocchiale del papa Leone X." *Atti della Reale Accademia delle Scienze di Torino*, LXII, 1927.

Boll, Franz J., and Carl Bezold. *Sternglaube und Sterndeutung*. Leipzig and Berlin, 1931.

Bordoni, Girolamo. *Triumpho della morte de papa Leone X*. Rome, 1521(?).

Bossi, Nivardo. *Le campane*. Macerata, 1897.

Braun, F.-M. "L'eau et l'Esprit." *Revue Thomiste*, XLIX, 1949.

Britt, Matthew, ed. *The Hymns of the Breviary and Missal*. New York, 1948.

Brown, David A., and Konrad Oberhuber. "*Monna Vanna* and *Fornarina*: Leonardo and Raphael in Rome." *Essays Presented to Myron P. Gilmore*. Florence, 1978.

Brown, George K. *Italy and the Reformation to 1550*. Oxford, 1933.

Bullard, Melissa M. *Filippo Strozzi and the Medici: Favor and Finance in Sixteenth-Century Florence and Rome*. Cambridge, 1980.

Burghardt, Walter J., S.J. "Cyril of Alexandria on 'Wool and Linen.'" *Traditio*, II, 1944.

Cambi, Giovanni. *Istorie di Giovanni Cambi cittadino fiorentino*, ed. I. di San Luigi (Delizie degli eruditi toscani, XXII). Florence, 1786.

Cancellieri, Francesco. *Storia de' solenni possessi de' sommi pontefici*. . . . Rome, 1802.

Canedy, Norman W. *The Roman Sketchbook of Girolamo da Carpi*. London, 1976.

[Castiglione, Baldassare.] *Il cortegiano*. In *Opere di Baldassare Castiglione, Giovanni della Casa, Benvenuto Cellini*, ed. C. Cordié. Milan and Naples, 1960.

*The Catholic Encyclopedia*. New York, 1911 (see also *New Catholic Encyclopedia*).

Chambers, David S. *Cardinal Bainbridge in the Court of Rome, 1509 to 1514*. London, 1965.

Chastel, André. *Art et humanisme à Florence au temps de Laurent le Magnifique*. Paris, 1982.

———. *Fables, formes, figures*. Paris, 1978.

———. "Les jardins et les fleurs." *Revue de l'art*, LI, 1981.

———. *Marsile Ficin et l'art*. Geneva, 1954.

Cherubini, Laerzio. *Bullarium, sive nova collectio*. . . . Rome, 1617.

Chew, Samuel C. *The Pilgrimage of Life*. New Haven and London, 1962.

Cian, Vittorio. "Su l'iconografia di Leone X." In *Scritti varii di erudizione e di critica in onore di Rodolfo Renier*. Turin, 1912.

Ciatti, Marco. "La Porta del Paradiso." In *Lorenzo Ghiberti, materia e ragionamenti*. Florence, 1978–79.

Cicero, Marcus Tullius. *De Divinatione*, trans. W. A. Falconer. Loeb Classical Library. Cambridge, Mass., 1959.

Cipriani, Giovanni. *Il mito etrusco nel rinascimento fiorentino*. Florence, 1980.

Ciraolo, Clara da Empoli. "La 'Divinità' di Raffaello." *Nuova antologia*, Anno 87, fasc. 1818, 1952.

Clark, Kenneth. *Leonardo da Vinci*. Cambridge, 1939.

Collison, Robert L. *Encyclopaedias: Their History Throughout the Ages*. New York, 1964.

Colvin, Sir Sidney. *A Florentine Picture-Chronicle*. . . . London, 1898.

*Commentary of Theodore of Mopsuestia on the Lord's Prayer and on the Sacraments of Baptism and the Eucharist*, ed. and trans. A. Mingana. Cambridge, 1933.

*Concilii Tridentini diariorum*, ed. S. Merkle. Freiburg-i.B., 1901–.

*Conciliorum Oecumenicorum decreta*, ed. J. Alberigo et al. Bologna, 1973.

Cook, Arthur B. *Zeus: A Study in Ancient Religion*. Cambridge, 1914–40.

*La corte il mare i mercanti . . . astrologia, magie e alchimia nel rinascimento fiorentino ed europeo* (Firenze e la Toscana dei Medici nell'Europa del Cinquecento). Florence, 1980.

Corvisieri, Costantino. "Antonazo Aquilio Romano, pittore del secolo XV." *Il Buonarroti*, IV, 1869.

Cox-Rearick, Janet. "Themes of Time and Rule at Poggio a Caiano: The Portico Frieze of Lorenzo il Magnifico." *Mitteilungen des Kunsthistorischen Institutes in Florenz*, XXVI, 1982.

Cruciani, Fabrizio. *Il teatro del Campidoglio e le feste romane del 1513*. Milan, 1968.

Cullmann, Oscar. *Salvation in History*, trans. S. G. Sowers et al. New York, 1967.

Cumont, Franz. "La fin du monde selon les mages occidentaux." *Revue de l'histoire des religions*, CIII, 1931.

———. *Recherches sur le symbolisme funéraire des romains*. New York, 1975.

Dacos, Nicole. "La Bible de Raphaël. Quelques observations sur le programme et sur les auteurs des fresques." *Paragone*, XXII, no. 253, 1971.

———. *La découverte de la Domus Aurea et la formation des grotesques à la renaissance*. London, 1969.

———. "Les Loges de Raphaël: Répertoire à l'antique, Bible et mythologie." In *Classical Influences on European Culture, A.D. 1500–1700*. Cambridge, 1976.

———. *Le Logge di Raffaello: Maestro e bottega di fronte all'antico*. Rome, 1977.

———. "Tommaso Vincidor un élève de Raphaël aux pays-bas." In *Relations artistiques entre les pays-bas et l'italie à la renaissance* (Etudes d'histoire de l'art, L'Institut historique belge de Rome, IV), 1980.

———. "'Il trastullo di Raffaello.'" *Paragone*, XIX, no. 219, 1968.

D'Amico, John F. "Papal History and Curial Reform in the Renaissance. Raffaele Maffei's *Brevis Historia* of Julius II and Leo X." *Archivum Historiae Pontificiae*, XVIII, 1980.

———. *Renaissance Humanism in Papal Rome*. Baltimore and London, 1983.

Daley, John. "The Vault Decoration of Raphael's Logge." M.F.A. diss., Department of Fine Arts, New York University, 1962.

D'Ancona, Mirella Levi. *The Garden of the Renaissance: Botanical Symbolism in Italian Painting*. Florence, 1977.

Daniélou, Jean, S. J. *The Angels and Their Mission, According to the Fathers of the Church*, trans. D. Heimann. Westminster, Md., 1957.

———. *The Bible and the Liturgy* (1951). Ann Arbor, Mich., 1956.

———. "Les divers sens de l'Ecriture dans la tradition chrétienne primitive." *Ephemerides Theologicae Lovanienses*, XXIV, 1948.

———. *Holy Pagans of the Old Testament*, trans. F. Faber. London, 1957.

———. *Platonisme et théologie mystique: Essai sur la doctrine spirituelle de Saint Grégoire de Nysse*. Paris, 1944.

———. *Les symboles chrétiens primitifs*. Paris, 1961.

Dannenfeldt, Karl H. "The Pseudo-Zoroastrian Oracles in the Renaissance." *Studies in the Renaissance*, IV, 1957.

Davidson, Bernice F. "The Landscapes of the Vatican Logge from the Reign of Pope Julius III." *Art Bulletin*, LXV, 1983.

———. "Pius IV and Raphael's Logge." *Art Bulletin*, LXVI, 1984.

———. "Pope Paul III's Additions to Raphael's Logge: His *Imprese* in the Logge." *Art Bulletin*, LXI, 1979.

Davies, Martin. *London. National Gallery Catalogues: Early Netherlandish School*. London, 1955.

Dempsey, Charles. " 'Et Nos Cedamus Amori': Observations on the Farnese Gallery." *Art Bulletin*, L, 1968.

Didron, Adolphe N., completed by M. Stokes. *Christian Iconography* (1886), trans. E. J. Millington. New York, 1965.

Dotson, Esther G. "An Augustinian Interpretation of Michelangelo's Sistine Ceiling." *Art Bulletin*, LXI, 1979.

Dussler, Luitpold. *Raphael*, trans. S. Cruft. London and New York, 1971.

Ehrle, Franz, S.J., and Hermann Egger. *Die Conclavepläne: Beiträge zu ihrer Entwicklungsgeschichte*. Vatican City, 1933.

Esmeijer, Anna C. *Divina quaternitas: A Preliminary Study in the Method and Application of Visual Exegesis*. Amsterdam, 1978.

*Essai sur le symbolisme de la cloche*. Poitiers, 1859.

Essling, Prince d', and Eugène Müntz. *Pétrarch: Ses études d'art, son influence sur les artistes, ses portraits et ceux de Laure*. Paris, 1902.

*L'Estasia di Santa Cecilia di Raffaello da Urbino nella Pinacoteca Nazionale di Bologna*. Bologna, 1983.

Ettlinger, Leopold D. *The Sistine Chapel Before Michelangelo*. Oxford, 1965.

Ferruolo, Arnolfo B. "Botticelli's Mythologies, Ficino's *De Amore*, Poliziano's *Stanze per la Giostra*: Their Circle of Love." *Art Bulletin*, XXXVII, 1955.

[Ficino.] *Marsilio Ficino's Commentary on Plato's Symposium*, ed. and trans. S. R. Jayne (University of Missouri Studies, XIX, no. 1). Columbia, Mo., 1944.

Fischel, Oskar. "Le gerarchie degli angeli di Raffaello nelle Logge del Vaticano." *L'Illustrazione vaticana*, VIII, no. 4, 1937.

———. *Raphael*, trans. B. Rackham. London, 1948.

Flacelière, Robert. *Greek Oracles*, trans. D. Garman. London, 1965.

Fletcher, Jennifer. "Marcantonio Michiel: His Friends and Collection." *Burlington Magazine*, CXXIII, 1981.

Forcella, Vincenzo. *Tornei e giostre, ingressi trionfali e feste carnevalesche in Roma sotto Paolo III*. Rome, 1885.

Förster, Ernst. *Raphael*. Leipzig, 1867–68.

Franchini, Dario, et al. *La scienza a corte; Collezionismo eclettico, natura e immagine a Mantova fra rinascimento e manierismo* (Centro studi "Europa delle corti," 7). Rome, 1979.

Freedberg, Sydney J. *Andrea del Sarto*. Cambridge, Mass., 1963.

———. *Painting in Italy: 1500 to 1600*. Harmondsworth, 1971.

———. *Painting of the High Renaissance in Rome and Florence*. Cambridge, Mass., 1961.

Friedmann, Herbert. *The Symbolic Goldfinch: Its History and Significance in European Devotional Art*. Washington, D.C., 1946.

Frommel, Christoph L. *Baldassare Peruzzi als Maler und Zeichner* (Beiheft zum Römischen Jahrbuch für Kunstgeschichte, XI), 1967/68.

———. "Eine Darstellung der 'Loggien' in Raffaels 'Disputa'?" *Festschrift für Eduard Trier zum 60. Geburtstag*. Berlin, 1981.

Ganz, Paul. *Hans Holbein: Die Gemälde*. Basel, 1950.

Gaurico, Luca. *Tractatus astrologicus. . . .* Venice, 1552.

Gilbert, Felix. "Christianesimo, umanesimo e la bolla 'Apostolici regiminis' del 1513." *Rivista storica italiana*, LXXIX, 1967.

Giovio, Paolo. *Illustrium virorum vitae . . . De vita Leonis decima*. Florence, 1549.

———. *Le vite di Leon Decimo et d'Adriano VI, sommi pontefici, et del cardinal Pompeo Colonna*. Florence, 1551.

Goetz, Oswald. *Der Feigenbaum in der religiösen Kunst des Abendlandes*. Berlin, 1965.

Goldberg, Victoria L. "Leo X, Clement VII and the Immortality of the Soul." *Simiolus*, VIII, 1975–76.

Golzio, Vincenzo. *Raffaello nei documenti, nelle testimonianze dei contemporanei e nella letteratura del suo secolo*. Vatican City, 1936.

Gombrich, Ernst. "Hypnerotomachiana." *Journal of the Warburg and Courtauld Institutes*, XIV, 1951.

———. *Norm and Form: Studies in the Art of the Renaissance*. London, 1966.

———. *The Sense of Order*. Oxford, 1979.

Gottlieb, Carla. "The Mystical Window in Paintings of

the Salvator Mundi." *Gazette des Beaux-Arts*, LVI, 1960.

———. *The Window in Art: From the Window of God to the Vanity of Man: A Survey of Window Symbolism in Western Painting*. New York, 1981.

Gregory of Nazianzus, St. "The Fifth Theological Oration—On the Spirit." In *The Library of Christian Classics*, III, ed. and trans. E. R. Hardy. Philadelphia, 1954.

[Gregory of Nyssa, St.] *From Glory to Glory, Texts from Gregory of Nyssa's Mystical Writings*, selected and with introduction by J. Daniélou, trans. and ed. H. Musurillo. New York, 1961.

———. *La vie de Moïse; ou, Traité de la perfection en matière de vertu*, trans. J. Daniélou. Paris, 1955.

Gruyer, François A. *Essai sur les fresques de Raphaël au Vatican: Loges*. Paris, 1859.

Gugitz, Gustav. *Das Jahr und seine Feste. . . .* Vienna, 1949.

Guldan, Ernst. *Eva und Maria*. Graz and Cologne, 1966.

Hanning, Barbara R. "Glorious Apollo: Poetic and Political Themes in the First Opera." *Renaissance Quarterly*, XXXII, 1979.

Hanson, Richard P. C. *Allegory and Event: A Study of the Source and Significance of Origen's Interpretation of Scripture*. Richmond, Va., 1959.

Hartt, Frederick. "*Lignum Vitae in Medio Paradisi:* The Stanza d'Eliodoro and the Sistine Ceiling." *Art Bulletin*, XXXII, 1950.

Hebert, Arthur G. *The Throne of David: A Study of the Fulfilment of the Old Testament in Jesus Christ and His Church*. London, 1941.

Heidt, William G. *Angelology of the Old Testament: A Study in Biblical Theology*. Washington, D.C., 1949.

Heimann, Adelheid. "Trinitas Creator Mundi." *Journal of the Warburg Institute*, II, 1938.

Heninger, S. K., Jr. *The Cosmographical Glass: Renaissance Diagrams of the Universe*. San Marino, Calif., 1977.

Hillers, Delbert R. *Covenant: The History of a Biblical Idea*. Baltimore, 1969.

Hirn, Yrjö. *The Sacred Shrine*, ed. C. H. Talbot. London, 1958.

Hirst, Michael. *Sebastiano del Piombo*. Oxford, 1981.

Hoogewerff, G. J. "Leonardo e Raffaello." *Commentari*, III, 1952.

Hopper, Vincent F. *Medieval Number Symbolism: Its Sources, Meaning, and Influence on Thought and Expression*. New York, 1969.

Hoskyns, Sir Edwyn C. *The Fourth Gospel* (1911), ed. F. N. Davey. London, 1947.

Jacobus de Varagine. *Mariale*. Venice, 1497.

James, Edwin O. *Christian Myth and Ritual: A Historical Study*. Cleveland, 1965.

———. *Origins of Sacrifice: A Study in Comparative Religion*. London, 1933.

Janitschek, Hubert. "Notizen-Ueber einige bisher unbekannte Künstler, die unter Leo X. im Rom arbeiteten." *Repertorium für Kunstwissenschaft*, II, 1879.

Janson, Horst W. *Apes and Ape Lore in the Middle Ages and the Renaissance*. London, 1952.

Jayne, Walter A. *The Healing Gods of Ancient Civilizations*. New Hyde Park, N.Y., 1962.

Jeremias, Joachim. *The Eucharistic Words of Jesus*, trans. N. Perrin. New York, 1966.

John Paul II [Karol Wojtyla]. *Love and Responsibility*, trans. H. T. Willetts. New York, 1981.

Jones, Rosemary D. *Francesco Vettori*. London, 1972.

Josephus. *Jewish Antiquities*, ed. and trans. R. Marcus. Loeb Classical Library. Cambridge, Mass., 1937.

Justin, The Martyr, St. "The First Apology." In *Library of Christian Classics*, I, ed. and trans. E. R. Hardy. Philadelphia, 1953.

Kellner, Karl A. H. *L'anno ecclesiastico e le feste dei santi nel loro svolgimento storico*, trans. A. Mercati. Rome, 1914.

Kemp, Martin. *Leonardo da Vinci: The Marvellous Works of Nature and Man*. Cambridge, Mass., 1981.

Klingender, Francis. *Animals in Art and Thought to the End of the Middle Ages*, ed. E. Antal and J. Harthan. London, 1971.

Knauer, Elfriede R. "Leda." *Jahrbuch der Berliner Museen*, XI, 1969.

Kris, Ernst, and Otto Kurz. *Legend, Myth, and Magic in the Image of the Artist*. New Haven, 1979.

Kristeller, Paul O. "Francesco da Diacceto and Florentine Platonism in the Sixteenth Century." *Miscellanea Giovanni Mercati* (Biblioteca Apostolica Vaticana, *Studi e testi*, 124). Vatican City, 1946.

———. *Renaissance Thought and the Arts: Collected Essays* (1965). Princeton, 1980.

Künstle, Karl. *Ikonographie der christlichen Kunst*. Freiburg-i.B., 1928.

La Brosse, Olivier de, O.P., et al. *Latran V et Trente* (*Histoire des conciles oecuméniques*, X), ed. G. Dumeige, S. J. Paris, 1975.

Lactantius. *The Divine Institutes*, trans. M. F. McDonald, O.P. Washington, D.C., 1964.

[Landino, Cristoforo.] *Cristoforo Landino: Scritti critici e teorici*, ed. R. Cardini. Rome, 1974.

[Landucci, Luca.] *Diario fiorentino dal 1450 al 1516 di Luca Landucci, continuato da un anonimo fino al 1542*, ed. I. del Badia. Florence, 1883.

Langedijk, Karla. "Baccio Bandinelli's Orpheus: A Political Message." *Mitteilungen des Kunsthistorischen Institutes in Florenz*, XX, 1976.

———. *The Portraits of the Medici*, I. Florence, 1981.

Lasseur, Denyse le. *Les déesses armées dans l'art classique grec et leurs origines orientales*. Paris, 1919.

Leo the Great, St. *Letters*, trans. E. Hunt, C.S.C. New York, 1957.

Leone Ebreo. *The Philosophy of Love*, trans. F. Friedeberg-Seeley and J. H. Barnes, introduction by C. Roth. London, 1937.

Levey, Michael. *Painting at Court*. London, 1971.

Lloyd, Joan B. *African Animals in Renaissance Literature and Art*. Oxford, 1971.

Lohuizen-Mulder, Mab van. *Raphael's Images of Justice, Humanity, Friendship: A Mirror of Princes for Scipione Borghese*. Wassenaar, 1977.

Lomazzo, Giovanni Paolo. *Trattato dell'arte della pittura, scoltura et architettura. . . .* Milan, 1584.

Lubac, Henri de. *Pic de la Mirandole: Études et discussions.* Paris, 1974.

Lundberg, Per. *La typologie baptismale dans l'ancienne église.* Leipzig and Uppsala, 1942.

Luzio, Alessandro. "Isabella d'Este ne' primordi del papato di Leone X e il suo viaggio a Roma nel 1514–1515." *Archivio storico lombardo,* XXXIII, 1906.

Macrobius. *The Saturnalia,* trans. P. V. Davies. New York and London, 1969.

Maguire, William E. *John of Torquemada, O.P.: The Antiquity of the Church.* Washington, D.C., 1957.

Mead, G. R. S. *Thrice-Greatest Hermes: Studies in Hellenistic Theosophy and Gnosis.* London, 1949.

*Meditations on the Life of Christ: An Illustrated Manuscript of the Fourteenth Century,* trans. I. Ragusa, ed. I. Ragusa and R. Green. Princeton, 1961.

Meller, Peter. "Physiognomical Theory in Renaissance Heroic Portraits." In *Studies in Western Art II: The Renaissance and Mannerism.* Princeton, 1963.

Mercati, Angelo. "Le spese private di Leone X nel maggio-agosto 1513." *Atti della Pontificia Accademia Romana di Archeologia: Memorie,* II, 1927.

Meyer-Baer, Kathi. *Music of the Spheres and the Dance of Death: Studies in Musical Iconology.* Princeton, 1970.

Middeldorf, Ulrich. *Raphael's Drawings.* New York, 1945.

Minear, Paul S. *Images of the Church in the New Testament* (1960). Philadelphia, 1977.

Minnich, Nelson H. "Concepts of Reform Proposed at the Fifth Lateran Council." *Archivum Historiae Pontificiae,* VII, 1969.

———. "The Participants at the Fifth Lateran Council." *Archivum Historiae Pontificiae,* XII, 1974.

Mitchell, Bonner. *Rome in the High Renaissance: The Age of Leo X.* Norman, Okla., 1973.

Mommsen, Theodor E. "Aponius and Orosius on the Significance of the Epiphany." In *Late Classical and Mediaeval Studies in Honor of Albert Mathias Friend, Jr.,* ed. K. Weitzmann. Princeton, 1955.

Moncallero, G. L. "La politica di Leone X e di Francesco I nella progettata crociata contro i turchi e nella lotta per la successione imperiale." *Rinascimento,* VIII, 1, 1957.

[Montesquieu, Charles de.] *Voyages de Montesquieu,* ed. A. de Montesquieu. Bordeaux, 1894–96.

Motherway, Thomas J. "The Creation of Eve in Catholic Tradition." *Theological Studies,* I, no. 2, 1940.

Muckle, J. T. "The Doctrine of St. Gregory of Nyssa on Man as the Image of God." *Mediaeval Studies,* VII, 1945.

Müntz, Eugène. *Raphael, His Life, Works, and Times,* ed. W. Armstrong. London, 1888.

Napoli, Giovanni di. *L'immortalità dell'anima nel rinascimento.* Turin, 1963.

Nelson, John C. *Renaissance Theory of Love.* New York and London, 1958.

*New Catholic Encyclopedia.* Washington, D.C., 1967.

*The Notebooks of Leonardo da Vinci,* trans. and ed. E. MacCurdy. New York, 1938.

Novelli, Francesco. *Compendium vitae Leonis papae. X.* Rome, 1536.

Oberhuber, Konrad. "Raphael and the State Portrait— I: The Portrait of Julius II." *Burlington Magazine,* CXIII, 1971.

———. *Raphaels Zeichnungen,* IX. Berlin, 1972.

Oettingen, Wolfgang von. "Antonio Averlino Filarete's Tractat über die Baukunst. . . ." *Quellenschriften für Kunstgeschichte und Kunsttechnik . . . ,* N.F. III. Vienna, 1890.

Offelli, Siro. "Il pensiero del Concilio Lateranense V sulla dimostrabilità razionale dell'immortalità dell'anima umana." *Studia patavina,* II, 1955.

Olin, John C. *The Catholic Reformation: Savonarola to Ignatius Loyola: Reform in the Church, 1495–1540.* New York, 1969.

O'Malley, John W., S.J. "The Discovery of America and Reform Thought at the Papal Court in the Early Cinquecento." In *First Images of America: The Impact of the New World on the Old,* ed. F. Chiappelli et al. Berkeley, 1976.

———. *Giles of Viterbo on Church and Reform: A Study in Renaissance Thought.* Leiden, 1968.

———. "Giles of Viterbo: A Reformer's Thought on Renaissance Rome." *Renaissance Quarterly,* XX, 1967.

———. *Praise and Blame in Renaissance Rome: Rhetoric, Doctrine, and Reform in the Sacred Orators of the Papal Court, c. 1450–1521.* Durham, N.C., 1979.

O'Malley, T. P. *Tertullian and the Bible: Language, Imagery, Exegesis.* Utrecht, 1967.

Origen. *Contra Celsum,* ed. and trans. H. Chadwick. Cambridge, 1965.

———. *Homélies sur l'Exode,* trans. P. Fortier. Paris, 1947.

———. *Homélies sur la Genèse,* trans. L. Doutreleau. Paris, 1943.

———. *The Song of Songs: Commentary and Homilies,* trans. and ed. R. P. Lawson. London, 1957.

Orosius, Paulus. *Seven Books of History Against the Pagans,* trans. and introd. I. W. Raymond. New York, 1936.

Otto, Bishop of Freising. *The Two Cities: A Chronicle of Universal History to the Year 1146 A.D.,* trans. and annotated C. C. Mierow, ed. A. P. Evans and C. Knapp. New York, 1966.

Ovid. *Metamorphoses,* trans. F. J. Miller. Loeb Classical Library. Cambridge, Mass., 1951.

Pächt, Otto. "Jean Fouquet: A Study of His Style." *Journal of the Warburg and Courtauld Institutes,* IV, 1943–47.

*Palazzo Vecchio: committenza e collezionismo medicei* (Firenze e la Toscana dei Medici nell'Europa del Cinquecento). Florence, 1980.

Panofsky, Erwin. *Renaissance and Renascences in Western Art.* Stockholm, 1960.

———. *Studies in Iconology: Humanistic Themes in the Art of the Renaissance.* New York, 1939.

———. *Tomb Sculpture,* ed. H. W. Janson. New York, 1964.

[Panvinio, Onofrio.] *La Historia di Battista Platina delle vite de' pontefici dal Salvatore nostro fino a Paolo II . . . con le vite de gli altri . . . fino a Pio IIII.* Venice, 1563.

Parigi, Luigi. *Laurentiana: Lorenzo dei Medici cultore della musica.* Florence, 1954.

Partridge, Loren W., and Randolph Starn. *A Renaissance Likeness: Art and Culture in Raphael's Julius II.* Berkeley, 1980.

Passavant, Johann David. *Raphaël d'Urbin et son pere Giovanni Santi,* trans. J. Lunteschutz, ed. P. Lacroix. Paris, 1860.

Pastor, Ludwig von. *Storia dei papi,* trans. A. Mercati. Rome: IV, 1960; V, 1959; VI, 1963; VII, 1950; IX, 1925.

Patch, Howard R. "The Last Line of the *Commedia.*" *Speculum,* XIV, 1939.

Peck, George T. *The Fool of God: Jacopone da Todi.* University, Ala., 1980.

Pedretti, Carlo. *The Literary Works of Leonardo da Vinci,* compiled and ed. J.P. Richter. Berkeley, 1977.

Perry, Marilyn. " 'Candor Illaesus': The 'Impresa' of Clement VII and other Medici Devices in the Vatican Stanze." *Burlington Magazine,* CXIX, 1977.

Peterson, Erik. *Pour une théologie du vêtement,* trans. M.-J. Congar. Lyon, 1943.

Pfeiffer, Heinrich, S.J. "Die Predigt des Egidio da Viterbo über das goldene Zeitalter und die Stanza della Segnatura." *Festschrift Luitpold Dussler.* Munich and Berlin, 1972.

———. *Zur Ikonographie von Raffaels Disputa: Egidio da Viterbo und die christlich-platonische Konzeption der Stanza della Segnatura.* Rome, 1975.

Philo Judeaus, trans. F. H. Colson and G. H. Whitaker. Loeb Classical Library. Cambridge, Mass., 1929–62.

Philostratus. *Imagines,* trans. A. Fairbanks. Loeb Classical Library. Cambridge, Mass., 1960.

*Physiologus: A Metrical Bestiary of Twelve Chapters by Bishop Theobald, Printed in Cologne, 1492,* trans. A. W. Rendell. London, 1928.

[Pico della Mirandola, Giovanni.] "Commento . . . sopra una Canzona de Amore composta da Hieronymo benivieni. . . . " In Girolamo Benivieni, *Opere.* Florence, 1519.

———. *Heptaplus: On the Sevenfold Narration of the Six Days of Genesis,* trans. D. Carmichael. Indianapolis, 1965.

———. *On Being and the One,* trans. P. J. W. Miller. Indianapolis, 1965.

———. "Oration on the Dignity of Man," trans. E. L. Forbes. In *The Renaissance Philosophy of Man.* Chicago, 1948.

Picotti, Giovanni Battista. *La prima educazione e l'indole del futuro Leone X.* Potenza, 1919.

Pieraccini, Gaetano. *La stirpe de' Medici di Cafaggiolo.* Florence, 1947.

Piper, Ferdinand. *Mythologie und Symbolik der christlichen Kunst . . .* (1847). Osnabrück, 1972.

Pirro, André. "Leo X and Music." *Musical Quarterly,* XXI, 1935.

*Pitagorici testimonianze e frammenti,* ed. M. T. Cardini. Florence, 1955–64.

Plato. *Laws,* trans. R. G. Bury. Loeb Classical Library. Cambridge, Mass., 1952.

———. *Phaedo,* trans. H. N. Fowler. Loeb Classical Library. Cambridge, Mass., 1960.

———. *The Republic,* trans. P. Shorey. Loeb Classical Library. Cambridge, Mass., 1956.

———. *Symposium,* trans. W. R. M. Lamb. Loeb Classical Library. Cambridge, Mass., 1961.

———. *Timaeus,* trans. R. G. Bury. Loeb Classical Library. Cambridge, Mass., 1952.

Pliny [Plinius Secundus, Caius]. *Natural History,* trans. H. Rackham. Loeb Classical Library. Cambridge, Mass., 1940.

[Pliny.] *The Elder Pliny's Chapters on the History of Art,* trans. K. Jex-Blake. London, 1896.

Plotinos. "On Beauty," *Ennead,* trans. A. H. Armstrong. Loeb Classical Library. Cambridge, Mass., 1966.

*Poesie italiane di Messer Angelo Poliziano.* Milan, 1825.

Pogány-Balás, Edit. *The Influence of Rome's Antique Monumental Sculptures on the Great Masters of the Renaissance,* trans. A. Debreczeni. Budapest, 1980.

Poliziano. See *Poesie. . . .*

Posner, Kathleen Weil Garris, *Leonardo and Central Italian Art: 1515–1550.* New York, 1974.

Puttfarken, Thomas. "Golden Age and Justice in Sixteenth-Century Florentine Political Thought and Imagery: Observations on Three Pictures by Jacopo Zucchi." *Journal of the Warburg and Courtauld Institutes,* XLIII, 1980.

Pythagorus. See *Pitagorici. . . .*

Quasten, Johannes. "A Pythagorean Idea in Jerome." *American Journal of Philology,* LXIII, 1942.

Quednau, Rolf. "Rezensionen: Konrad Oberhuber: Raphaels Zeichnungen. . . ." *Kunstchronik,* XXVII, 1974.

———. *Die Sala di Costantino im Vatikanischen Palast. . . .* Hildesheim and New York, 1979.

Réau, Louis. *Iconographie de l'art chrétien.* Paris, 1955–59.

Redig de Campos, Deoclecio. "Bramante e le logge di San Damaso." In *Studi Bramanteschi.* Rome, 1974.

———. "Dipinti Raffaelleschi tornati in luce nelle logge vaticane." *L'Osservatore romano,* October 31, 1952.

———. *I palazzi vaticani.* Bologna, 1967.

Riley, Hugh M. *Christian Initiation: A Comparative Study of the Interpretation of the Baptismal Liturgy. . . .* Washington, D.C., 1974.

Robbins, Frank E. *The Hexaemeral Literature: A Study of the Greek and Latin Commentaries on Genesis.* Chicago, 1912.

Roscoe, William. *The Life and Pontificate of Leo the Tenth.* Liverpool, 1805.

———. *Vita e pontificato di Leone X. di Guglielmo Roscoe,* ed. and trans. L. Bossi. Milan, 1816—17.

———. *The Life of Lorenzo de' Medici, called The Magnificent,* ed. T. Roscoe. London, 1851.

Rosenberg, Alfons. *Engel und Dämonen: Gestaltwandel eines Urbildes.* Munich, 1967.

Rowland, Beryl. *Animals with Human Faces: A Guide to Animal Symbolism.* Knoxville, 1973.

*Sacrum Lateranenense concilium novissimum sub Iulio. II. et Leone. X. celebratum,* ed. A. de Monte. Rome, 1521.

Sadlowski, Erwin L. *Sacred Furnishings of Churches.* Washington, D.C., 1951.

Saitta, Giuseppe. *Marsilio Ficino e la filosofia dell'umanesimo.* Bologna, 1954.

Salmi, Mario. *Italian Miniatures.* New York, 1954.

[Sanuto.] *I diarii di Marino Sanuto.* Venice, 1879–1903.

Saxl, Fritz. "Pagan Sacrifice in the Italian Renaissance." *Journal of the Warburg Institute,* II, 1939.

Schapiro, Meyer. "The Joseph Scenes on the Maximianus Throne in Ravenna." *Gazette des Beaux-Arts,* XL, 1952.

Schiller, Gertrud. *Iconography of Christian Art,* trans. J. Seligman. Greenwich, Conn., 1971.

Schwager, Klaus. "Über Jean Fouquet in Italien und sein verlorenes Porträt Papst Eugens IV." *Argo: Festschrift für Kurt Badt.* Cologne, 1970.

*Scritti d'arte del cinquecento,* ed. P. Barocchi. Milan, 1971–77.

Seligmann, Kurt. *The Mirror of Magic.* New York, 1948.

Setton, Kenneth M. "Pope Leo X and the Turkish Peril." *Proceedings of the American Philosophical Society,* CXIII, 1969.

Seznec, Jean. *The Survival of the Pagan Gods,* trans. B. F. Sessions. New York, 1953.

Shaw, James Byam. *Drawings by Old Masters at Christ Church, Oxford.* Oxford, 1976.

Shearman, John. *Andrea del Sarto.* Oxford, 1965.

———. "The Chigi Chapel in S. Maria del Popolo." *Journal of the Warburg and Courtauld Institutes,* XXIV, 1961.

———. "The Florentine *Entrata* of Leo X, 1515." *Journal of the Warburg and Courtauld Institutes,* XXXVIII, 1975.

———. "Raphael as Architect." *Journal of the Royal Society of Arts,* CXVI, 1968.

———. *Raphael's Cartoons in the Collection of Her Majesty the Queen and the Tapestries for the Sistine Chapel.* London, 1972.

———. "Raphael's Unexecuted Projects for the Stanze." *Walter Friedlaender zum 90. Geburtstag.* Berlin, 1965.

———. "The Vatican Stanze: Functions and Decoration." *Proceedings of the British Academy,* LVII, 1971.

Sheppard, Anne. "The Influence of Hermias on Marsilio Ficino's Doctrine of Inspiration." *Journal of the Warburg and Courtauld Institutes,* XLIII, 1980.

Sherr, Richard. "A new document concerning Raphael's portrait of Leo X." *Burlington Magazine,* CXXV, 1983.

Shorr, Dorothy C. "Some Notes on the Iconography of Petrarch's Triumph of Fame." *Art Bulletin,* XX, 1938.

Signorelli, Giuseppe. *Il card. Egidio da Viterbo agostiniano, umanista e riformatore, 1469–1532.* Florence, 1929.

Simpson, W. A. "Cardinal Giordano Orsini (†1438) as a Prince of the Church and a Patron of the Arts: A Contemporary Panegyric and Two Descriptions of the Lost Frescoes in Monte Giordano." *Journal of the Warburg and Courtauld Institutes,* XXIX, 1966.

Sinding-Larsen, Staale. "A Re-reading of the Sistine Ceiling." *Acta ad archaeologiam et artium historiam pertinentia* (Institutum Romanum Norvegiae), IV, 1969.

Smith, Graham. *The Casino of Pius IV.* Princeton, 1977.

Steger, Hugo. *David Rex et Propheta.* Nuremberg, 1961.

Steinberg, Leo. "Leonardo's *Last Supper.*" *Art Quarterly,* XXXVI, 1973.

*The Study of Liturgy,* ed. C. Jones, G. Wainwright, and E. Yarnold. New York, 1978.

Swanston, Hamish F. *The Kings and the Covenant.* London, 1968.

Tacchi Venturi, Pietro. *La vita religiosa in Italia durante la prima età della Compagnia di Gesù.* Rome, 1930.

Taja, Agostino. *Descrizione del Palazzo Apostolico Vaticano.* Rome, 1750.

"Tertullian on the Soul," trans. E. A. Quain. In *Tertullian: Apologetical Works, and Minucius Felix: Octavius.* New York, 1950.

*Tertullian's Treatises, Concerning Prayer, Concerning Baptism,* trans. A. Souter. New York, 1919.

Tervarent, Guy de. *Attributs et symboles dans l'art profane, 1450–1600.* Geneva, 1958–59.

Theodore of Mopsuestia. See *Commentary of. . . .*

Thomas Aquinas, St. *Basic Writings of Saint Thomas Aquinas,* ed. A. C. Pegis. New York, 1945.

Thomas, Jules. *Le Concordat de 1516.* Paris, 1910.

Tierney, Brian. *The Crisis of Church and State, 1050–1300.* Englewood Cliffs, N.J., 1964.

Tolnay, Charles de. *Michelangelo—II: The Sistine Ceiling.* Princeton, 1945; and *Michelangelo—III: The Medici Chapel.* Princeton, 1948.

Topsell, Edward. *The History of Four-Footed Beasts and Serpents and Insects* (1658, based on Conrad Gesner), ed. W. Ley. New York, 1967.

*Trattati d'arte del cinquecento, fra manierismo e controriforma,* ed. P. Barocchi. Bari, 1960–62.

Trinkaus, Charles E., Jr. *In Our Image and Likeness: Humanity and Divinity in Italian Humanist Thought.* London, 1970.

———. Introduction to "Lorenzo Valla, Dialogue on Free Will." In *The Renaissance Philosophy of Man.* Chicago, 1948.

Vasari, Giorgio. *Le vite de' più eccellenti pittori, scultori ed architettori,* ed. G. Milanesi. Florence, 1878–85.

Vaughan, Herbert M. *The Medici Popes* (1908). London, 1971.

Venturi, Adolfo. "Pitture nella Villa Madama di Gio. da Udine e Giulio Romano." *Archivio storico d'arte,* II, 1889.

Virgil. *Aeneid,* trans. H. R. Fairclough. Loeb Classical Library. Cambridge, Mass., 1978.

———. *Eclogues,* trans. H. R. Fairclough. Loeb Classical Library. Cambridge, Mass., 1978.

Vitruvius. *On Architecture,* trans. F. Granger. Loeb Classical Library. Cambridge, Mass., 1962.

Walker, Daniel P. *The Ancient Theology: Studies in Christian Platonism from the Fifteenth to the Sixteenth Century.* Ithaca, N.Y., 1972.

———. "Orpheus the Theologian and Renaissance Platonists." *Journal of the Warburg and Courtauld Institutes,* XVI, 1953.

———. *Spiritual and Demonic Magic from Ficino to Campanella.* London, 1958.

Wasserman, Jack. *Ottaviano Mascarino and His Drawings in the Accademia Nazionale di San Luca.* Rome, 1966.

Weitzmann, Kurt. "The Study of Byzantine Book Illumination, Past, Present, and Future." In *The Place of Book Illumination in Byzantine Art.* Princeton, 1975.

Wind, Edgar. "The Ark of Noah: A Study in the Symbolism of Michelangelo." *Measure,* I, 4, 1950.

———. "Michelangelo's Prophets and Sibyls." *Proceedings of the British Academy,* LI (1960), 1965.

———. *Pagan Mysteries in the Renaissance.* New Haven, 1958.

Winternitz, Emanuel. *Musical Instruments and Their Symbolism in Western Art.* New Haven and London, 1979.

Yates, Frances A. *Astraea: The Imperial Theme in the Sixteenth Century.* London, 1975.

———. *Giordano Bruno and the Hermetic Tradition.* London, 1964.

*Zimelien: Abendländische Handschriften des Mittelalters aus den Sammlungen der Stiftung Preussischer Kulturbesitz.* Berlin, 1975–76.

Zupnick, I. L. "The Significance of the Stanza dell'Incendio: Leo X and François I." *Gazette des Beaux-Arts,* LXXX, 1972.

# INDEX

# Illustrations

# PLAN OF THE VATICAN LOGGE

The west wall is the interior wall toward the palace. To the east are the open arches facing the city of Rome. South is the direction toward St. Peter's. North faces toward the Belvedere corridor.

**West**

| | e | | e | | e | | e | | e | | e | | e | | e | | e | | e | | e | | e | | e | |
|---|---|---|---|---|---|---|---|---|---|---|---|---|---|---|---|---|---|---|---|---|---|---|---|---|---|---|
| | a | | b | | a | | a | | a | | a | | a | | a | | a | | a | | a | | a | | a | |
| **South** e | d | **1** | b | a | **2** | c | d | **3** | b | d | **4** | c | d | **5** | c | d | **6** | b | d | **7** | b | d | **8** | b | d | **9** | b | d | **10** | b | d | **11** | b | d | **12** | b | d | **13** | b | **North** |
| | | c | | | d | | | c | | | b | | | b | | | c | | | c | | | c | | | c | | | c | | | c | | | c | | | c | |

**East**

### Bay 1
Creation

**a** God separating light from dark

**b** God separating land from water

**c** Creation of the sun and the moon

**d** Creation of the animals

**e** God establishes the Sabbath

### Bay 2
Fall of Man

**a** God presents Eve to Adam

**b** The temptation of Adam and Eve

**c** The expulsion from Paradise

**d** Adam and Eve laboring

**e** Cain and Abel

### Bay 3
Noah

**a** Construction of the ark

**b** The Deluge

**c** Exit from the ark

**d** Sacrifice of Noah

**e** God's covenant with Noah

### Bay 4
Abraham

**a** Abraham and Melchisedec

**b** God appears to Abraham

**c** Angels appear to Abraham

**d** Lot's family flees Sodom

**e** The sacrifice of Isaac

### Bay 5
Isaac

**a** God appears to Isaac

**b** Isaac embraces Rebekah

**c** Isaac blesses Jacob

**d** Esau appears before Isaac

### Bay 6
Jacob

**a** Jacob's dream

**b** Jacob meets Rachel

**c** Jacob asks for Rachel as wife

**d** Jacob returns to Canaan

**e** Jacob struggles with the angel

### Bay 7
Joseph

**a** Joseph tells his brothers his dream

**b** Joseph sold by his brothers

**c** Joseph and Potiphar's wife

**d** Joseph interprets the pharaoh's dream

**e** Joseph tells his brothers to return to Canaan

### Bay 8
Moses

**a** The infant Moses found by the river

**b** Moses and the burning bush

**c** Moses parts the Red Sea

**d** Moses strikes the rock at Horeb

**e** The gathering of Manna

### Bay 9
Moses

**a** Moses on the mountain

**b** Adoration of the Golden Calf

**c** God speaks to Moses

**d** Moses presents the tablets of the Law

**e** Destruction of the sons of Aaron

### Bay 10
Joshua

**a** Joshua crosses the Jordan

**b** The fall of Jericho

**c** The victory over the Amorites

**d** The distribution of lands

**e** The renewal of the covenant at Shechem

### Bay 11
David

**a** Samuel anoints David

**b** David kills Goliath

**c** David and Bathsheba

**d** David's victory over the Ammonites

**e** David promises Bathsheba that Solomon will rule

### Bay 12
Solomon

**a** Zadok anoints Solomon

**b** The judgment of Solomon

**c** Solomon builds the Temple

**d** Solomon and the Queen of Sheba

**e** Jeroboam kneels before Rehoboam

### Bay 13
Christ

**a** Adoration of the shepherds

**b** Adoration of the kings

**c** Baptism of Christ

**d** The Lord's Supper

**e** The Resurrection

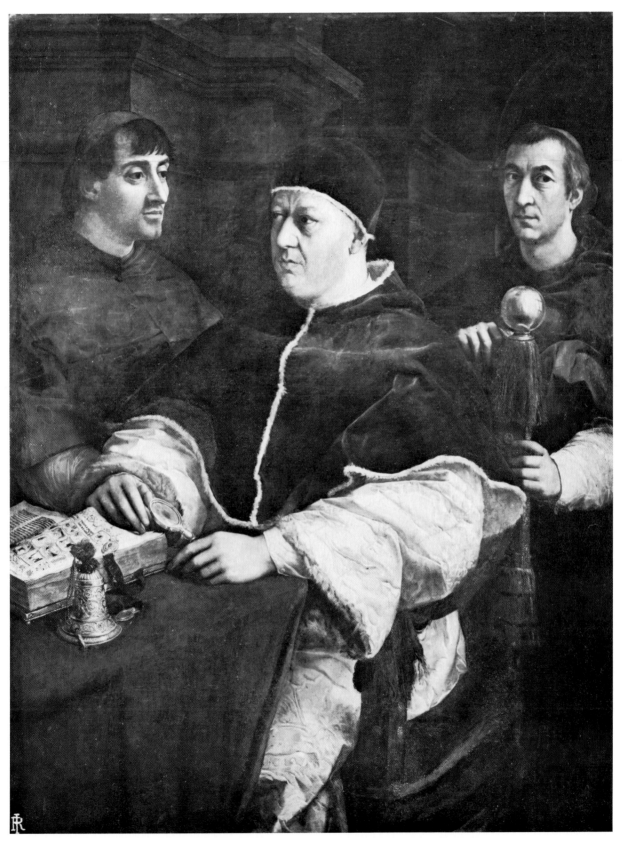

Fig. 1. RAPHAEL, *Portrait of Pope Leo X with Cardinals Giulio de' Medici and Luigi de' Rossi*

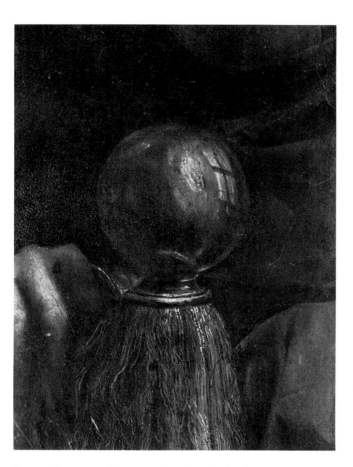

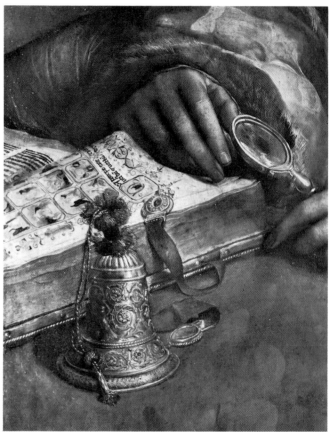

Fig. 2. Raphael, *Portrait of Pope Leo X,* detail

Fig. 3. Raphael, *Portrait of Pope Leo X,* detail

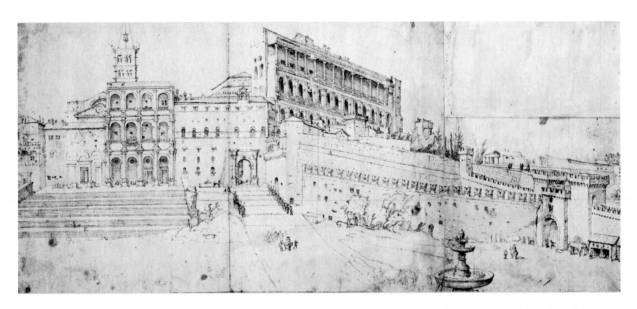

FIG. 4. MAARTEN VAN HEEMSKERCK, drawing of St. Peter's and the Vatican palace. Vienna, Albertina, Inv. 31681

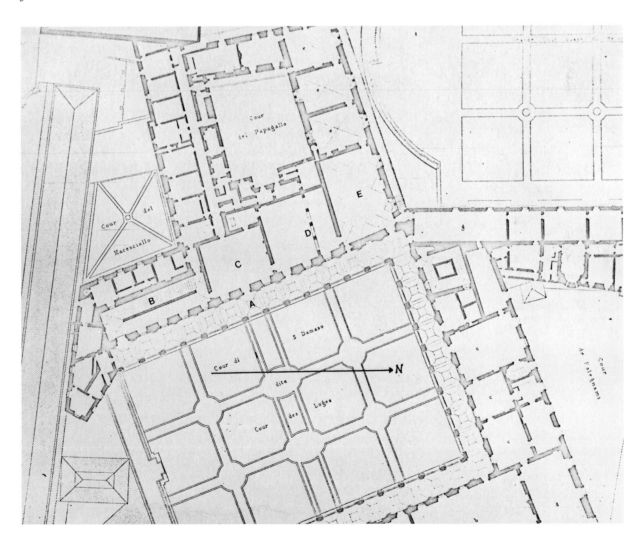

FIG. 5. Plan of the third level of the Vatican palace (detail from P. Letarouilly, *Le Vatican et la Basilique de Saint-Pierre à Rome*, Paris, 1882, I, pl. 18). A. Logge. B. Cordonata. C. Camera de' Paramenti. D. Sala de' Palafrenieri. E. Sala di Costantino.

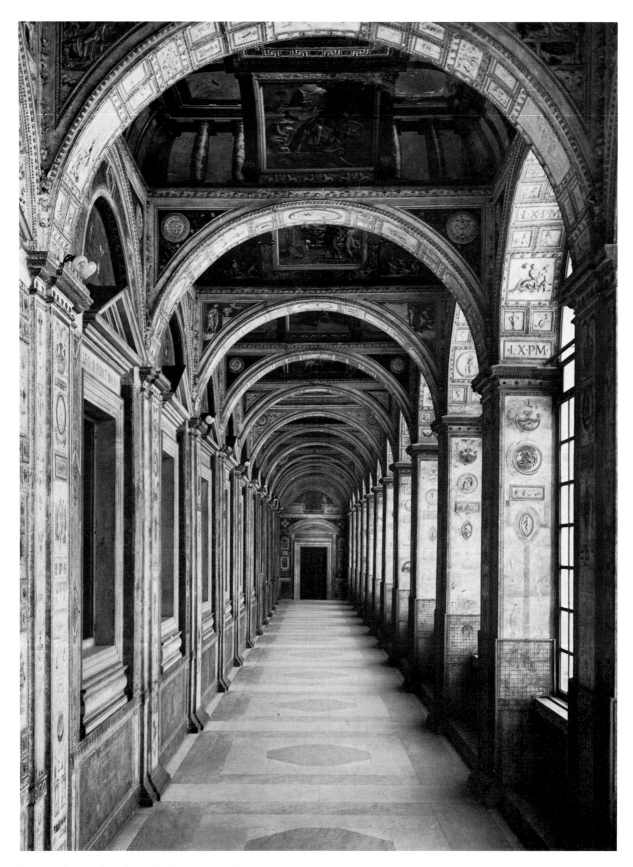

FIG. 6. Logge, interior view looking north

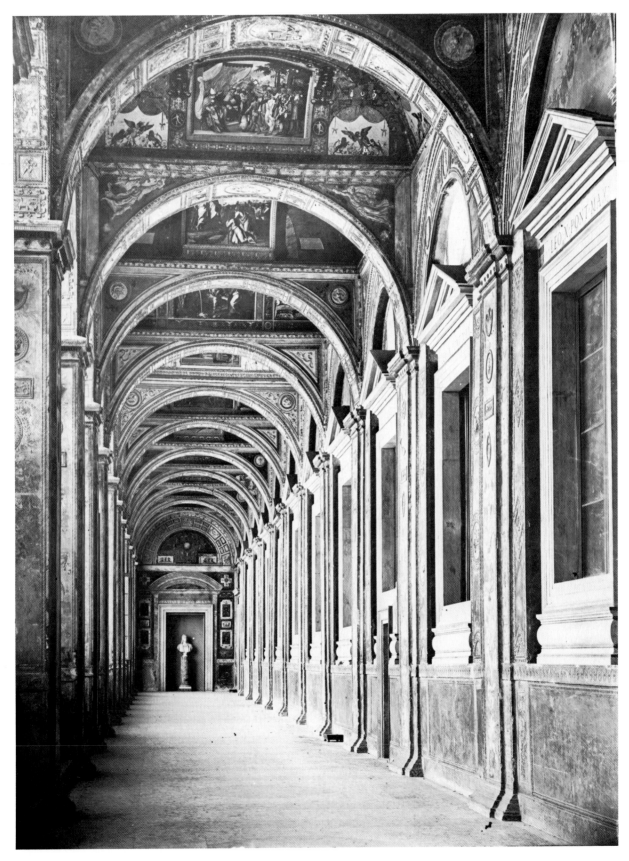

FIG. 7. Logge, interior view looking south

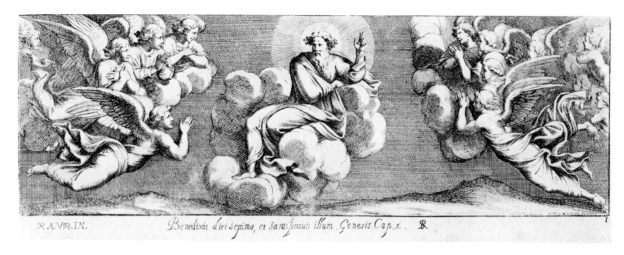

R.A.VR.IN.　　　　Benedixit diei septimo, et sanctificauit illum. Genesis Cap.2.　R.

Fig. 8.  Pietro Santo Bartoli, engraving after the basamento of Bay 1, *God Establishing the Sabbath*. New York, Metropolitan Museum of Art

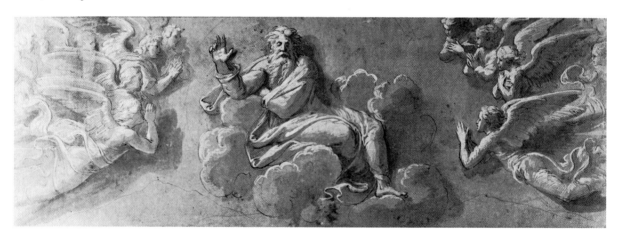

Fig. 9.  Copy after a drawing by Giovanni Francesco Penni (?), *God Establishing the Sabbath*. Haarlem, Teylers Stichting, A 73

Fig. 10. Bay 1 of Logge, vault

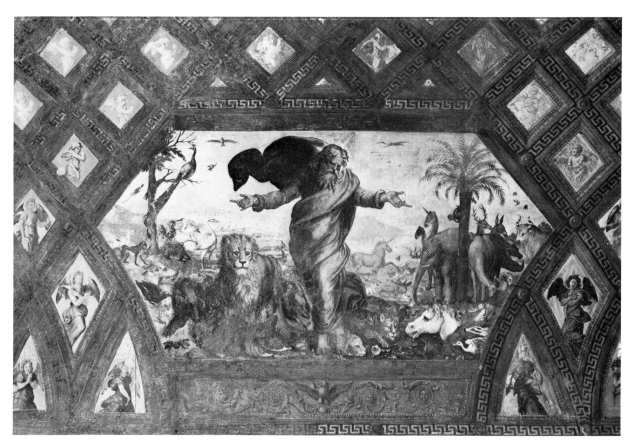

FIG. 11. Bay 1, *God Creating the Animals*

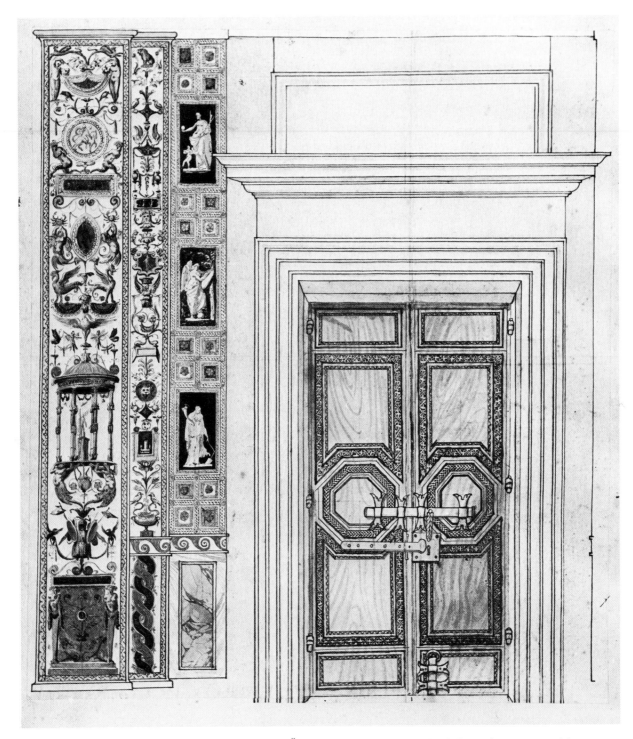

FIG. 12. Bay 1, drawing of the west wall. Vienna, Österreichische Nationalbibliothek, Codex min. 33, fol. 2

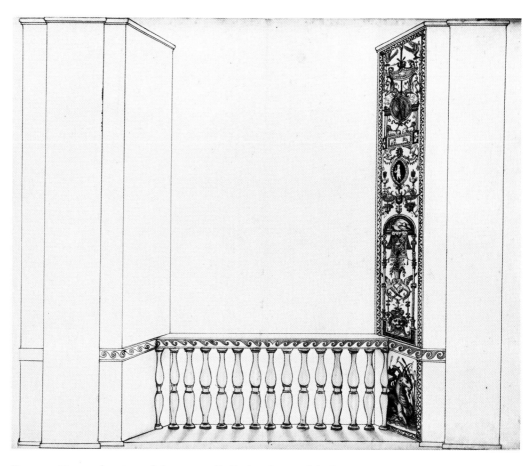

FIG. 13. Bay 1, drawing of the east wall. Cod. min. 33, fol. 6

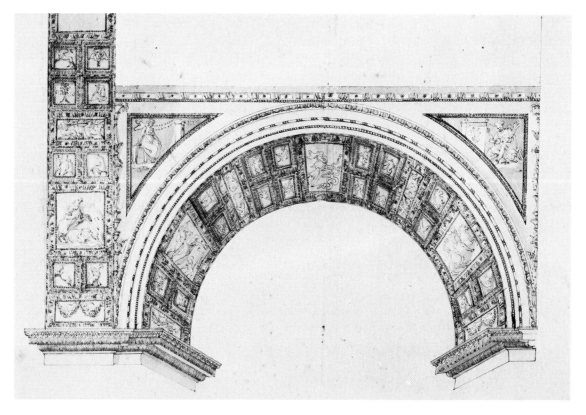

FIG. 14. Bay 1, drawing of the arch of the east wall. Cod. min. 33, fol. 7

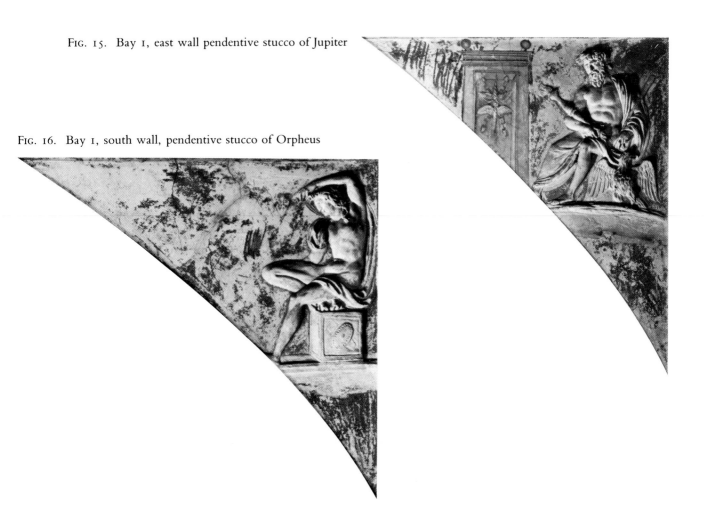

FIG. 15. Bay 1, east wall pendentive stucco of Jupiter

FIG. 16. Bay 1, south wall, pendentive stucco of Orpheus

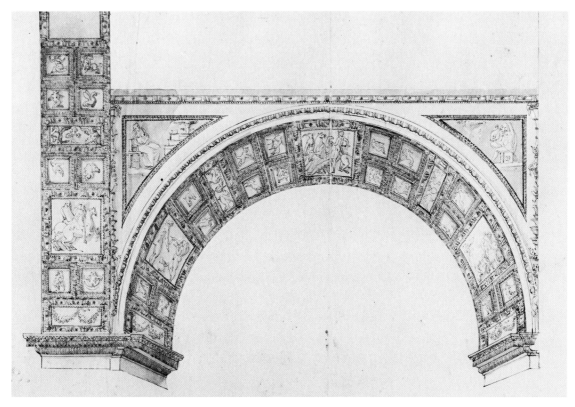

FIG. 17. Bay 1, drawing of the arch of the south wall. Cod. min. 33, fol. 4

FIG. 19. Bay 1, east wall, north pilaster

FIG. 18. Bay 1, west wall, pendentive stucco

FIG. 20. Bay 1, west wall, lunette

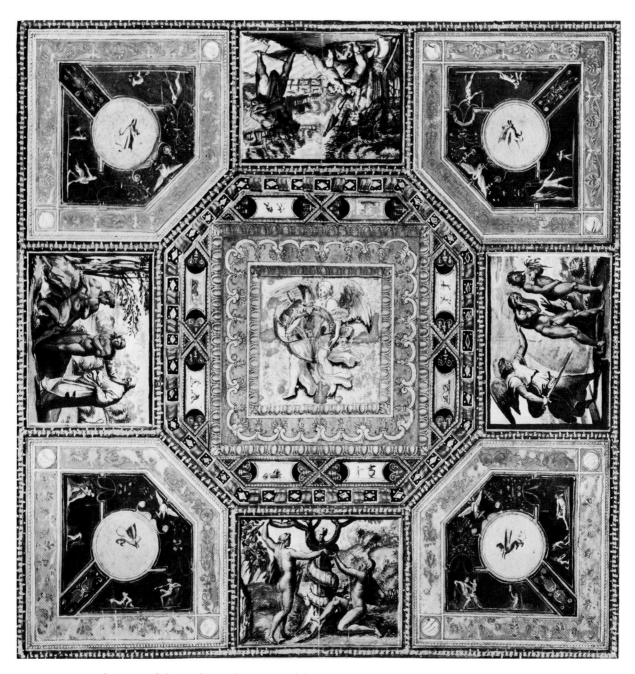

FIG. 21. Bay 2, drawing of the vault. Cod. min. 33, fol. 16

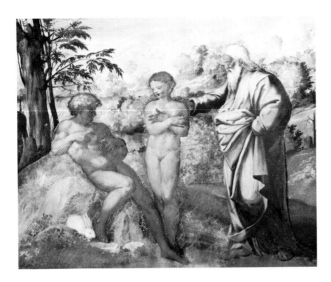

FIG. 22. Bay 2, *God Presents Eve to Adam*

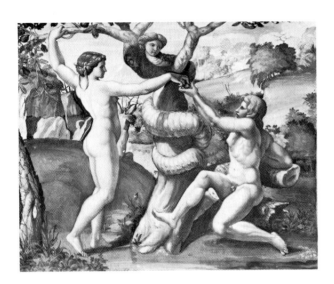

FIG. 23. Bay 2, *The Temptation of Adam and Eve*

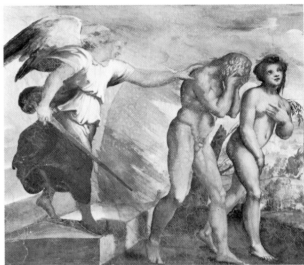

FIG. 24. Bay 2, *The Expulsion of Adam and Eve from Paradise*

FIG. 25. Bay 2, *Adam and Eve at Work*

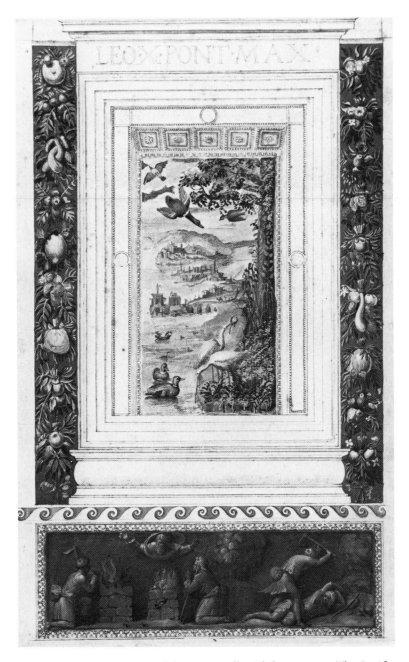

Fig. 26. Bay 2, drawing of the west wall with basamento, *The Sacrifice of Cain and Abel: Cain Kills Abel*. Cod. min. 33, fol. 10

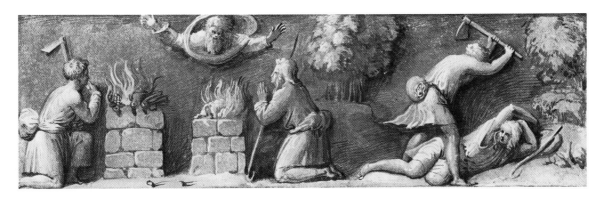

*Detail of basamento*

FIG. 27. Bay 2, east wall, stuccoes of the north pilaster, with *The Expulsion of Adam and Eve*

FIG. 28. Bay 2, north arch, pendentive stucco of an oracle

FIG. 29. Bay 2, south arch, pendentive stucco of a sleeping oracle

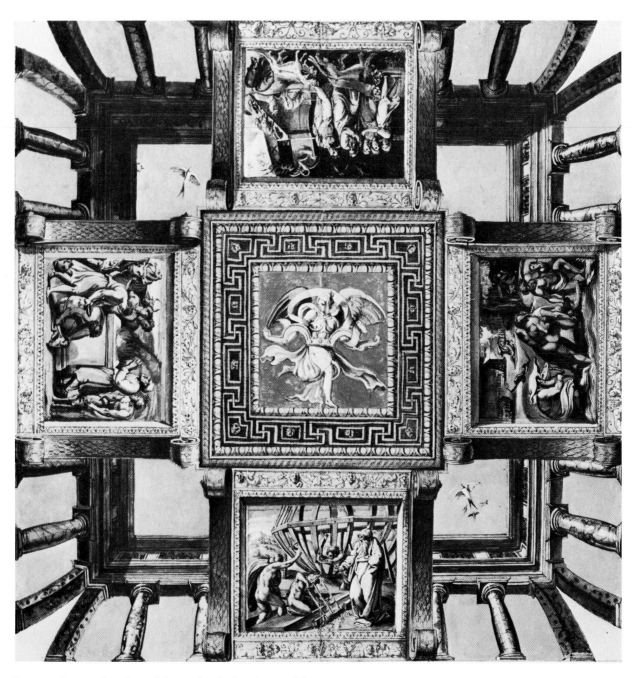

FIG. 30. Bay 3, drawing of the vault. Cod. min. 33, fol. 24

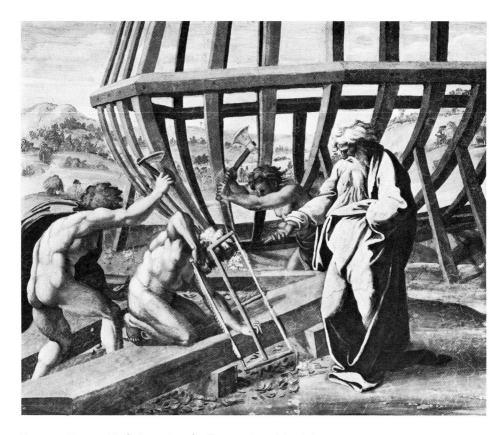

FIG. 31. Bay 3, *Noah Supervises the Construction of the Ark*

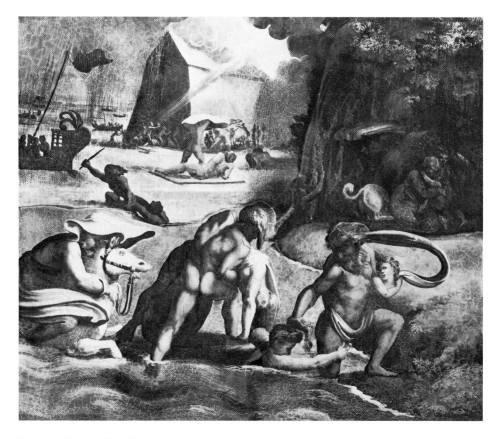

FIG. 32. Bay 3, *The Deluge*

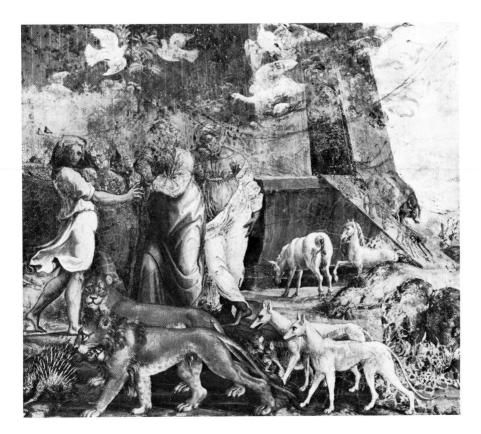

Fig. 33. Bay 3, *Disembarkation from the Ark*

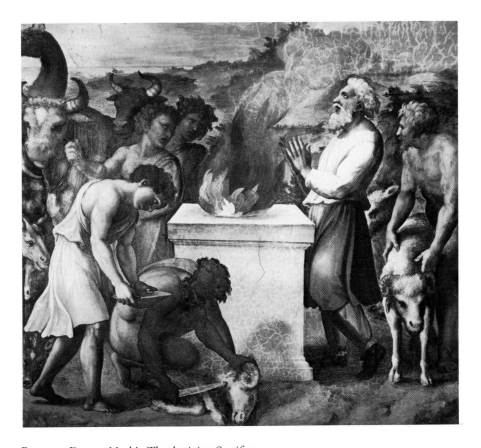

Fig. 34. Bay 3, *Noah's Thanksgiving Sacrifice*

Fig. 35. Bay 3, drawing of the west wall with basamento, *God's Covenant with Noah*. Cod. min. 33, fol. 18

*Detail of basamento*

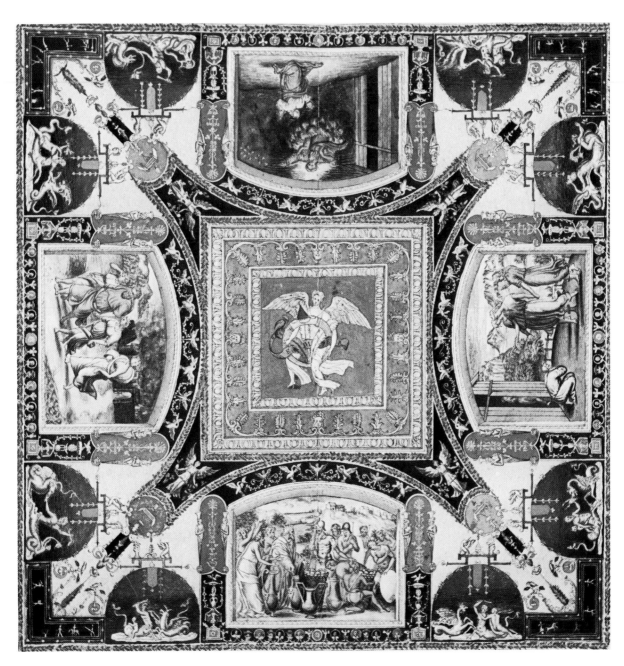

Fig. 36. Bay 4, drawing of the vault. Cod. min. 33, fol. 32

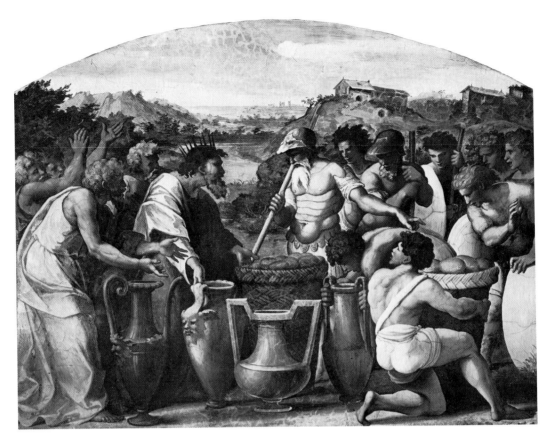

Fig. 37. Bay 4, *The Meeting of Abraham and Melchisedec*

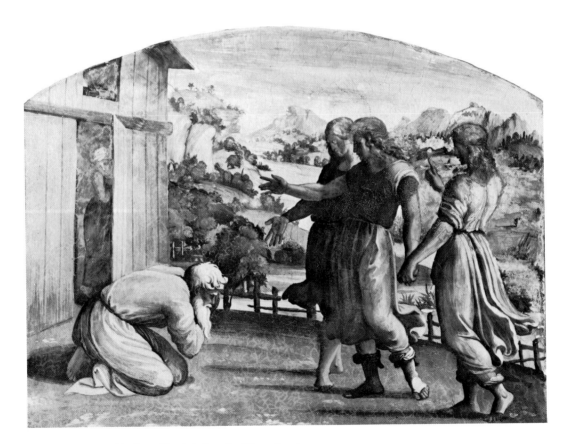

Fig. 38. Bay 4, *Abraham Kneels before the Three Angels*

FIG. 39. Bay 4, *God's Covenant with Abraham*

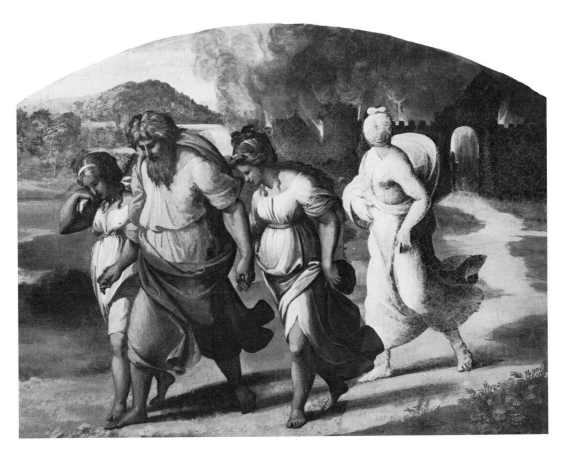

FIG. 40. Bay 4, *Lot and His Family Flee Sodom*

FIG. 41. Bay 4, drawing of the west wall with basamento, *The Sacrifice of Isaac.* Cod. min. 33, fol. 26

*Detail of basamento*

FIG. 42. Bay 4, drawing of the north arch. Cod. min. 33, fol. 28

FIG. 43. Bay 4, drawing of the east wall. Cod. min. 33, fol. 30

FIG. 44. Pilaster of the west wall, between Bays 4 and 5

FIG. 45. Bay 5, drawing of the vault. Cod. min. 33, fol. 41

FIG. 46. Bay 5, *God Renews the Covenant with Isaac*

FIG. 47. Bay 5, *Isaac Embraces Rebekah*

Fig. 48. Bay 5, *Isaac Blesses Jacob*

Fig. 49. Bay 5, *Esau Discovers that Isaac Has Blessed Jacob*

FIG. 50. Bay 5, drawing of the west wall. Cod. min. 33, fol. 34

FIG. 51. Pilaster of the east wall between
Bays 4 and 5

FIG. 52. Drawing of the pilaster of the west wall between
Bays 5 and 6. Cod. min. 33, fol. 40

FIG. 53. Bay 6, drawing of the vault. Cod. min. 33, fol. 48

FIG. 54. Bay 6, *Jacob's Dream*

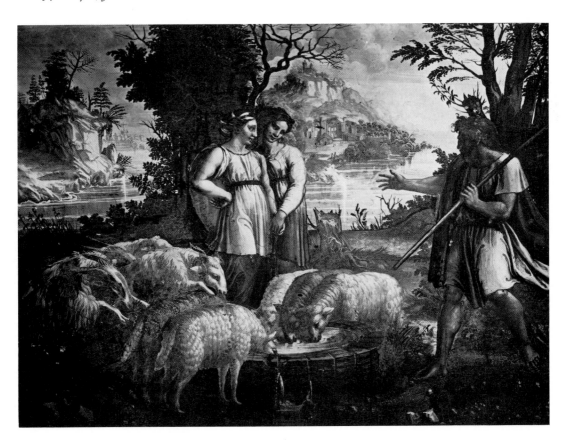

FIG. 55. Bay 6, *Jacob Meets Rachel*

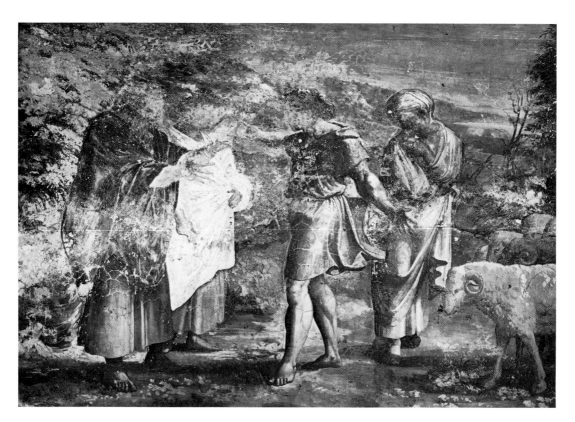

FIG. 56. Bay 6, *Jacob Asks for Rachel as Wife*

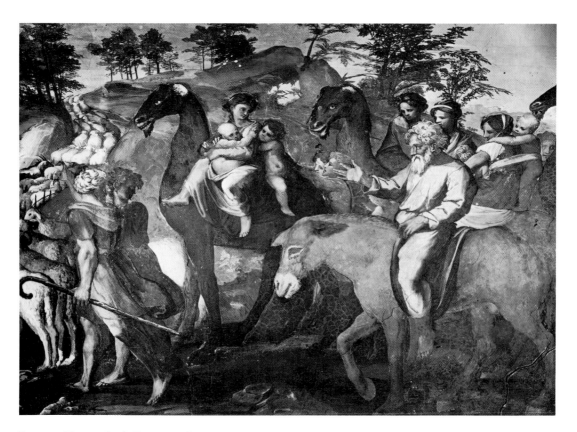

FIG. 57. Bay 6, *Jacob Returns to Canaan*

Fig. 58. Bay 6, drawing of the west wall with basamento, *Jacob Struggles with the Angel*. Cod. min. 33, fol. 42

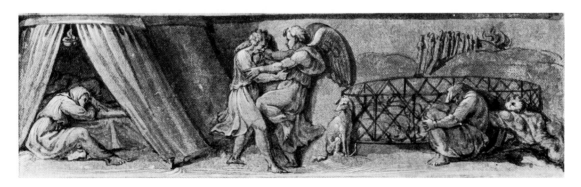

*Detail of basamento*

Fig. 59. Drawing of the pilaster of the west wall between Bays 6 and 7. Cod. min. 33, fol. 49

Fig. 60. Bay 7, vault

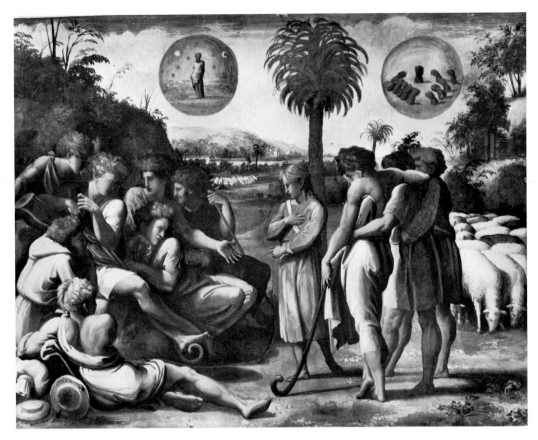

FIG. 61. Bay 7, *Joseph Tells His Brothers His Dreams*

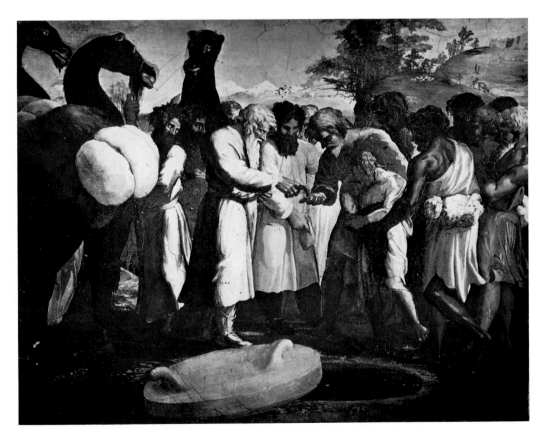

FIG. 62. Bay 7, *Joseph is Sold by His Brothers*

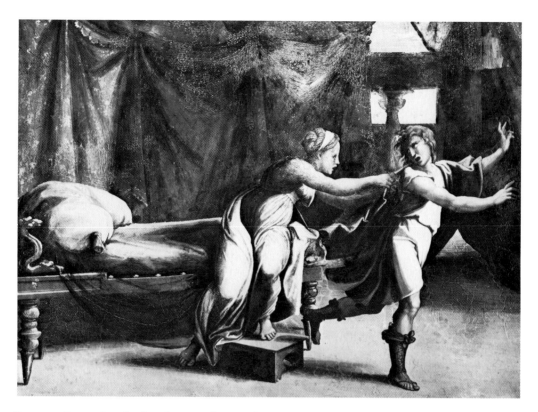

FIG. 63. Bay 7, *Joseph Flees from Potiphar's Wife*

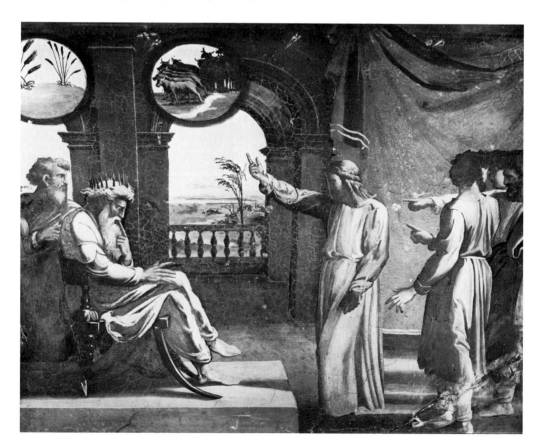

FIG. 64. Bay 7, *Joseph Interprets the Pharaoh's Dreams*

FIG. 65. Bay 7, drawing of the west wall with basamento, *Joseph Addresses His Brothers*. Cod. min. 33, fol. 50

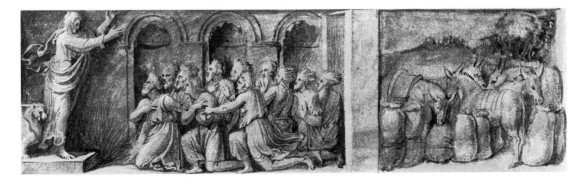

*Detail of basamento*

FIG. 66. Bay 7, pilaster of the east wall

FIG. 67. Bay 7, drawing of the east wall. Cod. min. 33, fol. 54

FIG. 68. Bay 8, drawing of the vault. Cod. min. 33, fol. 64

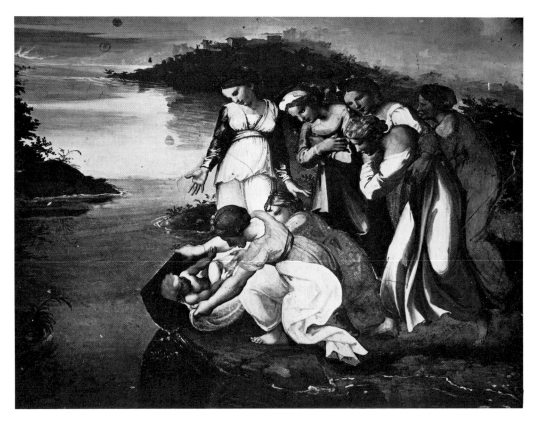

FIG. 69. Bay 8, *The Pharaoh's Daughter Discovers the Infant Moses*

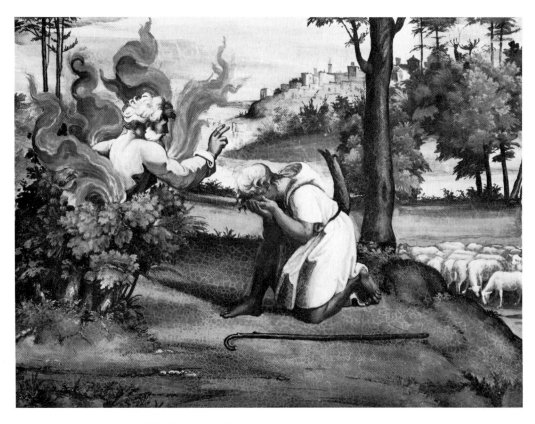

FIG. 70. Bay 8, *Moses and the Burning Bush*

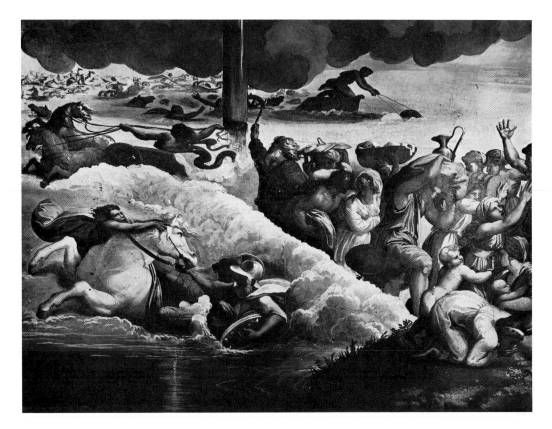

FIG. 71. Bay 8, *Moses Parts the Red Sea*

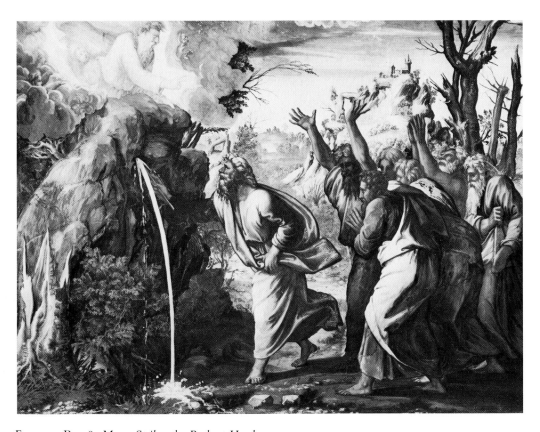

FIG. 72. Bay 8, *Moses Strikes the Rock at Horeb*

LEO·X·PONT·MAX·

FIG. 73. Bay 8, drawing of the west wall with basamento,
*The Gathering of Manna*. Cod. min. 33, fol. 58

*Detail of basamento*

FIG. 74. Pilaster of the west wall between Bays 8 and 9

FIG. 75. Bay 9, drawing of the vault. Cod. min. 33, fol. 72

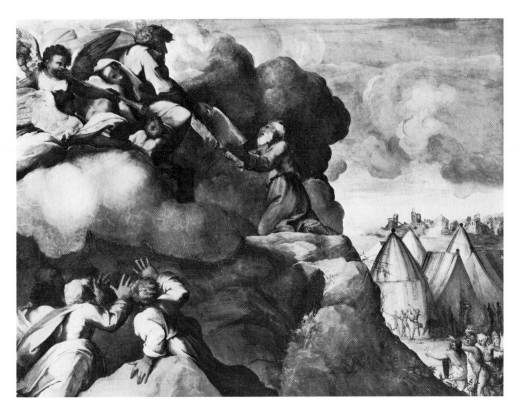

FIG. 76.  Bay 9, *Moses Receives the Tablets of the Law*

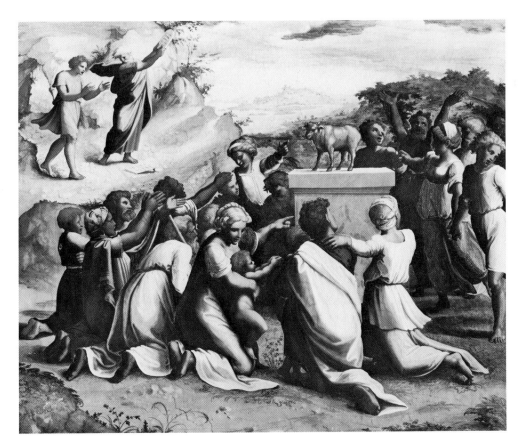

FIG. 77.  Bay 9, *The Israelites Worship the Golden Calf*

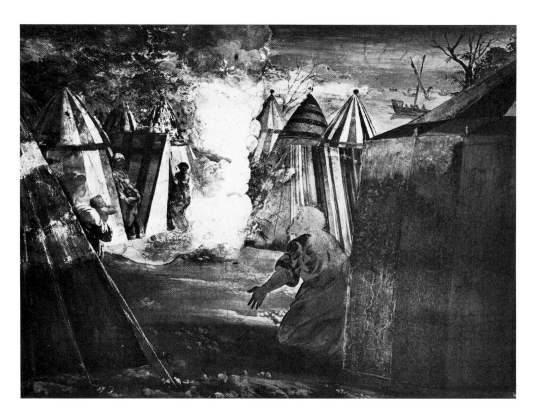

FIG. 78. Bay 9, *God Speaks to Moses from a Pillar of Cloud*

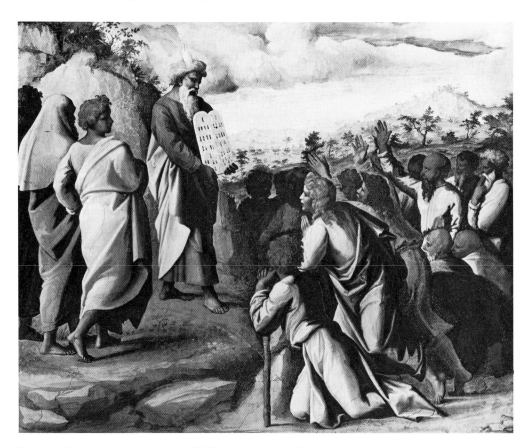

FIG. 79. Bay 9, *Moses Presents the Tablets of the Law to the Israelites*

FIG. 80. Bay 9, drawing of the west wall with basamento,
*The Destruction of the Sons of Aaron.* Cod. min. 33, fol. 66

*Detail of basamento*

Fig. 81. Girolamo da Carpi, copy after *The Destruction of the Sons of Aaron*. Philadelphia, The Rosenbach Museum and Library, R 133

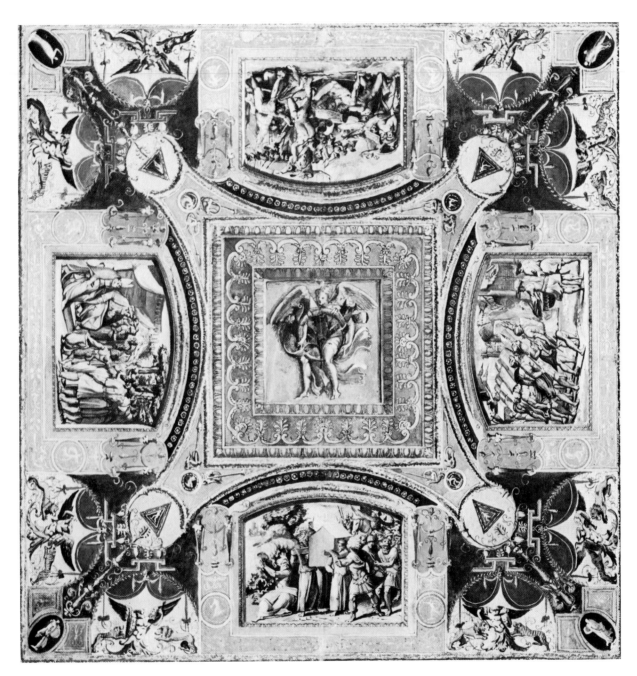

FIG. 82. Bay 10, drawing of the vault. Cod. min. 33, fol. 80

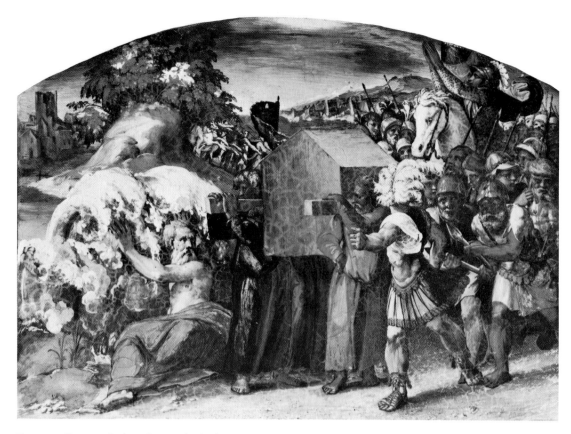

FIG. 83. Bay 10, *Joshua Crosses the Jordan*

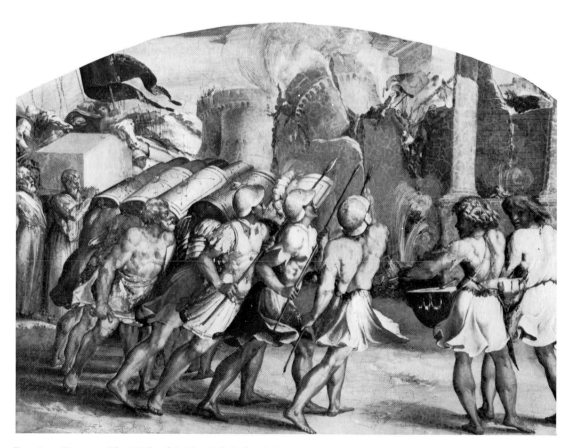

FIG. 84. Bay 10, *The Walls of Jericho Fall Before Joshua*

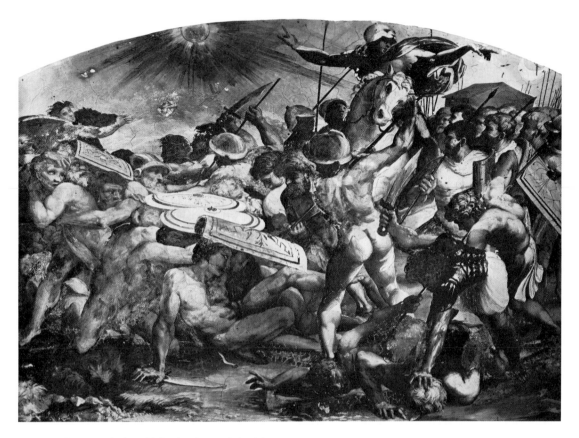

FIG. 85. Bay 10, *Joshua Halts the Sun and the Moon*

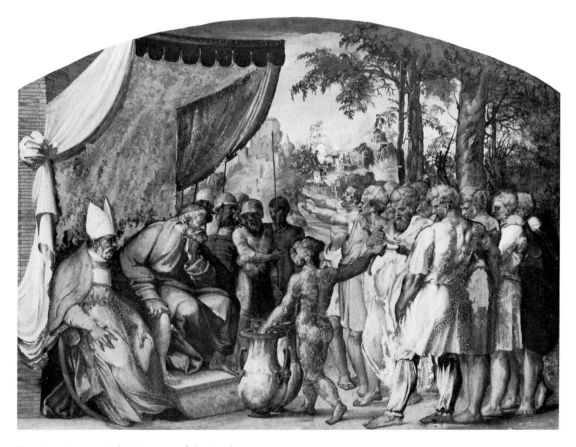

FIG. 86. Bay 10, *The Division of the Lands*

LEO·X·PONT·MAX·

FIG. 87. Bay 10, drawing of the west wall with basamento,
*Joshua Renews the Covenant at Shechem*. Cod. min. 33, fol. 74

*Detail of basamento*

FIG. 88. Bay 10, drawing of the south arch. Cod. min. 33, fol. 76

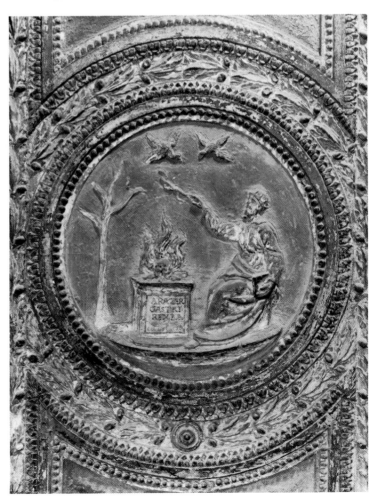

FIG. 89. Bay 10, pilaster of the west wall, stucco relief of Zoroaster

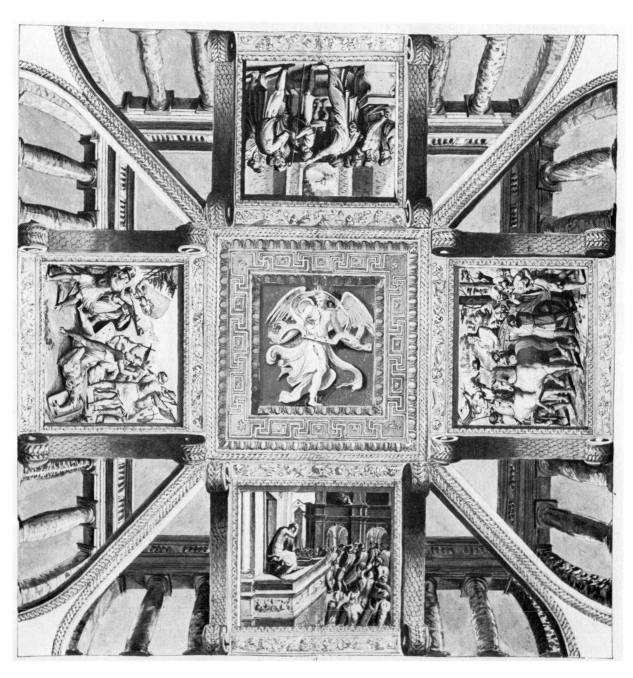

Fig. 90. Bay 11, drawing of the vault. Cod. min. 33, fol. 88

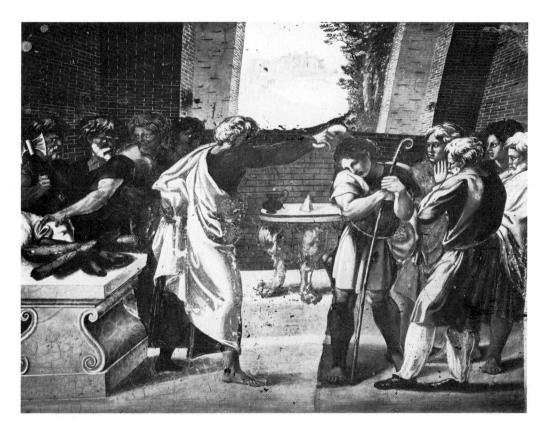

FIG. 91. Bay 11, *Samuel Anoints David*

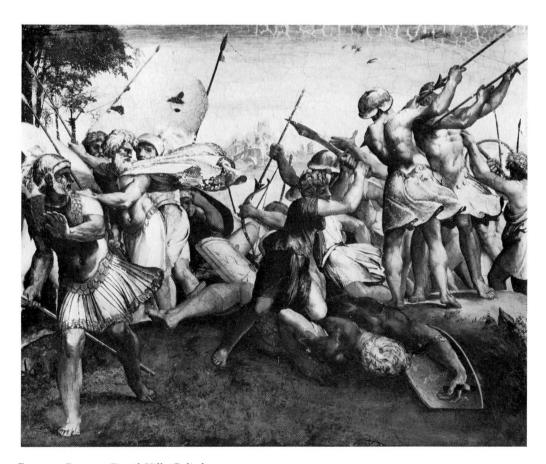

FIG. 92. Bay 11, *David Kills Goliath*

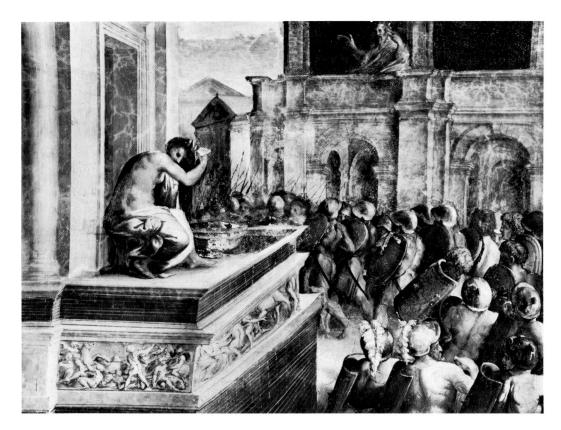

FIG. 93. Bay 11, *David and Bathsheba*

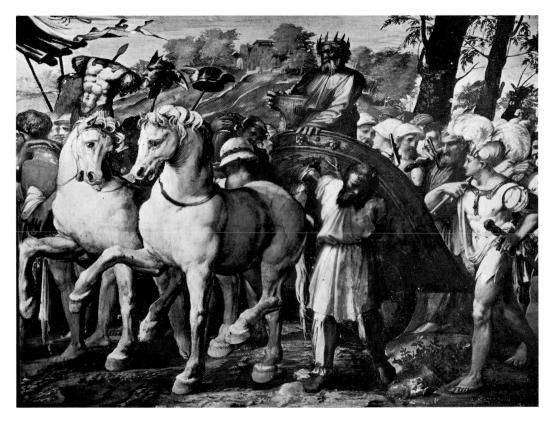

FIG. 94. Bay 11, *David's Victory over the Ammonites*

FIG. 95. Bay 11, drawing of the west wall with basamento, *David Promises Bathsheba that Solomon Will Rule*. Cod. min. 33, fol. 82

*Detail of basamento*

FIG. 96. Bay 11, drawing of the east wall. Cod. min. 33, fol. 86

FIG. 97. Bay 12, drawing of the vault. Cod. min. 33, fol. 97

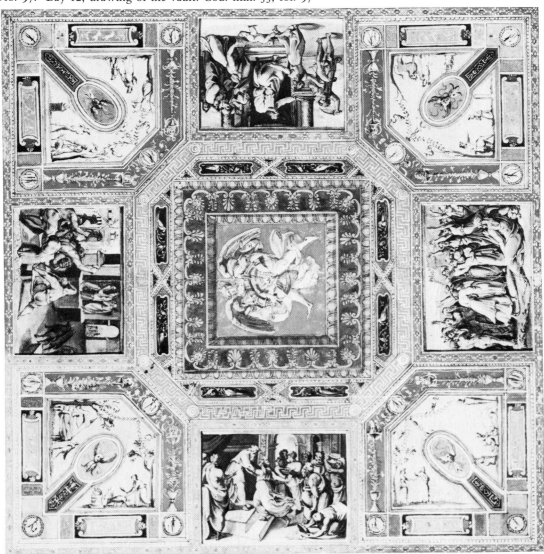

FIG. 98. Bay 12, *Zadok Anoints Solomon*

FIG. 99. Bay 12, *The Judgment of Solomon*

Fig. 100. Bay 12, *Solomon Builds the Temple*

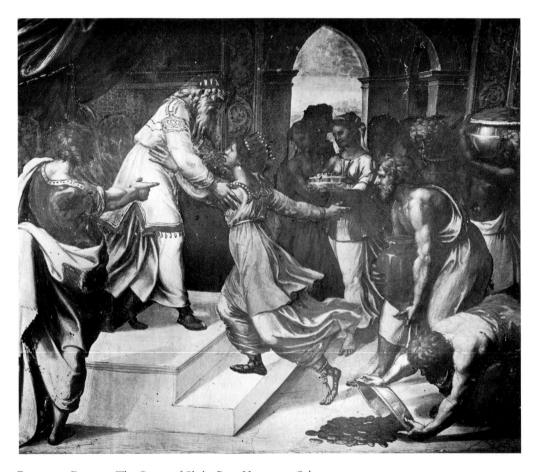

Fig. 101. Bay 12, *The Queen of Sheba Pays Homage to Solomon*

FIG. 102. Bay 12, drawing of the west wall with basamento, *Jeroboam
Kneels Before Rehoboam* (?) Cod. min. 33, fol. 90

*Detail of basamento*

FIG. 103. PIETRO SANTO BARTOLI, engraving of Bay 12 basamento scene, *Jeroboam Kneels Before Rehoboam* (?) New York, Metropolitan Museum of Art

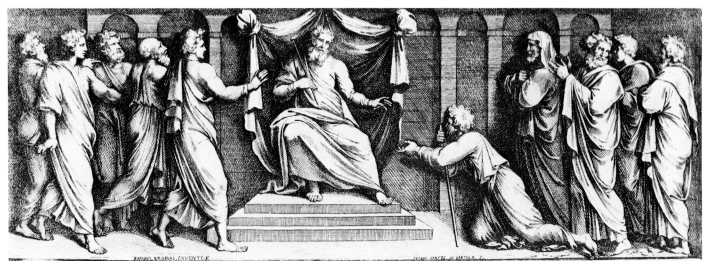

FIG. 104. Bay 12, drawing of the east arch. Cod. min. 33, fol. 92

FIG. 105. Bay 12, east arch, pendentive stucco of Jupiter and Ganymede

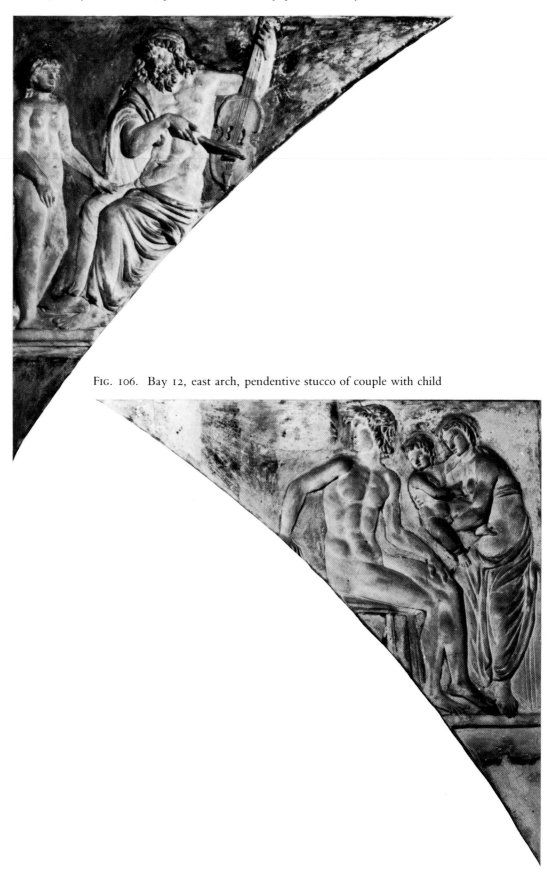

FIG. 106. Bay 12, east arch, pendentive stucco of couple with child

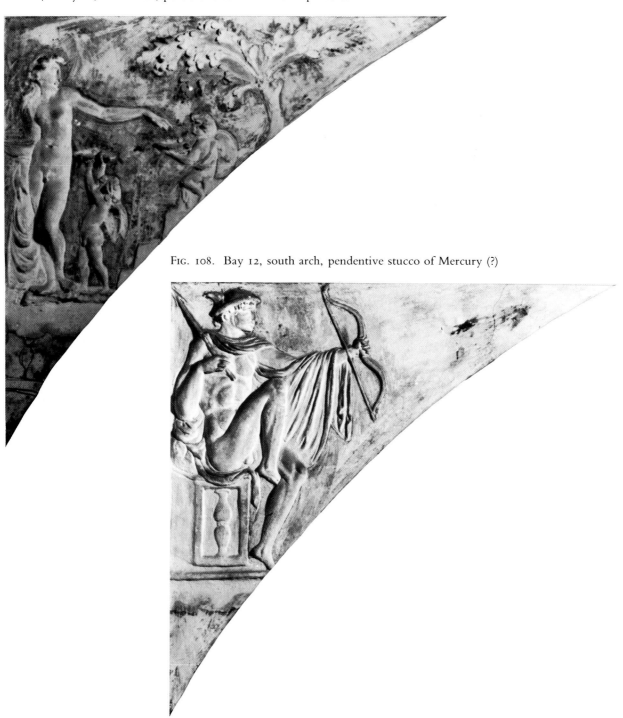

Fig. 107. Bay 12, north arch, pendentive stucco of Hermaphrodite

Fig. 108. Bay 12, south arch, pendentive stucco of Mercury (?)

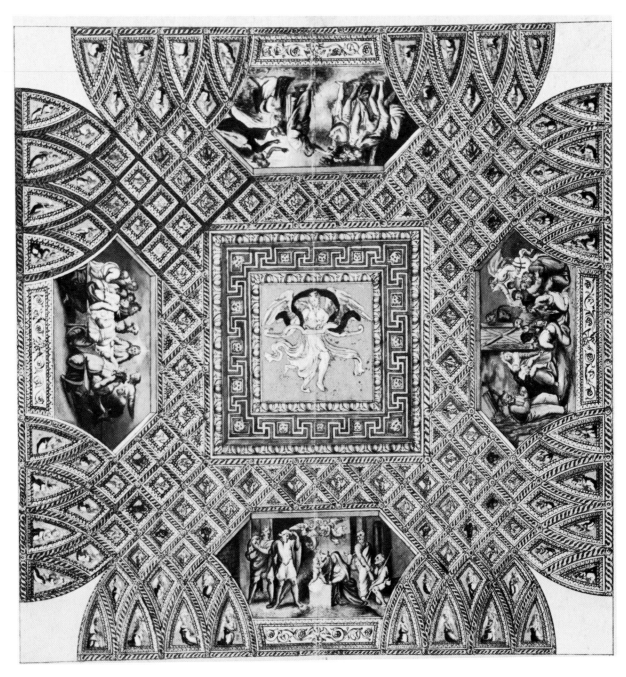

FIG. 109.  Bay 13, drawing of the vault. Cod. min. 33, fol. 105

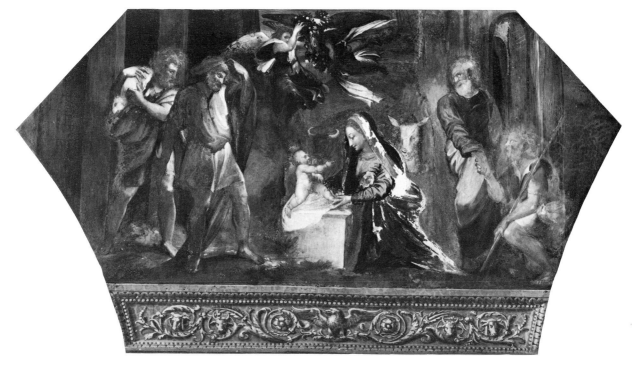

FIG. 110. Bay 13, *The Adoration of the Shepherds*

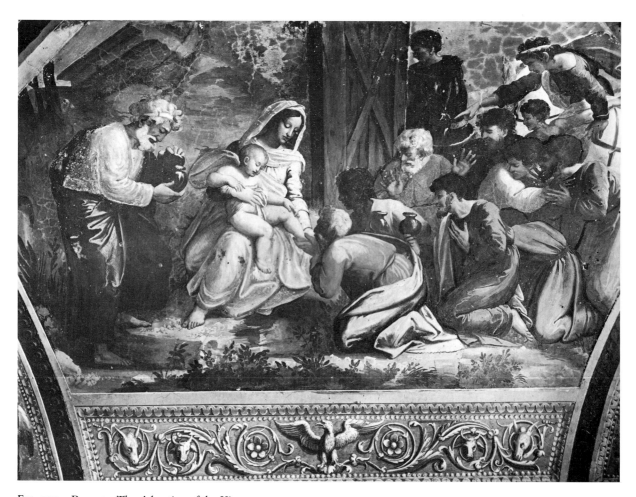

FIG. 111. Bay 13, *The Adoration of the Kings*

FIG. 112. Bay 13, *The Baptism of Christ*

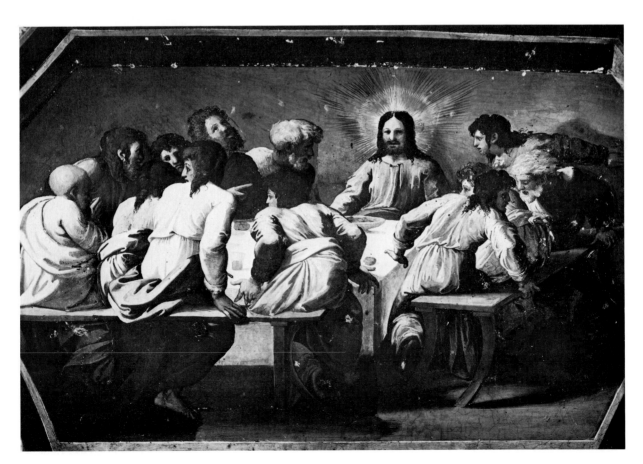

FIG. 113. Bay 13, *The Lord's Supper*

FIG. 114. Bay 13, drawing of the west wall with basamento, *The Resurrection*. Cod. min. 33, fol. 98

*Detail of basamento*

FIG. 115. Bay 13, vault detail with angels

Fig. 116. Bay 13, north end wall arch, pendentive stucco of mourning woman

Fig. 117. Bay 13, south arch, pendentive stucco of two women with infant holding palm frond

Fig. 118. Bay 13, west wall lunette and pendentive stuccoes of women outside city walls, with *The Creation of Adam* in the keystone panel of the arch

FIG. 119. Bay 13, north end wall arch, pendentive stucco of a woman with Amor

FIG. 120. Bay 13, east arch, pendentive stucco of Lachesis and Amor

FIG. 121. Bay 13, north end wall underarch, stucco of Jupiter, Amor, and an infant

FIG. 122. Bay 13, north end wall underarch, stucco of Leda and the swan

FIG. 123. Bay 13, north end wall underarch, stucco of Amor and Psyche (?)